Eleanor Antin

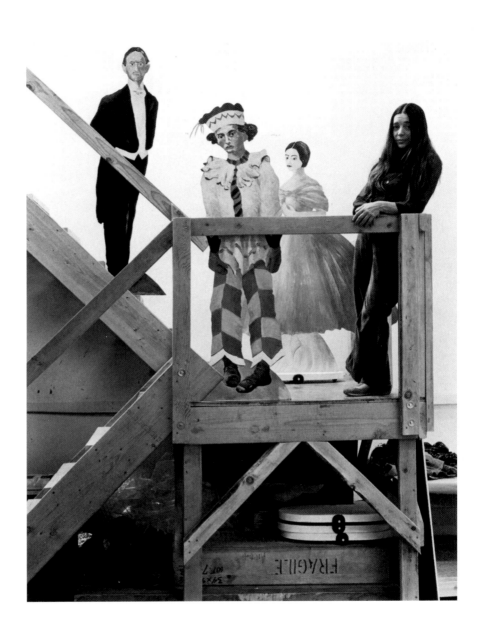

Eleanor Antin

Howard N. Fox

With an essay by Lisa E. Bloom

Los Angeles County Museum of Art
Fellows of Contemporary Art

This book was published in conjunction with the exhibition *Eleanor Antin,* organized by the Los Angeles County Museum of Art and initiated and sponsored by the Fellows of Contemporary Art. In-kind support for the exhibition is provided by KKGO, the museum's official classical radio station. Additional support was generously provided by Hotel Nikko at Beverly Hills. The exhibition was held at the Los Angeles County Museum of Art from May 23 through August 23, 1999.

Published by
Los Angeles County Museum of Art
5905 Wilshire Boulevard
Los Angeles, California 90036

Fellows of Contemporary Art
777 South Figueroa Street, 44th floor
Los Angeles, California 90017

Distributed by
D.A.P./Distributed Art Publishers
155 Sixth Avenue, 2nd floor
New York, New York 10013
Phone: (212) 627-1999; Fax: (212) 627-9484

Library of Congress Catalogue Card Number: 98-52807
ISBN: 0-911291-27-x

Portions of Lisa E. Bloom's essay were excerpted by arrangement with the University of California Press.

Photography credits
Most photographs in this volume are reproduced courtesy of the creator or lender of the artwork depicted. For certain documentary photographs we have been unable to trace copyright holders; we would appreciate notification of same for acknowledgment in future editions. Additional credits: Patricia Layman Bazezon, pp. 143, 146–47; Anne Bray, p. 133; © Becky Cohen, cover, pp. 129, 135–37, 139–41, 145, 151; Lenny Cohen, p. 153; D. James Dee, p. 127; eeva-inkeri, pp. 95, 117; © Kurt E. Fishback, p. 2; Michael Goodman, pp. 149–50; Craig Krull, p. 47; Steve Oliver, pp. 25, 30–31; Denise Simon, p. 115; Phel Steinmetz, pp. 66–69, 82–83, 89; Mary Swift, pp. 111, 118–19, 183; John F. Waggaman, p. 23; Zindman/Fremont, p. 33

Edited by Nola Butler
Designed by Lausten+Cossutta Design
Design supervised by Jim Drobka
Catalogue photography supervised by Steve Oliver
Production coordinated by Rachel Ware Zooi
Printed by C & C Offset Printing Co., Ltd., Hong Kong

Cover
From the Archives of Modern Art, 1987.
Frontispiece
Representational Painting, 1971.
Page Two
Eleanor Antin in her studio, ca. 1981.

Contents

Foreword

For more than three decades Eleanor Antin has been a notable presence on the American art scene, first in New York City and later in her adoptive home in Southern California. During that time she has developed a body of work that is remarkable for its inventiveness, its wit, and its poignancy. Beginning her career as a painter but moving early into conceptual art, she became a pioneering figure in the development of video, performance, and installation art. Deeply affected by feminist thought and activity in the late 1960s and early 1970s, she was among the first artists to reassert the importance of biography, autobiography, and history for contemporary art. And she has been widely acknowledged by critics and artists alike as a formidable influence on successive generations of artists and on individuals.

Antin has had dozens of solo exhibitions, performances, and video and film screenings in museums and galleries over the years and has been represented in countless group exhibitions and festivals. The bibliography of critical response to her art is impressive. Recently she has earned such prestigious awards as the John Simon Guggenheim Memorial Foundation Fellowship (1997) and the Cultural Achievement

Award of the National Foundation for Jewish Culture (1998), reflecting her long record of artistic accomplishment. Surprisingly, until now, there has not been a full survey of Antin's artistic development—possibly because some of her most ambitious works, being ephemeral, have had to be partly or entirely replicated to be seen; and, once replicated, they involve complex, space-consuming installations. The challenges of organizing such an exhibition are imposing for any institution; yet, as curators and art historians continue to reassess the art of the very recent past, it is appropriate that Eleanor Antin's significant contribution be acknowledged and studied. I am proud that the Los Angeles County Museum of Art, in association with the Fellows of Contemporary Art, has met the challenges of producing this comprehensive representation of one of the most stimulating, thought-provoking, and rewarding artists of the period.

Graham W. J. Beal
Director
Los Angeles County Museum of Art

Sponsor's Statement

It is with great pleasure that the Fellows of Contemporary Art has collaborated with the Los Angeles County Museum of Art to present *Eleanor Antin.* This retrospective exhibition provides a timely opportunity to reexamine the myriad forms of the artist's innovative work. Eleanor Antin was an early advocate of the idea that art documents life—and what inventive, interesting, quirky lives she has shown us! We heartily anticipate revisiting documentations of the past as well as exploring the new work created for this exhibition.

 Eleanor Antin is the twenty-eighth exhibition sponsored by the Fellows since the group's inception in 1975. During the past twenty-four years, the mission of the Fellows has been to encourage and present the art of emerging and midcareer California artists. A scholarly catalogue is published in conjunction with each exhibition underwritten by the Fellows.

 Although *Eleanor Antin* is the first collaboration of the Fellows of Contemporary Art with the Los Angeles County Museum of Art, the members of the Fellows have previously enjoyed a long and congenial association with curator Howard N. Fox. His astute and witty observations have informed numerous art encounters with the members of the

Fellows. We thank him for the lively dialogues of the past and are grateful indeed for his superlative guidance and the command that he has exercised over this project. Thanks also to Lisa E. Bloom, whose insightful essay provides a context for Eleanor Antin's work. The Fellows wishes to thank LACMA's president and chief executive officer, Andrea L. Rich, and director Graham W. J. Beal for the opportunity to work with the museum on this important exhibition.

Numerous Fellows helped to bring this exhibition to fruition. Thanks go to immediate past chair Diane Cornwell; to past chair of long-range exhibition planning Tina Petra and her committee for selecting this show; and to current chair of long-range exhibition planning Linda Polesky. Thanks also to Suzanne Deal Booth, who has provided able leadership as Fellows' liaison for the exhibition, and to administrative director Merry Scully, who has cheerfully and competently orchestrated communications and countless details. Very special appreciation goes to the members of the Fellows, whose financial support and dedication to the contemporary art of California bring to life exhibitions like *Eleanor Antin.*

Joan Rehnborg
Chairman (1997–98)
Fellows of Contemporary Art

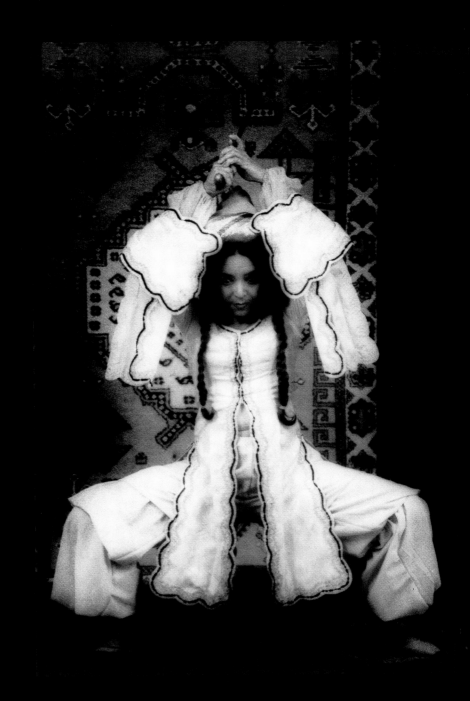

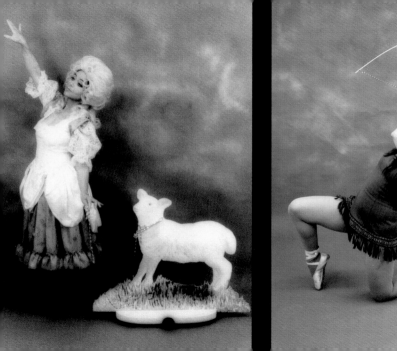
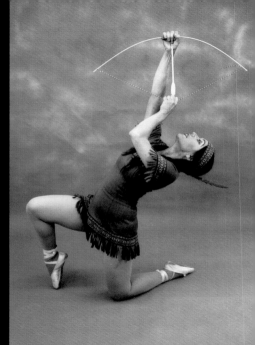

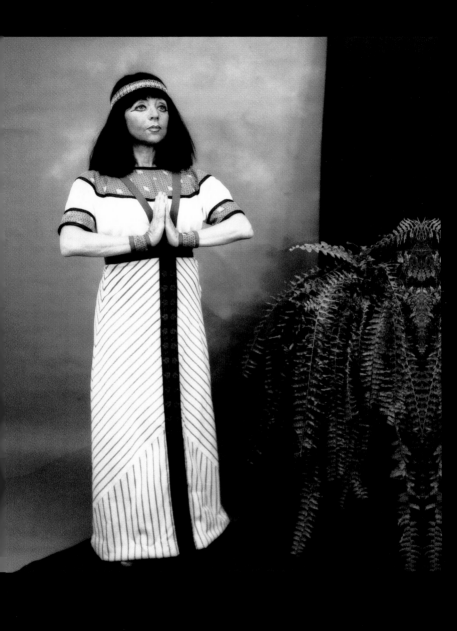

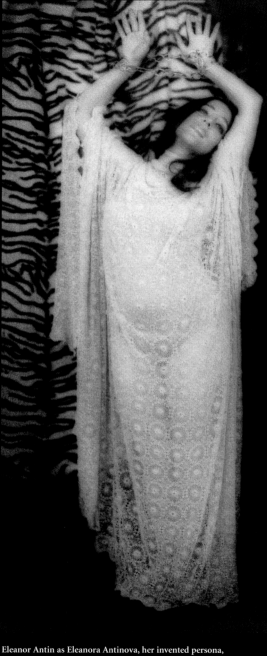

Eleanor Antin as Eleanora Antinova, her invented persona, the black ballerina of Sergei Diaghilev's Ballets Russes, in Antinova's Great Roles in *The Prisoner of Persia, Before the Revolution, Pocahontas, The Hebrews* (pp. 11–13), and *L'Esclave* (The slave), above.

Waiting in the Wings:
Desire and Destiny in the Art of Eleanor Antin

Howard N. Fox

PROLOGUE

As a student at City College of New York, CCNY, Eleanor Antin majored
in creative writing and minored in art, taking acting classes on the side.
With hindsight it is easy to see the clear trajectory her pursuits took, ulti-
mately combining in a rather elegant and seamless fusion, but in her
nascent career—perhaps careers might be more accurate—she was, like
many talented young people, eclectic in her interests, undecided in her
intentions, and intoxicated by the gamut of possibilities. The pursuits of
acting and making art vied for her creative attention; and they were com-
plicated by a fling with writing poetry and fiction, a flirtation with danc-
ing, a fantasy about directing films, and prescient experiments in what
would soon come to be called performance art.

Antin's acting career appeared to have real potential: she was a
member of Actors' Equity Association, had a stage name—Eleanor Barrett,
which she probably rightly assumed would land her more roles in those
days than her family name, Fineman—had appeared in supporting roles in
stage and television productions, and had been offered a full-time position
in the cast of the Living Theater, the vibrant and highly political acting

troupe that was forming a permanent company. She did not take that position, however, because union hiring regulations presented her with the thorny choice of changing her stage name or resigning Actors' Equity, either of which she deemed an unwise career move. She continued to act in uninteresting bit parts until the day she walked out of rehearsals for what she calls a "stupid" television drama for children, a truly bowdlerized version of the tale of Joan of Arc that ended *happily!* Whether disillusioned or simply no longer interested, she never resumed professional acting.

This by no means left her with nothing to do; for at the same time that she was moving from bit part to bit part, she was painting. Antin was initially influenced by the tradition of abstract expressionism, by then in its third generation or so, but still active and still attractive to many younger painters. Her canvases at that time, roughly 1961–63, were very painterly, impastoed, earthy-colored, and often sported three-dimensional accoutrements—household junk, kitchenware, and the like—that were attached to the surfaces, a not uncommon thing to find in New York painting at that juncture. Artists like Jim Dine, Robert Rauschenberg, Niki de Saint Phalle, and Jasper Johns, among others, had been incorporating such found objects into their painterly production for some time. This infiltration of the artifacts of daily life—the really humble discards and detritus of life outside the atelier—tended to debunk, or at least to undercut somewhat, the pious awe that many observers reverenced upon classical abstract expressionism, including its lionization of the artist as a haunted genius or a kind of shaman. These incipient gestures of intrusion into the face of the highest form of contemporary art were a kind of precocious expression of pop art; and Antin, like so many of her generation, was emotionally stirred and intellectually intrigued by the intromission of daily life into art. Pop art, then, or its impulse, rather than abstract expressionism or some other studio practice, was a significant lure for Antin. She was good enough at painting to have been represented in a few group

exhibitions around New York, but her involvement with painting seems, in retrospect, to have been more of a youthful experiment, whose results tended to entice her away from pure painting and nudge her curiosity more toward the direction of exploring popular culture.

But young Antin, or Fineman, as she still was, also had literary aspirations. She had met her future husband, David Antin, in writing classes at CCNY. Though David was a fellow student—a perpetual student, who ultimately was graduated against his wishes after seven years at CCNY—he was several years older than Eleanor and was a published poet. David introduced Eleanor to many writers, and together they circulated through his literary world as readily as they did through her art world. Their lively social and creative lives brought them into contact with many of the best minds of their generation, and the heady mix somewhat blurred the orthodox distinctions between their respective interests. For a period during the early 1960s, their activities even began to resemble one another's: David, the poet, was writing art criticism; and Eleanor, the painter, was writing poetry and fiction. They married in 1961, and they acknowledge that although they have pursued separate careers since then—they formally collaborated only once, on the 1997 movie *Music Lessons*—they have significantly influenced each other, particularly in the practice of freely incorporating the modes, the methods, and the lore of multiple disciplines into their art. Meanwhile back in New York in the early 1960s, yet another area of activity was exerting what can only be regarded as a formative influence on Eleanor Antin—the advent of Fluxus.

It is difficult to describe, much less to define, what Fluxus was or the nature of its influence. As Owen F. Smith points out, "Fluxus artists saw themselves neither as part of a movement nor as proponents of a specific style—possibly not even as a 'group'—but principally as adherents of an alternative attitude toward art making, culture, and life. . . . Indeterminacy, in fact, was built into the name itself, coined by George Maciunas in 1961

as the title for a proposed magazine that would publish works by experimental artists, writers, and musicians, but [was] soon adopted to describe a range of performance, music, and other activities subsumed under the Fluxus rubric."[1] Fluxus art resembled Dada, not only in appearance but in the anarchic and iconoclastic spirit it had inherited from the Dadaists. But the Dadaists often seemed cynical or even sneering in their ridicule of bourgeois values and conventional culture, whereas Fluxus artists seemed far more good-natured, being genuinely populist and politically idealistic in their endless experimentation and explorations.

Among the manifestations of Fluxus art were performances and interactive events involving absurd antics or structured activities; concerts incorporating every sort of new-musical and nonmusical mode (reflecting the important influence of John Cage); art exhibitions; festivals devoted to the presentation of the new intermedia forms; and the publication and distribution of multiple editions of experimental artworks in the form of poetry and picture books, posters, broadsides, manifestos, board games, custom-made rubber stamps, and, particularly in the late 1960s, *containers*—cigar boxes, plastic sorting boxes, file-card boxes, toolboxes, briefcases, bins, cabinets, drawers, even vending machines—filled with toys, foodstuff, trinkets, machine parts, postcards, medicines, debris, photographs of debris, anything and everything.

Clearly, Fluxus artists were deliberately tweaking the conventional definitions of (even avant-garde) art, effectuating a mixture that was about two parts Groucho Marx to one part Karl Marx. Fluxus artists wanted to demystify high art, to expose its inherent triviality, and to create humorous art of raucous absurdity; what is more, they harbored the high moral purpose of liberating art from its own conventionality and pomp and the desire to democratically disseminate their vision to the broadest possible public. Fluxus art reveled in the artifacts and accidents of daily life in which their enterprise was innately rooted. Antin was never

formally associated with Fluxus, nor did she share to any great degree its mistrust of fine or high art. But in the early 1960s she knew its principal figures and many who were attracted to the Fluxus attitude; she frequently attended their activities and exhibitions; and she enjoyed its ironic humor and open spirit, which eagerly embraced non-art, "life" concerns, while freely ignoring the traditional boundaries that separated the arts into discrete disciplines.

"Fluxus posits a view of the world and its operations," observes Smith, "that celebrates an absence of higher meaning or a unified conceptual framework, while simultaneously stressing the act of this very celebration. . . . Fluxus embodied the desire of artists to direct their energies toward the recognition and celebration of life, not art. As this attitudinal aspect of Fluxus developed, it continuously moved toward a more open-ended enjoyment of life. . . ."[2] The broadest contribution of Fluxus, art-historically speaking, may have had less to do with specific products and events generated by its international brotherhood than with its introduction of even the most far-flung and unexalted content as a legitimate ingredient of art making. The great legacy of Fluxus was its attitude—its anarchic, innocent, giddy open-mindedness, which primed practitioners and viewers alike to embrace virtually any artistic strategy, form, or content. Eleanor Antin shared that attitude. With her own eclectic background in acting, writing, and painting, and with a penchant for populism and an apparently inborn sense of curiosity and freewheeling invention, she soon began producing a body of work that, over the next three decades, would resist generic categorization, both provoking viewers' responses to her new art forms and sustaining a rich legacy of interpretation.

Beginning in 1965 and continuing until 1968, Antin set about collecting blood samples dabbed on glass microscope slides from one hundred poets she knew, including such now legendary figures as John Ashbery, John Cage, Allen Ginsberg, Jackson Mac Low, and Jerome Rothenberg. Antin arranged the slides in a commercially manufactured wood box and exhibited them along with a numbered list of the specimens. Her *Blood of a Poet Box* (no. 1, opposite) is a kind of homage, albeit one tempered by gentle irony, to Jean Cocteau's surrealistic film of 1930, *Le Sang d'un poète* (The blood of a poet), which explored, and exalted, the fantastical inner life of the creative artist.

While the form of *Blood of a Poet Box* is not without historical precedent—Ann Goldstein points to Marcel Duchamp's *La Mariée mise à nu par ses célibataires, même (Boîte verte)* (The bride stripped bare by her bachelors, even [green box]), 1934, as a similarly conceived collection of specimens[3]—in the context of New York in 1965, it really is closer in spirit to the wit, idealism, and populism of Fluxus art. Antin's project is rooted in the real lives of people with whom she had a personal relationship and all of whom are as individually and collectively present in the work as she is. It uses organic material and manufactured goods that look like anything but fine art to explore the relationship of art and life; and it implies a celebration of and a regard for life in its suggestion of human mortality. The piece is totally engaged in its social and cultural milieu.

Antin also introduces a level of content beyond the interests or sensibility of Fluxus. A charming memento mori and a true reliquary, *Blood of a Poet Box* indeed contains something of the physical essence of the poets' selves, but this is, of course, merely a cultural conceit. Though Antin, in fact, did collect authentic blood samples from each of the poets named in the piece, their actual samples count for absolutely nothing in either vital or poetical reality. They are merely souvenirs, and, for all the

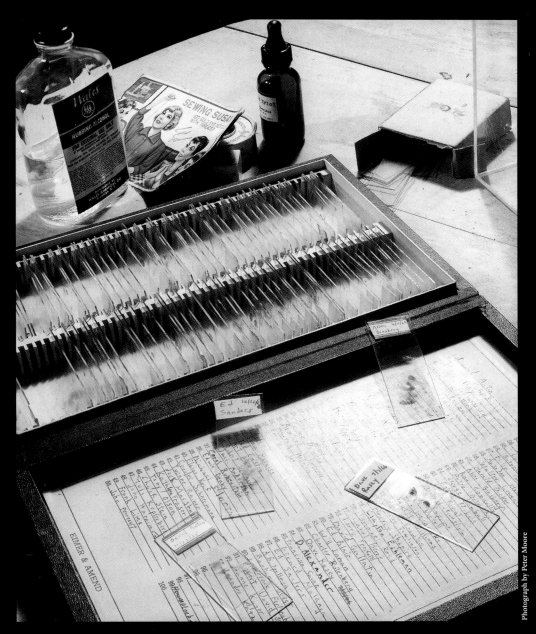

Photograph by Peter Moore

Blood of a Poet Box, 1965–68

One hundred poets—among them, John Ashbery, John Cage,
Allen Ginsberg, Jackson Mac Low, Jerome Rothenberg—
each contributed a drop of precious poet's blood, preserved
on microscope slides, for this witty homage to the poet,
filmmaker, and fiction writer Jean Cocteau.
Checklist no. 1

viewer knows, these smears might be any old blood, not "poetic" blood, whatever that might be. Antin is dealing with the power of the imagination here, not with issues of authenticity. Anything that these authentic blood samples can provide is nothing more, and nothing less, than some dimly perceived (but enduring) narrative about the Poet—that tormented, possessed, creative soul, whose very lifeblood comprises the collection. What is actually preserved? Nothing more than a few drops of dried blood. What is evoked? Nothing less than the whole Romantic tradition of poetry and the Romantic ideal of art—especially the creation of art—as a transcendent and transporting experience. This is a prescient piece in Antin's oeuvre (and one of the earliest examples of "conceptual art," or concept-driven art, which emerged during the mid- to late 1960s) in which the artist had already established the tenets that would abide in her art until the present: an interest in evoking personal history through narrative; a fascination with artists, and an even more pronounced preoccupation with the relationship between life and art; and an inherently romantic faith in art as a practice through which to realize one's life.

It is certain that Antin did not deliberately articulate these notions at this nascent stage in her career, and it would have been preposterous for her to have set out to pre-chart her artistic evolution. In the next bodies of work, however, Antin did step up the narrative element in her art. In 1967 she made a series of collages that combined imagery from old-master paintings, art photography books, and fashion magazines into small, irregularly shaped and individually framed, quasi-surrealistic tableaux, each representing some moment in a nonspecific narrative. She then gathered the collages into irregular, nonlinear wall arrangements that collectively tend to suggest some overall story through the relationship of parts. Antin painstakingly cropped and spliced the images, making her conjoinings as technically convincing as they were startling. A woman, for example, seamlessly transmutes into a horse. Lacking plot or sequence,

these grouped collages plainly are not conventional storytelling, but they do provoke a virtually inborn desire in the viewer to read out of the incoherent parts an intuited, if not entirely comprehensible, whole.

By 1969, the Antins had moved to Southern California, where David had accepted a faculty position teaching critical studies at the University of California, San Diego (where Eleanor has also been a faculty member since 1975). She made a series of *Movie Boxes* (nos. 2–3, p. 25), which resembled the glass-and-aluminum display cases of still photos commonly used in movie theater lobbies at that time to advertise coming attractions. Antin had always been intrigued with such displays and enjoyed trying to guess the story line from the movie stills. Her own *Movie Boxes,* however, do not employ stills from any actual movie. Rather, she had to create, and in turn to suggest, the content of her imaginary movies from found photographs that she appropriated (and sometimes combined into photomontages) from magazines, newspapers, books, and so on. The three or four resulting pictures in the display cases evoke a kind of narrative, though not a straightforward story. The strategy builds upon that of her earlier collages but with the fantastical elements yielding to a more realistic, if equally elusive, depiction of events. This strategy also compounded Antin's creative role in the work, as she assumed, in some obscure, make-believe way, the functions of the screenwriter, director, and

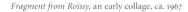

Fragment from Roissy, an early collage, ca. 1967

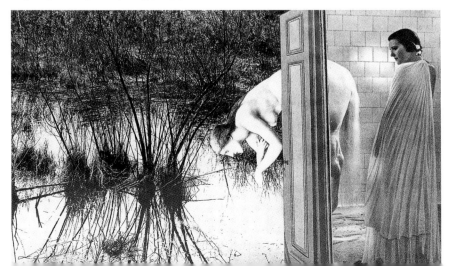

cinematographer on movies that she could only dream of producing in the usual way. This strange bit of role playing would have deep significance in later works.

Antin had come far afield from her early pursuits as a painter, writer, and actor when she left the hothouse milieu of downtown New York. Though she had been resident in, and had moved fluidly through, the New York art world of the 1960s, she operated largely outside of its canon. Fluxus was deliberately marginal; and Antin was even outside of Fluxus. In moving to California, she positioned herself at the far fringe of the New York art world, without breaking her bonds with it—indeed, she has since maintained strong ties with New York artists, critics, curators, and dealers—but remaining apart from its strong professional undertows.

Antin asserts that New York had become boring and stifling and that California seemed wide open and full of possibilities.[4] The creative climate in the New York art world, then and now, ranged from doctrinaire to liberal; but no matter what an artist, even an unknown and unshown neophyte, did there, it typically would be scrutinized, held accountable, and sanctioned, or not, according to The Discourse—that ever-shifting set of orthodoxies and licenses of the moment. Attention would be paid. The determined, highly mobilized New York art scene, with all its earnest commentary and hypercriticism, its vested interests, and its fads and fashions could be exhilarating, empowering, and supportive; or it could be academic, stultifying, and exclusionary. California neither offered nor imposed such a milieu.

It is true that in the late 1960s Southern California was rapidly emerging as a national center for the visual arts, and it has since become an international center for the creation and exhibition of art, but it has never mustered an overweening or authoritarian critical center. There are prominent figures and voices, but no dominant ones. Individual artists can make strides of significant professional attainment and be assured of

from *Movie Boxes*, 1969–70

In 1969 Antin began working with photographs she appropriated from magazines and books, treating them as if they were still photographs from imaginary motion pictures. She juxtaposed and combined them with the briefest of texts to evoke the sense of a pictorial narrative. Antin describes these "movie boxes," reminiscent of the lobby displays used to advertise coming attractions, as "nonmotion pictures."

Here
Checklist no. 2
And
Checklist no. 3

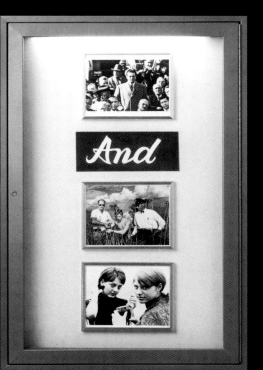

suffering little notoriety or critical consequence for it. The freedoms and communal fairness—or indifference—are more palpable than in virtually any other sophisticated art community. The facts of life in the Southern California art scene of the last three decades parallel the popular mythology of "California" itself: the individual had not only the possibility of inventing herself, but the necessity. There was little structure in place to facilitate an emerging artist's assumption of a prefigured role, and no hegemony of forces to dictate norms of experimental behavior. Here, even more than in seething New York, anything could happen. If a sense of wide-open inventiveness was an optimistic way of looking at a not-yet-organized artistic milieu, some artists opted to make the most of it.

Antin recounts that it was the notion of inventing a life, or a personal history, that motivated her next series, *California Lives* (nos. 5, 7, and 8, pp. 28–31), begun in 1969 and exhibited at New York's Gain Ground Gallery the following year. The works are "portraits" of individuals—some real, some imagined—assembled from brand-new consumer goods and household artifacts. The associations these common objects evoke, together with the assist of an accompanying narrative text panel written by Antin, enable viewers to conjure up an impression of the characters she portrays. The person of *Jeanie*, for example, is revealed through a few stray personal articles—a melamine cup and saucer, a pink hair curler, a king-size filter-tipped cigarette, and a matchbook from Bully's Prime Rib restaurant—strewn on a folding snack table with a text giving a few sketchy details about Jeanie's day-to-day life:

> She worked nights, late. Liked to watch the surf in the mornings. She didn't get much sleep then but she didn't really care about that. She worried about her little girl. Maybe her mother would send money from Idaho but she never did. Twice a week the lifeguard with the moustache would visit and they went inside the

house. Later he came out alone and trotted back down to the beach. Much later she became a masseuse and her mother sent the granddaughter a red Camaro. She smashed it up on the freeway but she wasn't hurt.

The text resembles the brief character sketches that often precede playscripts, acquainting the actors with their characters. Such details usually have little to do with the dramatic action of the play but are hints to the mind-sets and habitual behavior of the characters. Antin's Jeanie, like the other individuals portrayed in *California Lives*, contrasts profoundly with the hundred New York poets Antin had celebrated in her earlier work or any of the people she had likely known in her native New York. Most of her California people are decidedly uneducated, somewhat downtrodden working-class people: common, simple folk, with complicated lives. Some of the portraits in the series are based on real people she knew or had met, but had not necessarily socialized with; some are simply made up. It is probable that at some level the series derives from Antin's attempt to make sense of her new surroundings (and what she imagined to be a "California pop culture") through her art. Tellingly, she called these characters "iconic people," as if their generic personal histories might illuminate her new world.

California Lives was succeeded by a complementary series of consumer goods sculptures from 1970 titled *Portraits of Eight New York Women* (nos. 9–11, pp. 33, 178–79), which Antin exhibited at a rented room in the Chelsea Hotel in New York. Unlike most of the figures in *California Lives*, the eight characters Antin portrays in *New York Women* are real and for the most part were active players on the cultural scene: gallery owner Naomi Dash; painter and critic Amy Goldin; anthropologist Margaret Mead; dancer and choreographer Yvonne Rainer; painter and performance artist Carolee Schneemann; museum publicist Lynn Traiger; poet Hannah Weiner; and poet and playwright Rochelle Owens.

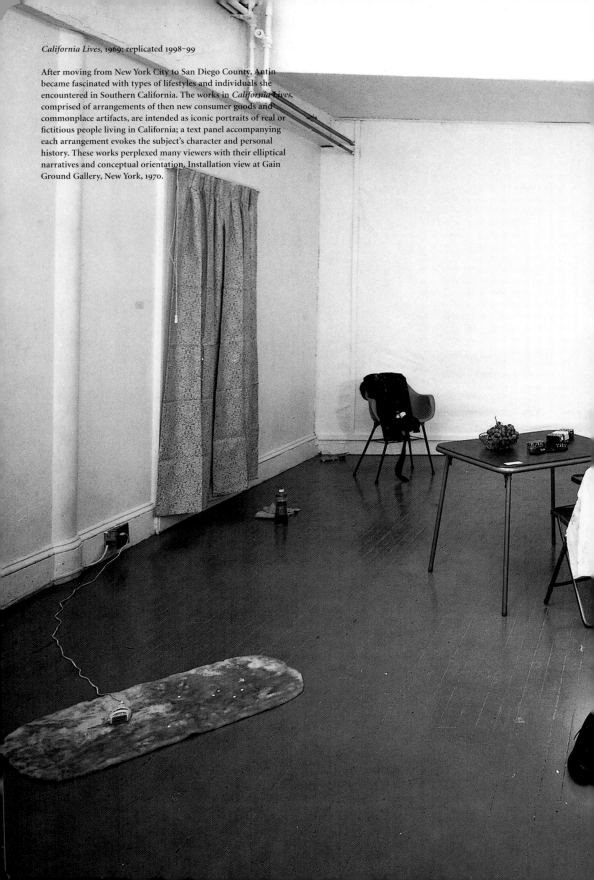

California Lives, 1969; replicated 1998–99

After moving from New York City to San Diego County, Antin became fascinated with types of lifestyles and individuals she encountered in Southern California. The works in *California Lives,* comprised of arrangements of then new consumer goods and commonplace artifacts, are intended as iconic portraits of real or fictitious people living in California; a text panel accompanying each arrangement evokes the subject's character and personal history. These works perplexed many viewers with their elliptical narratives and conceptual orientation. Installation view at Gain Ground Gallery, New York, 1970.

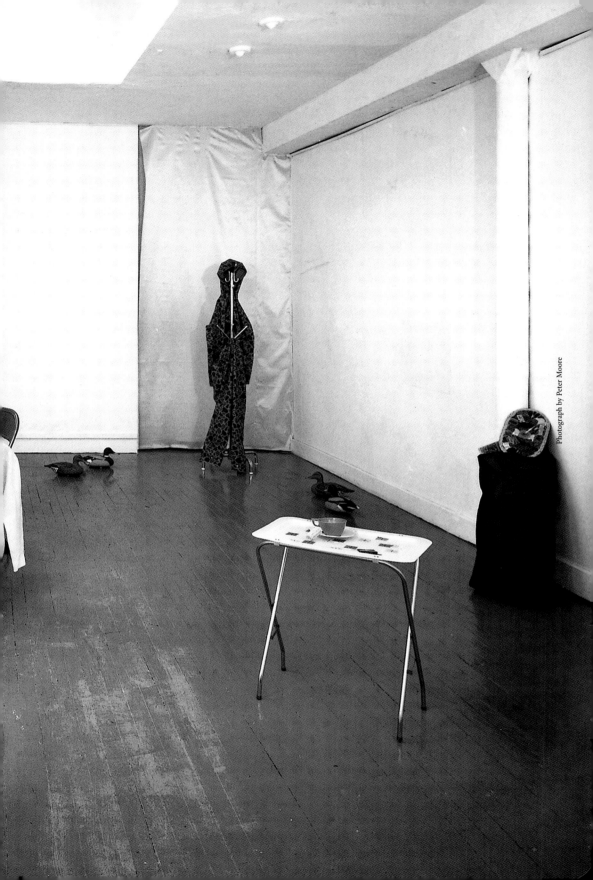

Jeanie, from *California Lives*, 1969; replicated 1998
Checklist no. 5

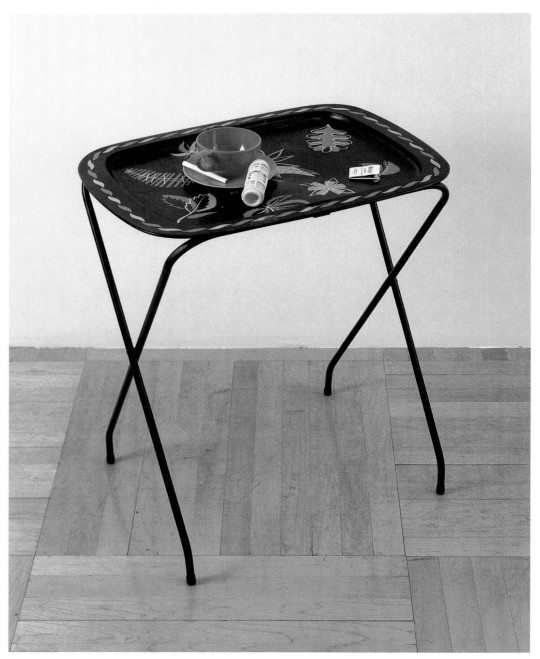

She worked nights, late. Liked to watch the surf in the mornings.
She didnt get much sleep then but she didnt really care about
that. She worried about her little girl. Maybe her mother would
send money from Idaho but she never did. Twice a week the life-
guard with the moustache would visit and they went inside the
house. Later he came out alone and trotted back down to the beach.
Much later she became a masseuse and her mother sent the grand-
daughter a red Camaro. She smashed it up on the freeway but she
wasn't hurt.

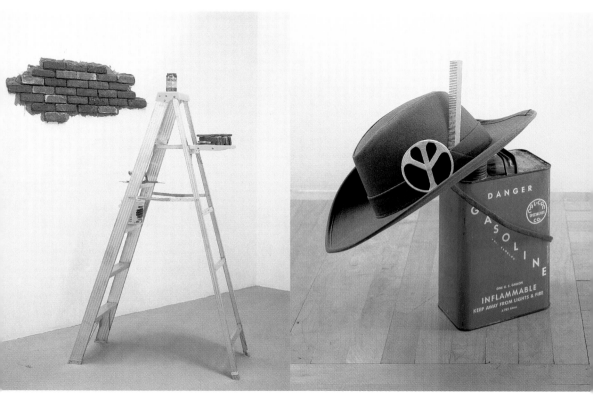

Anne was a real go-getter, an artist. She did
hand painted signs, liked to do pictures of
surfers and cowpokes. But it was a conserva-
tive town. George was a precise man, wore
white shirts and ties. He sold plumbing sup-
plies. The house was on a triangular lot on
the corner of the street. They were always
working on it. Every month it looked differ-
ent. Stevie played the guitar and smoked
dope. He had a Nixon poster in his room with
a bumper sticker above it that said "Peace
Now!" Suzie baby-sat quietly. She was think-
ing. One day Anne ran off with Ruby to a
cabin in the woods in northern Minnesota.
George sold the house and moved onto a boat
in the harbor.

KNX reported that Robert Olmstead of Del
Mar, California, was shot by the highway
patrol while hitching near Sacramento.
According to the news report, when the
officers stopped to question him he
opened fire on them at point blank range
with a sub-machine gun and they were
forced to kill him.

Today these two series emerge as transitional ones in Antin's oeuvre, introducing character and biography as well as a spectrum of content that was fresh, daring, and a little perplexing to the audiences who saw them. Not portraits in any traditional sense, they nonetheless purported to fill a traditional role, incorporating non-art, store-bought goods into little tableaux that drew upon pop art in their selection of materials, assemblage in their formal arrangement, theater in their presentational mode, and fiction in the text that was part of the work. How different these quirky consumer goods pieces seem when considered side by side with contemporaneous work, such as Carl Andre's floor arrangements of square copperplates or Donald Judd's brushed aluminum–and-Plexiglas stackable boxes or Robert Morris's draped-felt forms, all of which stress the quiddity of their industrial materials and the straightforwardness of their fabrication. Antin's sculptures, on the other hand, can be read as intuitive, personal, and domestic—attributes that traditionally have been deemed emphatically feminine. Indeed, Antin was deeply influenced by her readings in women's issues at this juncture, and she saw in the feminist movement an ideological and ethical corroboration of her fundamentally artistic belief that the range of content in contemporary art could, and should, be expanded to include modes of personal exploration, biography and autobiography (both true and fictional); narrative; and fantasy. If this perception provided a mission statement, Antin's art production of the next two years fulfilled it.

During the period from 1971 to 1973, an especially prolific one for Antin, many of her works were textual or combined text with image and object. Like other conceptual artists of the time, she was interested in information systems—not computer data systems, but those intellectual constructs such as nomenclatures, taxonomies, typologies, semiotics—whereby we organize bodies of knowledge. Progressive artists throughout the United States and Europe, and to some extent Japan, were also making

Portraits of Eight New York Women, 1970; replicated 1998

After *California Lives*, which was based mostly on fictitious people, Antin made
another group of consumer goods portraits, this time focusing on the lives of eight
actual women living and working in New York, who were in one way or another
affiliated with the city's art and intellectual circles. This feminist-oriented project,
exploring personal history and protonarrative forms, contrasted with the
dispassionate, male-dominated minimalist aesthetic that prevailed in American art
during the early 1970s. Originally exhibited in a room at New York's Chelsea Hotel
in 1970, these works were replicated in 1998 and exhibited at Ronald Feldman
Fine Arts, New York (below). (See also pp. 178–79.)
Checklist nos. 9–11

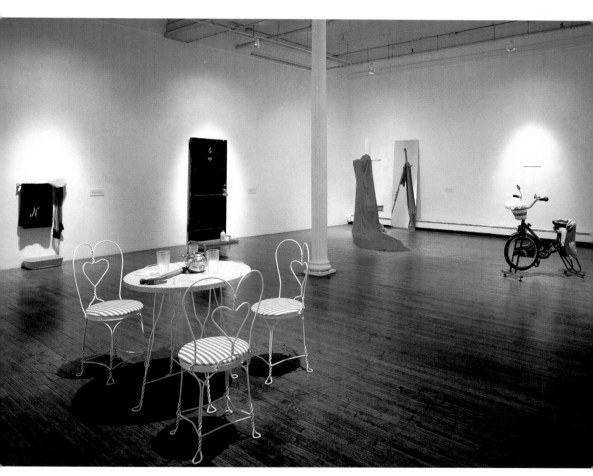

information art or conceptual art. Their work took such forms as open-ended counting projects (On Kawara, Hanne Darboven), photodocumentation of buildings or building types (Ed Ruscha, Bernd and Hilla Becher), verbal recordings or photodocumentation of simple physical tasks (Vito Acconci, Bruce Nauman), maps (Robert Smithson), graphs and charts (Group OHO, Dan Graham), "poetry systems" (John Giorno), and even displays of dictionary definitions (Joseph Kosuth). Perhaps there was an unperceived or underrecognized basis for these exercises in the manipulation and structuring of information in the political life of the international art community, especially with regard to the Vietnam conflict and the growing global refusal to tolerate it: concerned people of many nations came to the realization that an inherent, systemic interdependence of political, economic, and military interests—the "military-industrial complex," as it was called—essentially conspired to preempt the democratic process and perpetuate a reprehensible war. The widespread interest in information systems among artists may reflect a categorical effort to get at the dynamics behind appearances, the systemic forces that make things happen and give form to the basis of public opinion. Or perhaps information- and concept-based art forms were simply an art-historical consequence of the final stage in the dialectic of minimalist strategies that attempted to concentrate art into a pure, formal essence.

Whatever the matrix of reasons for the sudden rise of conceptualism in the late 1960s, it lent itself to many curious works of art. In 1971, for example, Antin produced *Library Science* (no. 15, pp. 35–37), a variation on the theme of the iconic and personal portraits. The artist invited female friends and colleagues to participate in the project by contributing an object that each thought represented something significant about her identity. Antin responded by creating a subject card, using the Library of Congress classification system, which corresponded to her own associations with each of the women and the objects they had contributed, so that each person was represented by a physical object—a houseplant, say—and a

from *Library Science,* 1971

Antin asked women artists to participate in a conceptual art project at the Love Library, San Diego State University, by providing "a piece of information"—an object a document—that each one believed represented something significant about her (the lender's) identity. Antin responded by cataloging each piece of information according to the Library of Congress classification system and creating a card catalogue subject entry, complete with a call number. The objects and their corresponding subject cards were displayed in the library reading room. (A touring version of the show, in which the objects were shown photographically, was circulated to libraries in the United States and Canada.)
Checklist no. 15

from *Library Science*

LITERARY FORGERIES AND MYSTIFICATIONS

PN
171.F7A Annaloro, Marilyn
A4

Certificate of Confirmation

✠

Church of

Divine Aesthetics

San Diego, California

-:- This is to Certify -:-

That Marilyn GOOD-ART Annaloro
 (BAPTISMAL NAME) (CONFIRMATION NAME) (SURNAME)

Son
Daughter } of Wilber R. Parsons
 (FATHER)

and Jenny Marie Parsons
 (MOTHER)

was Baptized September 18 19 49

at Curch of the Super De-Lux San Jose, California
 (CHURCH) (CITY) (STATE)

received the Sacrament of Confirmation

on June 28 1969
 (MONTH) (DAY) (YEAR)

in the Church of Divine Aesthetics

at San Diego California
 (CITY) (STATE)

in the Diocese of Fine Art

by the Most Rev. Marilyn Annaloro

the Sponsor being Marilyn Annaloro

Dated May 13th, 1971

Issued by Marilyn Good Art
 Annaloro

GUERILLA WARFARE

U
240 Fredman, Faiya
F2

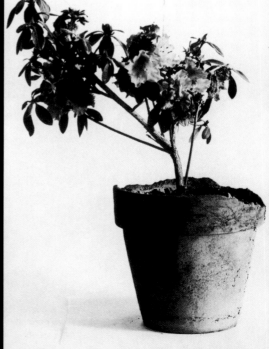

written concept. It is notable that nowhere in her earlier consumer goods portraits or in this library piece does Antin set forth any facts about any of her ostensible subjects, whether real or fictitious. She prefers to communicate through metaphor and artifice, to establish one reality through the form of another. It would have been much easier to simply state a few facts about her subjects, but Antin was never genuinely compelled by facticity. Facts can tyrannize the imagination; and they plainly would in Antin's art. So it is significant that in her subsequent conceptual works, Antin embedded narratives that were intended to play themselves out in real life.

For *Domestic Peace,* 1971–72 (no. 16, pp. 40–41, 171, 173), Antin prepared for a weeklong visit with her mother by noting down old family stories and opinionated observations about relatives. When she arrived, she wryly introduced these anecdotes and remarks into discussions with her mother and made mental notes of her mother's and her own emotional responses. She later recorded their responses as waves on a graph. Her project was a highly subjective profile of a mother-daughter relationship, presented as faux science. *4 Transactions,* 1972 (no. 17, opposite), also utilized secret setups to engage Antin and others in potentially awkward social situations. She contrived four events by documenting her future activities in texts that she then had notarized. At the appointed time, she would complete the planned action, such as criticizing a sister feminist "for her own good," at the risk of creating "bad vibes." These social situations were real in that they actually transpired, but they were fictitious in that they were preplanned episodes of acting out.

Antin's shrewdest works from this period combine her interest in feminism, narrative, and conceptual art forms in a witty critique of the norms and ideals of feminine beauty. *Representational Painting* (no. 14, p. 45), a black-and-white videotape of 1971, features Antin applying makeup to her face, transforming it from "plain" to "beautiful," or at least what

from *4 Transactions*, 1972

Unbeknownst to the other members of a women's encounter group, Antin made written plans to engage in potentially awkward social situations at a future meeting, such as being unsupportive of her colleagues or speaking only while standing behind a colleague she was addressing. In order to authenticate her apparently eccentric actions as premeditated and purposeful activity, Antin had a typescript of her plans certified by a notary public in advance. A witty conflation of art and life, this project deliberately manipulated tacit codes of feminist etiquette and commonplace legal procedures in the name of art.
Checklist no. 17

Encounter # 2
Withdrawal # 2

ENCOUNTER #2

At the February 27th meeting I shall come in drag. I will wear a green velvet maxi-dress, Spanish boots, and a brown suede gaucho hat from Saks 5th Ave. It will be the first dress I have worn in over 2 years. I will not let anyone know it is my birthday.

Eleanor Antin

STATE OF CALIFORNIA
COUNTY OF San Diego
On Feb. 26, 1972 , before me, the undersigned, a Notary Public in and for said State, personally appeared Eleanor Antin

known to me to be the person whose name is subscribed to the within instrument and acknowledged to me that She executed the same.
WITNESS my hand and official seal.
Signature James M. Camp

OFFICIAL SEAL
James M. Camp
NOTARY PUBLIC — CALIFORNIA
SAN DIEGO COUNTY
My Commission Expires Nov. 7, 1975

James M. Camp
Name (Typed or Printed)

(This area for official notarial seal)

WITHDRAWAL #2

At the Feb. 6th meeting any conversation I initiate will be addressed to persons from their rear, never frontally or from the side. I can respond to comments or questions initiated by others regardless of position. If I initiate a conversation from the wrong position I shall leave the meeting immediately.

Eleanor Antin

STATE OF CALIFORNIA,
COUNTY OF San Diego ss.

On this 5th day of February in the year one thousand nine hundred Seventy-two before me Frances R. Cornwell a Notary Public in and for the said County of San Diego personally appeared Eleanor Antin

OFFICIAL SEAL
FRANCES R. CORNWELL
NOTARY PUBLIC — CALIFORNIA
PRINCIPAL OFFICE IN
SAN DIEGO COUNTY
My Commission Expires Dec. 29, 1972

personally known to me to be the person whose name is subscribed to the within instrument, and she acknowledged to me that she executed the same.
In Witness Whereof, I have hereunto set my hand and affixed my Official Seal, at my office in the said County of San Diego the day and year in this certificate first above written.
Frances R. Cornwell
Notary Public in and for the County of San Diego State of California.

QUALITY OFFICE SUPPLIES, SANTA CRUZ—FORM NO. 4

from *Domestic Peace*, 1971–72

Antin drafted notes synopsizing numerous family anecdotes and observations about friends and relatives that she secretly planned to bring up, apparently candidly, in discussions with her mother. After engaging her unsuspecting mother with each preselected topic, Antin made an annotated wave graph whose amplitudes registered her mother's and her own (often divergent) emotional responses to the subject at hand. The pseudoscientificism lends irony to this comic, if somewhat manipulative, game. (See also pp. 171 and 173.)

Checklist no. 16

DOMESTIC PEACE: An Exhibition of Drawings by Eleanor Antin

I live in California and from Nov.29th to Dec.15th, 1971 - a period of 17 days - I planned to visit New York City with my husband and small child. We planned to stay with my mother in her Manhattan apartment. It would serve our economic and domestic convenience (i.e. baby-sitting, meals, other services) but was also an opportunity for me to discharge familial obligations. However, though my mother insists upon her claim to the familial she is not at all interested in my actual life but rather in what she considers an appropriate life. No matter what kind of life a person leads he can always, by careful selection, produce an image corresponding to anyone elses view of appropriateness. By madly ransacking my life for all the details that suited my mother's theory of appropriateness and by carefully suppressing almost all the others, I was able to offer her an image of myself that produced in her a 'feeling of closeness'. It should be kept in mind that this 'closeness' was a 'closeness' to her theory rather than to her life but appeal to her didacticism was the only way to give her sufficient satisfaction to ensure the domestic peace necessary to free me for my own affairs. I planned a daily set of conversational openers consisting of carefully chosen stories. Several of these stories contained slightly abrasive elements which might be expected to mitigate peace. I considered these to be alternates for use only on 'good' days. For those hectic times when I would be forced to remain in the apartment for fairly long periods, I kept a set of reserves I could throw in to hold the line. Hopefully, these stories would act as gambits leading to natural and friendly conversation.

The documentation consists of maps or graphic notations - 15 drawings of the

daily 'coming together' along with the verbal material which engendered it. Included here is a Map Code and one of the drawings.

MAP CODE

	Boredom
	Calm
	Artful and Pleasant
	Agitation
	Argumentative
	Hysteria
	Provocation
S	Story Delivery

Dec. 9,

(Save for a cheerful relaxed day) Why do you get bugged when David talks about Ted Kennedy? You act as if David is guilty of leaving someone in the river to drown. If Kennedy hadn't done it David wouldn't be able to talk about it, right? Look, I didn't say I wouldn't vote for him. If a body or two in your closet is sufficient evidence to disqualify a man from being president who would we ever have to vote for? When they asked Truman on his 80th birthday if he had any regrets he said "One, that I didn't marry earlier."

RENUNCIATIONS (Choose 1)

In the winter of 1972, Fidel Danieli invited me to
be in the first issue of the L.A.Artists' Publication,
planned as an uncollated manuscript appearing quarterly,
in which artists prepared work they found suitable for
a multiple, instant print distribution system. Each
artist was offered as many pages as she/he wished, provided
that they could pay the $8. production fee per page.

I've often wondered what a precise accountant like Jane
Austen meant when she said a gentleman needed 200 pounds
to marry. Or what did it cost a tenant to hand over 50
roubles to his landlord in a Dostoyevski novel? I think
I understand what Rachel cost Jacob - 14 years of his life -
but if a beautiful slave girl cost a rich Athenian 2 talents,
what was she worth? 1 trireme or 6 oars?

Since money is a fluctuating metric that becomes nearly
meaningless as the distance from the time of its use and
the life of its user increases, I decided to measure the
actual cost of an $8. "art" work in terms of my own life
costs at that particular time in my particular space.

 Eleanor Antin

1

Eleanor Antin
Solana Beach, California

No.	Item		Cost per item plus tax	Total
	RENUNCIATIONS (Choose 1)			
8lbs 11 1/5 ozs	Organic dried peaches from Peoples Food	@ $.92/lb	$ 8.00
4hrs	Housecleaning	@ $	2.00/hr	"
3 1/2	Cab rides to and from Santa Fe Montessori School	@ $	2.25	"
10 2/3 hrs	Baby-Sitting	@ $.75/hr	"
39 1/2 min	Long Distance Sunday morning telephone conversations with my mother	@ $.70/3 min	"
360	Chlorpheniramine pills	@ $	2.25/ 100	"
8	Simenon paperbacks	@ $.95	"
1	Neil Young record + 2 knights on horseback with 4 yeomen	@ $ @ $	4.95 2.65	"

© WILSON JONES COMPANY G7202 GREEN 7203 BUFF MADE IN U.S.A.

2

Eleanor Antin

No.	Item		Cost per item plus tax	Total
	RENUNCIATIONS (Choose 1)			
2 2/3	Mexican automobile insurance policies for Tijuana trips	@ $	3.00	$ 8.00
13 5	Felt tip pens + Ball point pens	@ $.49 .25	"
266 2/3	Air Mail Stamps instead of Regular	@ $.03dif/ ea	"
80	Xeroxes	@ $.10	"
1 mo.	Dope	@ca $	25./oz	"
1 pair	White sneakers	@ $	7.62	"
8 13 1/3	Round Trip bus fares to La Jolla or One Way fares	@ $.95 .60	" "
4 4 8	Breakfasts + Specials + Tips at the House of Pancakes	@ $ @ $ @ $	1.00 .50 .25	"

© WILSON JONES COMPANY G7202 GREEN 7203 BUFF MADE IN U.S.A.

passes for beauty in a woman's face according to Antin. The work captures the irony in making such arbitrary distinctions between plain and beautiful, and it slyly begs the question of why women subject themselves to this exercise of making their appearance conform to preferred tastes. The sequel to *Representational Painting* is *Carving: A Traditional Sculpture*, 1972 (no. 19, p. 47), a sequential, gridlike arrangement of 144 photographs documenting Antin's ten-pound weight loss over a thirty-six–day period. The methodical, modular presentation of Antin posing nude in front, back, left, and right views produces a daily account that looks like a series of photographs of a police lineup or the individual shots of a slow-motion film. With great deadpan skill, the piece gently satirizes much of the humorless monotony, ponderously presented under a veneer of pseudo-science and alleged clinical objectivity, that characterized much of the conceptual art of the day. Antin had said it herself: "The early conceptualists were primitives. Contrary to their belief, documentation is not a neutral list of facts. It is a conceptual creation of events after they are over. All 'description' is a form of creation. There is nothing more biased than scientific documentation. It presents a non-psychological image of the 'natural order' with no more claim to 'objective' truth than William Blake's symbolic universe."[5]

The standard feminist interpretation suggests that "these two pieces convey the idea that, for women, dieting and cosmetics take the creative place of art and that in this culture women themselves are the art product."[6] There is truth to this argument, just as there is truth to the troubling implication that in making the body conform to cultural norms of how a body should look, dieting, anorexia, starvation, possibly even death might be considered art forms. It is the argument of victimization. It may be equally true that for Antin a latent artistic and romantic aspiration lurked within the more commonplace practices of "beautification." The ritual of painting her face in *Representational Painting* also mimics the

Representational Painting, 1971

This was Antin's first "life performance" and her first video,
documenting her transformation from a "plain" woman into a
"beautiful" woman by painting her face with makeup. The
piece embodies a subtly wry feminist critique of conventional
notions of feminine beauty and of the objectification of a
woman's body as if it were a work of art.
Checklist no. 14

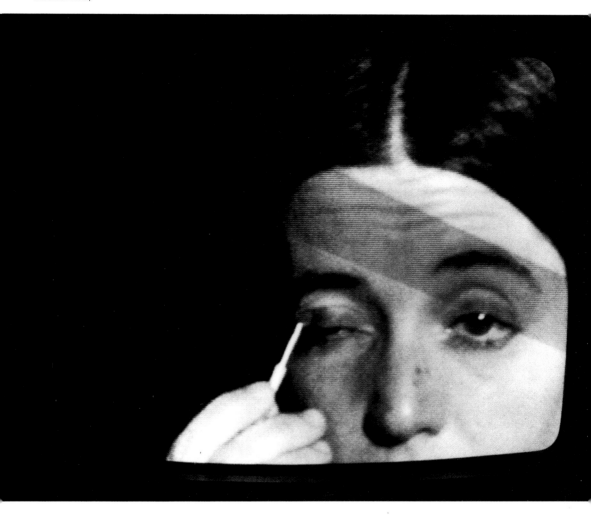

mythology of desire and transformation, as in the fable of the ugly duck-
ling who becomes a magnificent swan. The very title *Carving: A Traditional
Sculpture* alludes to the classical conceit of sculpture: ideal form resides
within the block of stone, and it is the sculptor's job to liberate it, to take
away the excessive physicality. The life corollary is that by taking away what
is superfluous, an artful ideal can be found. In these ambivalent works
Antin does not deny—indeed, she seems to be soulfully attracted to the
possibility—that while art can imitate life, life can also imitate art.

Antin's best-known early work, *100 BOOTS*, 1971–73 (no. 12, pp.
52–57), actually consists of fifty-one separate works, each published as a
picture postcard and mailed to hundreds of recipients around the world.
The postal strategy was right out of Fluxus. Mail art was not new, nor did
Fluxus invent it, but, as Ken Friedman reports, Fluxus artists were "the
first group of artists to understand the potential of the postal system as a
world-spanning, cost-effective distribution system. It was open. It went
everywhere. The direct operating cost to the artist was low."[7] Friedman
goes on to describe how, in large part through Fluxus activities (especial-
ly through the widely distributed *Something Else Press Newsletter,* edited
by Fluxus poet Dick Higgins), mail art evolved from a private exchange of
correspondence among small circles of artists to a public international
network of experimental artists, musicians, and writers. He explains how
mail art ultimately became a full-fledged global communications system,
independent of the commercial galleries and museums that are the usual
venues for disseminating art. Antin participated in the burgeoning move-
ment, and today her *100 BOOTS* is legendary in the history of mail art.

The piece is a mock picaresque tracing the exploits of an unlikely
hero—a band of one hundred black rubber boots—who goes marching
through the towns and countryside of Southern California and beyond.
The photographs reproduced on the fifty-one postcards were shot "on
location." Antin transported the BOOTS, set them up, and photographed

"carving" her body to its "ideal" form through ten pounds of weight loss over a period of thirty-six days of dieting. Antin photographed herself in four views (front, back, left, right) each day. The work is arranged in a grid: each day's poses are shown vertically, while the cumulative weight loss can be read horizontally, like a graph. As in *Representational Painting* (no. 14, p. 45), this narrative treats popular ideas about ideal feminine form with deadpan irony.
Checklist no. 19

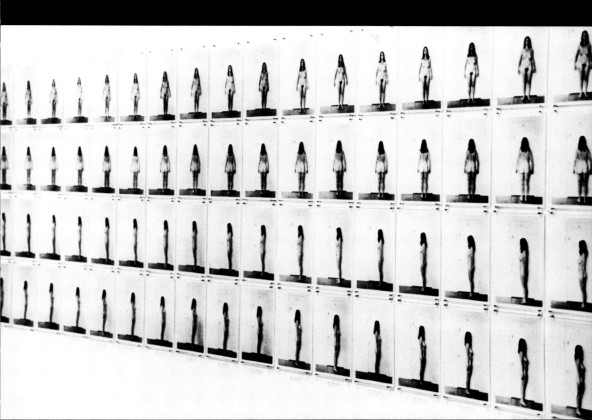

them discovering the world. Their adventures range from the common-place—100 BOOTS go to the supermarket, 100 BOOTS go to church—to the curious—100 BOOTS visit a cemetery, 100 BOOTS trespass a property—to the fun—100 BOOTS ride a roller coaster, 100 BOOTS park at the drive-in. But their most glorious destination was the final one—New York City. The BOOTS ride the Staten Island Ferry, explore Manhattan, and finally in the summer of 1973 end up in the Museum of Modern Art, where all 100 BOOTS and all fifty-one postcards were actually exhibited to the public. Antin displayed the postcards linearly, spanning the walls of the gallery space at regular intervals so that they could be read like a story. To this day, she conceives of the display (in characteristic fashion) as a kind of movie composed of still photos. If the postcards were exhibited at MoMA as "a movie," the BOOTS themselves were pure theater, glimpsed through a beaten-up wood door that opened onto a seedy downtown crash pad. Some of the BOOTS were sacked out on the crummy mattress lying on the floor, others huddled in a small group under the bare lightbulb hanging from a wire, and some just stood around listening to the pop music playing on the radio in the corner.

The BOOTS have no character traits, no pathetic fallacy for the viewer to identify with, yet even the most disinclined, curmudgeonly viewer instantly and willingly goes along with the impossible scenario. Antin's intention is neither to make us believe nor even to encourage a suspension of disbelief; the BOOTS are beyond issues of belief. Antin's issues are art, artifice, and narrative, and she engages these issues with crystalline clarity in *100 BOOTS*, setting the stage for radical innovations and a new cast of characters soon to appear.

The Eight Temptations, 1972

In mock histrionic gestures, Antin
represents herself resisting the tempting
snack foods that would violate her diet.
The progress of this same diet was
documented in *Carving: A Traditional
Sculpture* (no. 19, p. 47).
Checklist no. 20

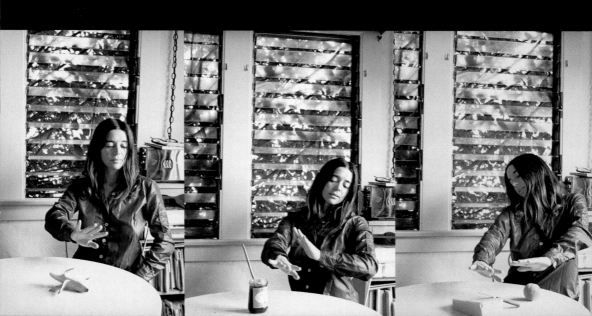

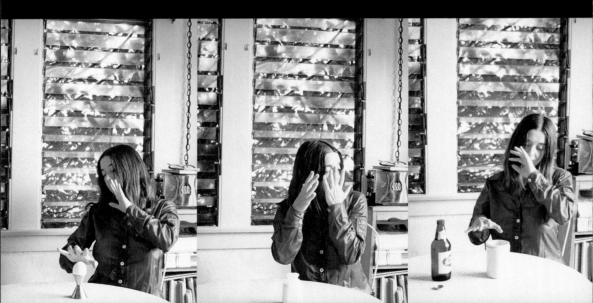

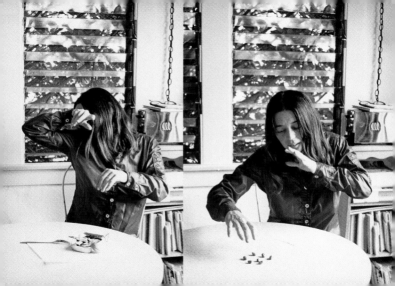

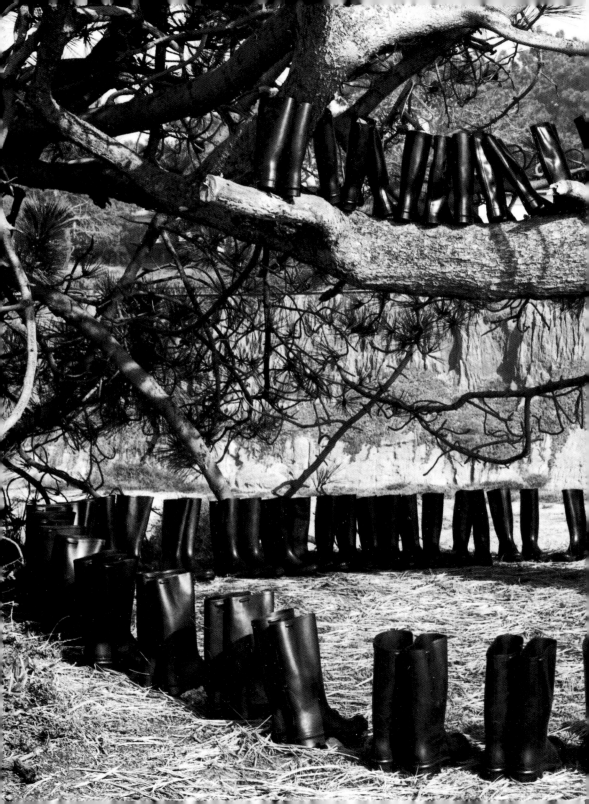

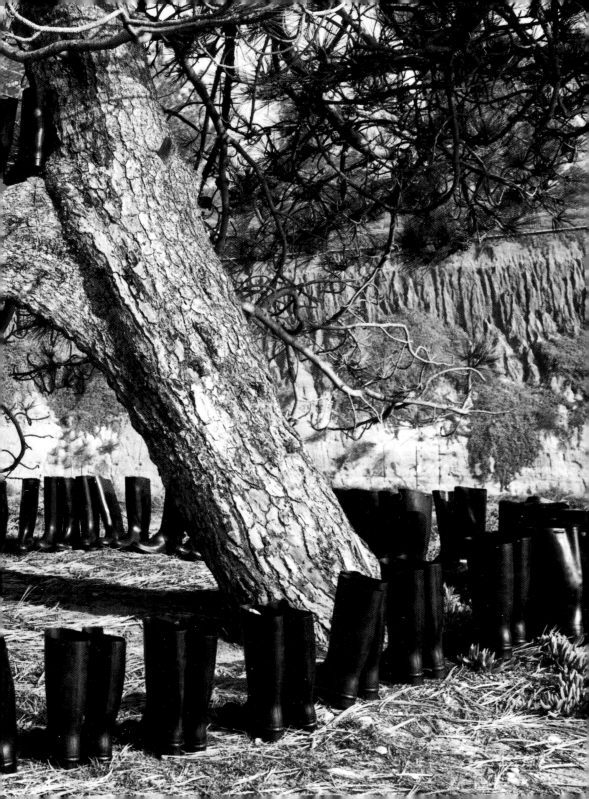

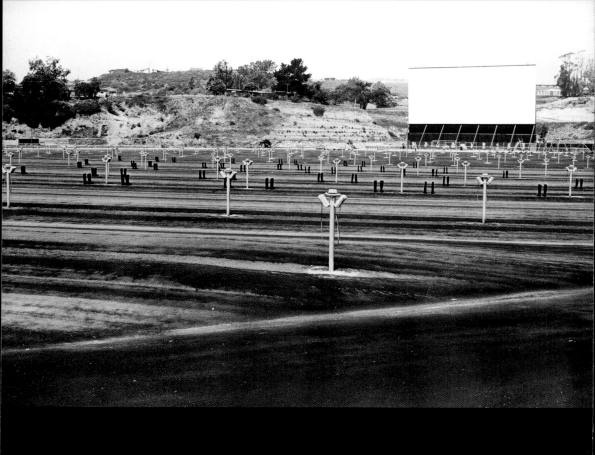

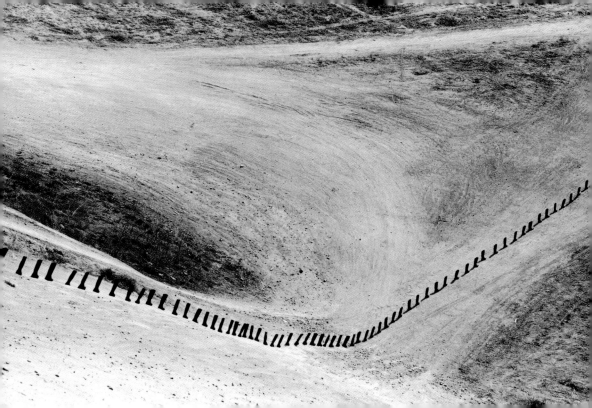

100 BOOTS, 1971–73

Perhaps Antin's best-known conceptual work, this narrative series of fifty-
one picture postcards was mailed and distributed incrementally between 1971
and 1973 to hundreds of recipients throughout the United States, Europe, and
Japan. It features the BOOTS in a mock picaresque beginning at the Pacific
Ocean and ending in New York City, where, at the Museum of Modern Art,
their journey was presented as an exhibition of the postcards. (Below and pp.
52–55.) The MoMA show also included the celebrity boots themselves,
glimpsed through a narrowly opened doorway into what appears to be a
seedy New York apartment. The BOOTS were variously sacked out on a
broken-down mattress, standing around in groups, listening to the radio, etc.
Checklist no. 12

Perhaps Antin's best-known conceptual work, this narrative series of fifty-one picture postcards was mailed and distributed incrementally between 1971 and 1973 to hundreds of recipients throughout the United States, Europe, and Japan. It features the BOOTS in a mock picaresque beginning at the Pacific Ocean and ending in New York City, where, at the Museum of Modern Art, their journey was presented as an exhibition of the postcards. (Below and pp. 52–55.) The MoMA show also included the celebrity boots themselves, glimpsed through a narrowly opened doorway into what appears to be a seedy New York apartment. The BOOTS were variously sacked out on a broken-down mattress, standing around in groups, listening to the radio, etc. Checklist no. 12

One of the important motivations of the women's movement, parallel to that of the civil rights movement, was the demand for self-determination. This went far beyond constitutional rights, civil liberties, and equal opportunity employment. Issues of parity notwithstanding, the feminist cause went beyond mere self-determination to explore what was meant by the "self" in the first place. If feminism was to challenge the norms associated with traditionally defined women's roles, then it would also necessarily challenge what it meant "to be a woman." The generation that came to maturity in the 1960s and 1970s refuting traditional Western concepts of womanhood set about re-creating woman in their own image. Not that they maintained one image or paradigm as an alternative to the norm. To the contrary, by shedding the perceived straitjacket of the norm, women found that they could conceive of themselves as engineers of their own identity and destiny. Enlightened or radicalized women would no longer tolerate predetermined identities and roles in life: one's identity, one's self, was seen as constantly evolving, with choices to be made and preferences—even prejudices—to be dealt with. Revolutionary as these claims were, they were no different from what was expected of men in Western—or certainly in American—culture. Now women were staking these claims for themselves as well. The difference was that women tended to see these issues as attributes of selfhood—that is, as partaking of the nature and possibilities of the inner soul—as much as of civil liberty. For Antin, inventing new possibilities of selfhood became the basis of her creative life for nearly two decades. As she declared in 1974:

> I am interested in defining the limits of myself, meaning moving out to, in to, up to, and down to the frontiers of myself. The usual aids to self-definition—sex, age, talent, time and space—are merely tyrannical limitations upon my freedom of choice.... But

gratuitous or random choices, as well as quick violent forays to the edge, are equally limitations on my understanding. I wanted to work with nuclear images, magnetic gravitational fields—geo-centers of the soul. My sense was that they had to be permanent and mobile, not immutable or fixed, repetitive, like the parts of the Freudian allegory. I needed core images, something like Jungian archetypes that could couple, uncouple, and transform.[8]

In this oft-quoted and influential statement, Antin described the inspiration for her next artistic phase. The aspiration to the protean self—the ideal of the ever-engaged, ever-evolving, ever-wiser soul—is as rooted in high Romantic tradition as it is in feminist ideology. Antin had determined that she had not only the moral possibility but the existential obligation to explore her self through her art. Any of us, she reasoned, might be more than a single-minded, unified, and consistent self: we may experience and understand life in more than one way; and we can develop inner, deeper, "other" selves than those "real" life has conferred upon us, thus attaining a better understanding of our own humanity. In essence, we can make more of our lives than life makes of us. With this apperception Antin undertook the creation and exploration of the personal histories of several personae, or other selves, who she could have been, or who she could dream of being, if it were not for her own circumstances and choices in life.

SCENE 1: THE KING

The King was the first of Antin's other selves, and given that she was attempting to discover and explore other parts of her humanity, it seems not only logical but natural that she should look first to the other half of humankind—to man-kind, that is—to fathom what else she might be, or might become. If she were to become a man, she reasoned, he should be her perfect male self—the archetypal male, the King, and that, indeed, was

her choice. Not any particular historical or mythological king, but the generic, iconic king—*the* King. To become the King, Antin first had to transform her appearance. To look like a man she required a beard; and in one of her earliest performances, a "life performance"[9] titled *The King,* 1972 (nos. 21–22, pp. 63–65), she documented her transformation into a man by applying a false beard, bit by bit, to her face.

Now the archetypal king in our collective imagination stands not only for masculinity, but for leadership, polity, providence. In our most noble conception (and perhaps only there, if not in actual human affairs), the king is father, protector, and provider to his subjects. And such is the model for Antin's King of Solana Beach, a small beach town in north San Diego County, near the University of California, San Diego. In life performances beginning in 1972, Antin would put on a beard, a grand chapeau, a velvet cape, and leather boots over denim jeans to emerge as the King of Solana Beach (no. 29, pp. 66–69). The King would stroll through the streets of the kingdom, stopping occasionally to speak to his (often puzzled) subjects and extend his best wishes or proffer sage advice about kingship and the state of the realm. From these curious life performances, which she did essentially for herself, Antin evolved an hour-long performance piece, a monologue titled *The Battle of the Bluffs,* which she presented frequently throughout the United States and Canada between 1975 and 1978 and at the Venice Biennale in 1976. Although the piece involved some improvisation (as virtually all of Antin's performances do), it consistently returned to a true incident. Real estate developers of an office complex in Solana Beach were planning to wipe out a significant number of the rare Torrey pines that grow only along a brief stretch of the Southern California coast. Encountering scant local dissent, the developers ultimately prevailed. Ironically, the complex that was erected housed the Order of Foresters. Antin's indignation at this callous and hypocritical act was the inspiration for *The Battle of the Bluffs.*

In Antin's quasi-humorous fable, the King is challenged by wealthy landowners who want to seize the royal forest for their self-gain. The good King does all that he can to protect his subjects and his land from ecological disaster at the hands of the marauding developers, but to no avail. Finally, he assembles a citizens' militia comprising an infantry of retired people wielding shuffleboard sticks and a cavalry of young people riding skateboards. Their enemies are the bankers, developers, and chamber of commerce of the realm. In the end the King and his army are defeated, and the monarch is deposed and exiled, left alone to contemplate his destiny. The King's monologue is a rumination on power, the responsibilities and burdens of ethical leadership, the loss of personal power, and the onset of ecological destruction. The piece ends with the King wondering at having led a revolution in his own kingdom. The idea of a popular rebellion being led by an establishment figure, such as the King, would have been read in the 1970s as politically radical. In her other self as the King, Antin thus created a benevolent ruler: a caregiver, something of a political moralist, and, alas, a loser.

In 1974 and 1975 Antin developed the King a bit more through a series of charming ink and watercolor drawings, collectively titled *The King's Meditations* (nos. 24, 26, and 28, pp. 70–71). These informal sketches of the King's palace and grounds, courtiers, and events, sometimes rendered in sepia, sometimes fleshed out with a few carefully chosen colors, are usually accompanied by a brief handwritten text musing on the subject of the drawing. The series thus constitutes a kind of visual diary that reveals the King's private reveries and reminiscences.

Perhaps, though, the real significance of Antin's King is not the persona she created—in fact, he is a somewhat indistinct character—but that Antin chose to conceive her art in terms of personae, or other selves, in the first place. Note that to become a man, she had not needed to change her sex but only her gender—that culturally codified matrix of

behavioral traits and norms that define one as "male" or "female"—by adapting imaginatively to the behavior that suggested a man. The very concept that one could assume a different gender derives from a postulate based on what was then called "women's liberation": the claim that because gender is a cultural construct and not a biological fact, the individual can be liberated, ideologically and personally, from the tyranny of prescribed sexual roles that define and delimit nearly every aspect of behavior. This liberation was a corollary of the democratic idealism inherent in American culture and a practical result of the period's radicalized political climate, which so profoundly influenced Antin and hundreds of thousands of other members of her generation and the next. Far from merely pretending to be a man by donning a costume, the gesture itself has deep political, ideological, and psychological significance. It presumes that human desire to understand what one doesn't already know and wonderment at the range of imaginative possibilities are liberators from the supposedly ironclad facts of life.

"Stone walls do not a prison make, nor iron bars a cage," wrote Richard Lovelace in 1649. The human imagination can transcend any boundary of physical happenstance. The concept is not new, but the assertion, within the feminist discourse of the period, that gender is not a biological determinant of how people live, but may be instead an unwitting consensus foisted upon real persons by traditionally ingrained social, political, and ecclesiastical orders, was radical and has proved to be revolutionary in its application to daily behavior. Antin had no genuine wish to become a man, but imagining that she could—indeed, even presuming to imagine—was liberation enough. Along with this self-granting of permission to become by imagining came the knowledge that one's life, or at least one's inner life, need not be determined and delimited by norms, shibboleths, and taboos. Antin's small, almost childlike gesture of dressing up has stunning, far-reaching implications, and it has become a powerful

creative force in her mature art. Desire, wondering, make-believe—these capacities of human intelligence separate humankind from other animals and are the basis of all human endeavor. They have engendered such unique human inventions as science, religion, philosophy, and art. And it is in art, more than in politics, discourse, teaching, or any other arena, that Antin has chosen to explore and realize her life.

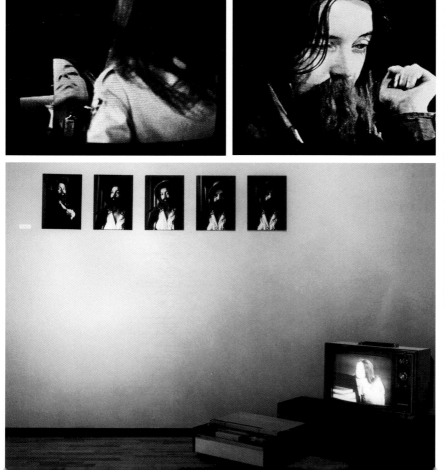

The King, 1972

The first of three major personae, whose fictional histories formed the core of Antin's art for more than a decade, the King represented her early exploration of aspects of self-hood—in this case, her idealized male self. A videotape (top) shows her gradual "transformation" into a man through the application of a false beard. A group of formal photographic portraits, *Portraits of the King* (no. 22, pp. 64–65) accompanied the videotape in its exhibition at Stefanotty Gallery in New York, 1975. Checklist no. 21

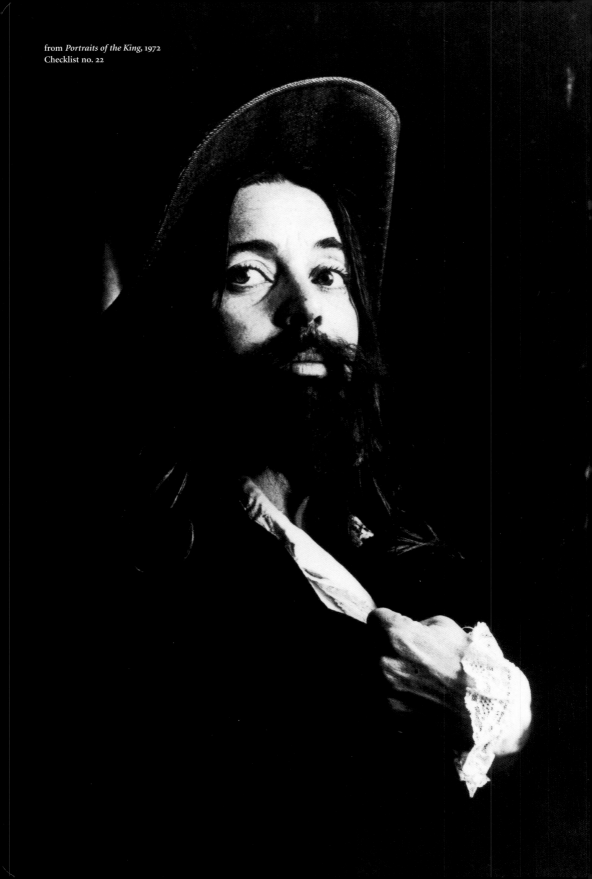

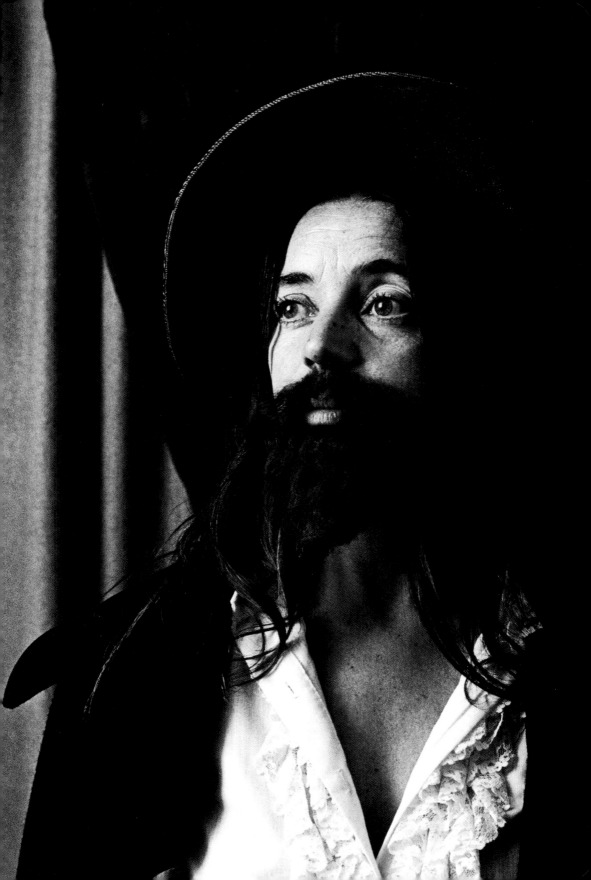

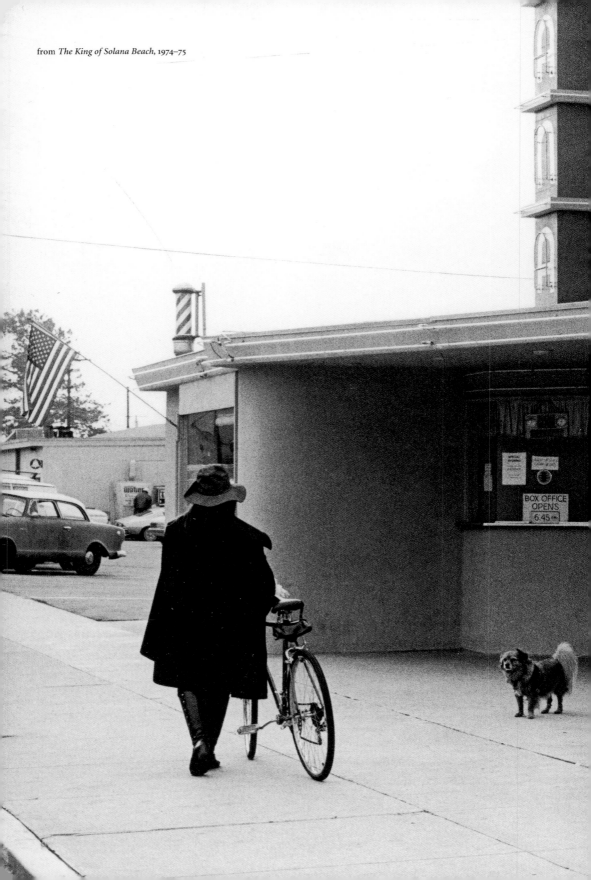

WONDER
OF IT ALL
TIME 7 & 9

COMING · COMING

NOW SHOWING

The King of Solana Beach, 1974–75

Photodocumentation (below and pp. 66–67) of an
unannounced "life performance" in which the artist in her
persona as the King greets his subjects all around the
kingdom of Solana Beach, California.
Checklist no. 29

from *The King's Meditations*, 1974

Delicate pen-and-ink sketches, tinted with splashes of watercolor
and sometimes accompanied by evocative handwritten texts,
comprise *The King's Meditations*—a visual diary of the King's
reveries of romance and cultural life in his imagined realm.
Checklist nos. 24, 26, and 28

SCENE 2: THE BALLERINA

An aside: In 1974 Antin created another persona, the Black Movie Star, who made a brief appearance in her oeuvre. Antin wanted to explore what it means to be black in American society, but she retired the Black Movie Star after one exhibition, quickly realizing the limitations of making skin color a determinant of character. Moreover, by making the persona an actress, whose role it is to play other roles, Antin's attempt to get at a personal history was all the more obstructed. Antin would later reintroduce blackness in the persona of Eleanora Antinova, about whom more will be said later.

If it was natural in the emerging feminist movement for Antin the woman to seek an extension of herself in the person of a man, then it was logical for Antin the artist to seek yet a further elaboration of her potential as her ideal female self. Her quest led to the invention of a new persona, the Ballerina. Like the King, the Ballerina is iconic and stands not only for the dancer but by easy extrapolation—and Antin's art is always about extrapolation—for all creative types and aspirants to an ideal. Significantly, Antin's iconic Ballerina is exactly that: an aspirant. She is not the virtuoso danseuse she might appear to be in her photographs, but one seeking to fulfill the image of the ideal. In 1973 Antin created her first project involving the Ballerina. It is a multipart affair, consisting of several sets of still photographs (each set of a different size) and an accompanying videotape, all sharing the collective title *Caught in the Act* (no. 34, pp. 73–75, 77). Some of the photographs look as if they are appropriated moments from Edgar Degas's glimpses of backstage life in the ballet theater: the Ballerina making up, dressing, or fixing a broken ribbon on her toe shoes. But most of the photographs that comprise the sets *Choreography I, II,* and *III* are arranged in careful sequence—in the manner of Eadweard Muybridge's photographs of runners and horseback riders going through their paces—like short movies presenting the Ballerina executing the five positions,

Caught in the Act, 1973

Antin's second major persona was her idealized female self: the Ballerina—a nameless iconic figure, the mere image of a dancer. In a sequence of photographs (pp. 74–75), the Ballerina assumes the idealized positions of the classical ballet and executes pirouettes and other graceful balletic movements. However, an accompanying videotape of the photo session (below) belies the pretense of Antin as an accomplished ballerina and shows her stumbling, falling, and requiring props to help her maintain her split-second poses. Antin, *poseuse extraordinaire,* juxtaposes the "truth" of the idealized photographic image with the "truth" of the videotape's more extensive duration. Checklist no. 34

from *Caught in the Act: Choreography I—Center Stage* (Short Tutu)
Checklist no. 34

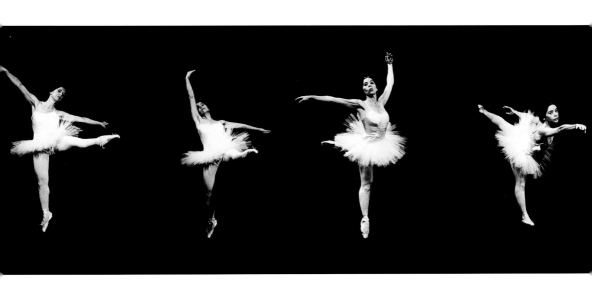

arabesques, pirouettes, leaps, and balances on pointe of classical ballet. At first glance, in her toe shoes and tutu, Antin as the Ballerina is perfectly posed and exquisitely poised.

Caught in the Act, the companion videotape to the photographs, however, tells a different story. Ostensibly, the tape documents the shooting of the *Choreography* photographs, but it reveals the Ballerina to be a klutz: despite her élan, she can't dance, she can't move like a dancer, she can't even hold a pose for more than the $\frac{1}{125}$ of a second that it takes to snap a photo. Incessantly falling, stumbling, or losing her footing—and laughing about it—she has to support herself on pointe with a broomstick or a chair hidden from view in order to complete each picture. All that the Ballerina can really do is pretend to be a ballerina: she can only imitate her ideal and repeatedly fail to attain it. Yet, in her desire to be the ideal dancer, she persists despite the absurdity. Antin, after all, never formally studied ballet but learned about it from books and from looking at herself in a mirror in her studio. She could only mimic what she saw in the books: "I'm a terrific ballerina standing still," she would comment in the 1975 video *The Little Match Girl Ballet* (no. 36, pp. 84–87). It is just such delicious irony, which recurs frequently in Antin's art, that makes her work so endearing, so very human and touching. In the roles of her other selves, Antin never takes herself or her personae too seriously. With a sense of humor that surely echoes Antin's childhood roots in Yiddish culture, she often creates characters who are sweetly sad, misled by their own dreams and desires, and who find themselves in dramatic situations that are at best bittersweet.

Indeed, this is the Ballerina's lot. In *The Ballerina and the Bum,* 1974 (no. 35, pp. 78–83), a movie that Antin shot on videotape because it was more affordable than film, our romantic young waif of a heroine is, in Antin's words, "a would-be ballerina from the sticks, who plans to walk across the United States to make it in the Big City. She meets a bum on a

freight train, and together they dream of success."[10] So, like the King, the Ballerina's significance is centered less in virtuoso ability, triumphal achievement, or the heroic deeds that are recorded in the master narratives of Western civilization than it is in her aspirations, her inner life, her spiritual and psychological self. The biographies of Antin's personae became the substance of her art.

from *Caught in the Act: Backstage Moments—Torn Ribbon* Checklist no. 34

Almost as soon as the technology of portable video became available to consumers, Antin used it to make a rudimentary (and financially feasible) black-and-white "movie." Antin describes herself as playacting a "would-be ballerina from the sticks" who plans to trek across the United States to "make it in the Big City." She meets a bum on a freight train, and together they dream of success. Checklist no. 35

freight train, and together they dream of success."[10] So, like the King, the Ballerina's significance is centered less in virtuoso ability, triumphal achievement, or the heroic deeds that are recorded in the master narratives of Western civilization than it is in her aspirations, her inner life, her spiritual and psychological self. The biographies of Antin's personae became the substance of her art.

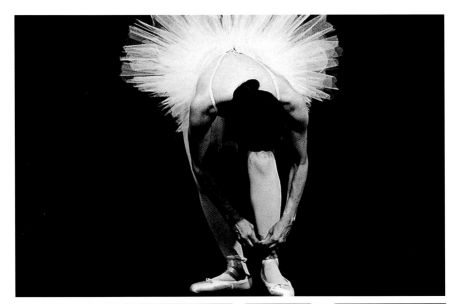

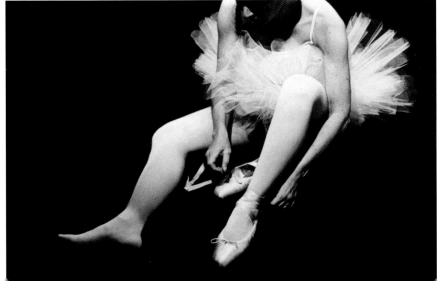

from *Caught in the Act: Backstage Moments— Torn Ribbon* Checklist no. 34

Almost as soon as the technology of portable video became available to consumers, Antin used it to make a rudimentary (and financially feasible) black-and-white "movie." Antin describes herself as playacting a "would-be ballerina from the sticks" who plans to trek across the United States to "make it in the Big City." She meets a bum on a freight train, and together they dream of success.
Checklist no. 35

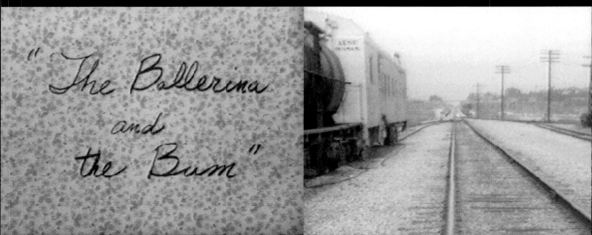

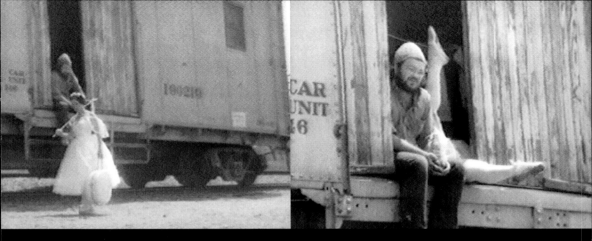

"Howdy!" "What I really need is a stake—

"Howdy!" you know, capital."

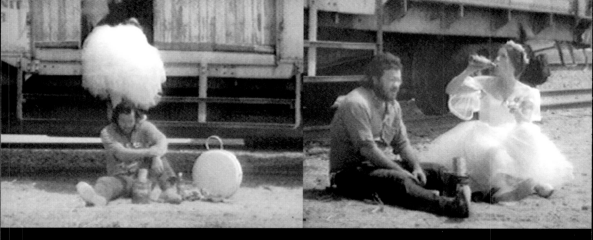

"The Russians are the best dancers."

"Yeah—the best!"

"Banks aren't people."

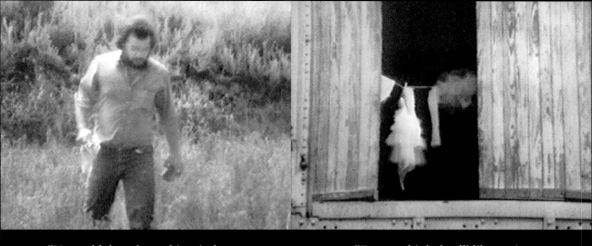

"He couldn't make up his mind . . .

till he got a terminal disease.

That made up his mind for him."

"Do you think they'll like me in

New York?"

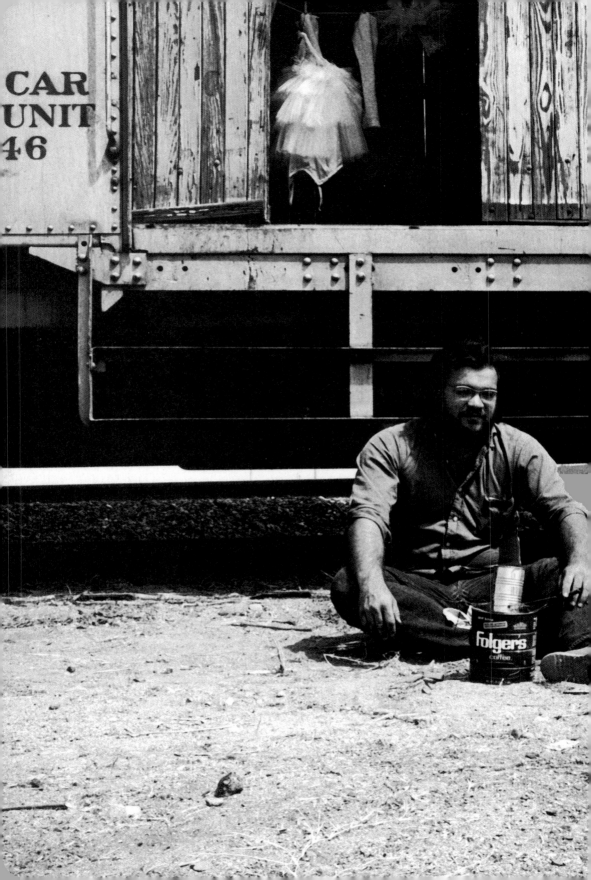

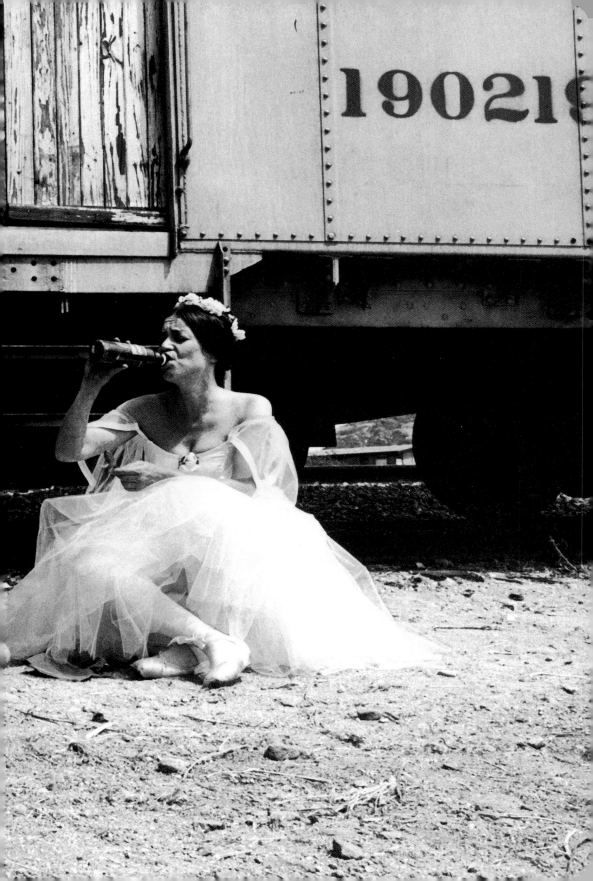

A melodrama—Antin's adaptation of Jean Renoir's 1928 silent film, *La Petite Marchande d'allumettes*—in which the impoverished Ballerina, reduced to making her living by selling matches to passersby on the street, dreams of a life in art; her fantasies suffuse and overtake her consciousness as she freezes to death.
Checklist no. 36

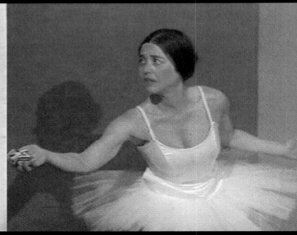

"Won't you buy my matches, kind sir? I'm so cold."

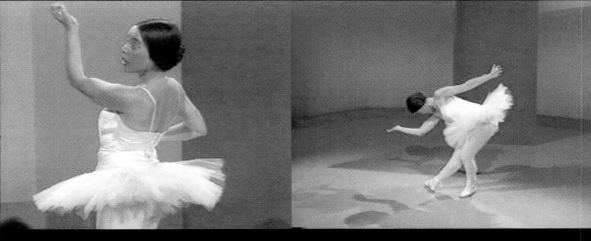

"Actresses never have to light
their own cigarettes."

"A little old man comes out
with a key and locks the door

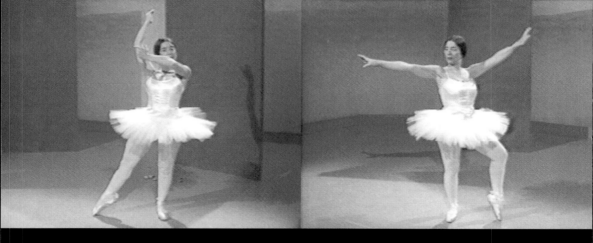

"I arise as the Black Match Girl."

"Now I don't need a chair—

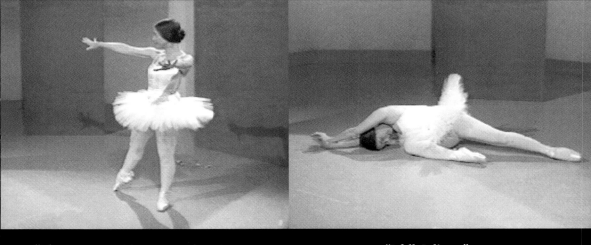

"The Demon Critic turns—Aieeee!—

and he spurns me . . ."

"I fall. I die . . ."

SCENE 3: THE NURSE

Popular culture is the birthplace of Antin's next self, the Nurse. Antin saw that nursing was a field that (at that time) was relegated to women, and for sexist reasons having to do with male hegemony in the medical profession it was regarded less as a profession than as a service class, marginal to the mission of doctors. "I began my investigation of my 'nurse' self," reports Antin, "by taking what lay closest at hand—the popular clichés by which the culture knows the 'nurse.' I found that Nurses are defined by a narrow set of cultural expectations, so fixed as to render them mythological figures—a jaunty blend of servant and geisha, sharing features with many other women's service professions like secretaries, airline stewardesses and wives."[11] Why should this be, Antin questioned, when, in fact, modern nursing began, with Florence Nightingale, as a virtually selfless and noble calling to minister to the needs of the suffering? What cultural pathology might account for our regard for nurses as déclassé members of society? The analysis of these questions is complex, but Antin would have no trouble pointing up the cheapened status of nurses in two deft satires based on two favorite story genres in American popular culture, the soap opera and the adventure movie.

In 1976 Antin produced and directed her first feature-length movie, a sixty-four–minute color videotape titled *The Adventures of a Nurse* (no. 31, pp. 90–93). A melodramatic—albeit comical—soap opera, it features Antin herself as narrator, a cast of eight characters, and a crowd of extras. Except for the narrator, however, all the cast members are paper dolls, each about ten inches high, complete with individual wardrobes. The unique dolls and their costumes were created by Antin, who also operated them on the stage set, which consisted of a bed with a few throw pillows used as improvised scenery. Working with paper dolls, without incurring the expense of a stage, a cast, and a crew, not only solved the practical problem of producing a movie, it underscored the powers of

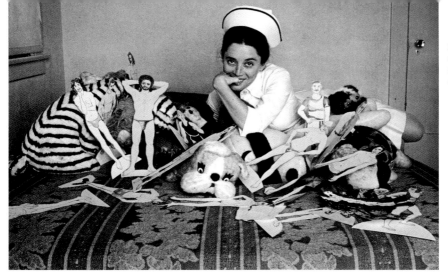

Eleanor Antin, R.N., and cast on the set of *The Adventures of a Nurse*, 1976.

make-believe, fiction, and fantasy in Antin's creative exploration of self-hood. "My means were those available to little girls everywhere," Antin says, "paper dolls and narrative invention."[12] Her use of paper dolls was a brilliant and altogether captivating device—all the more so when we recall that this was a period when "rigor" and "toughness" were the buzzwords of an art world that was perhaps less macho than its discourse.

The central figure in *The Adventures of a Nurse* is, predictably, Nurse Eleanor (whom Antin would call the Little Nurse to distinguish her from the heroic Eleanor Nightingale, a later incarnation of the nurse persona). Nurse Eleanor is perky, naive, and unflappable, which is fortunate, considering the follies and foibles that seem to habitually beset her. In rapid succession she falls in love with, or is (somewhat willingly) seduced by, a parade of men: a terminally ill poet named Jack; Jack's friend Chick, a motorcyclist; Soriah Moriah Caslow, M.D., her boss; French ski bum Jean-Pierre Schneider; and Schneider's estranged father, a famous American antiwar senator. Each flirtation leads to a romantic interlude, and each romantic interlude leads to disappointment; yet, dumped on and dumped by a succession of cads and womanizers, Little Nurse Eleanor just keeps on trucking.

The Adventures of a Nurse, 1976

Antin introduced her third major persona, the Nurse, in this video
movie starring Antin with a supporting cast of paper dolls.
Using the means available to little girls everywhere—paper dolls
and narrative invention—Nurse Eleanor relates a succession of her
brave but tragic romances with a dying poet, a biker, a doctor, a
French ski bum, and an antiwar senator. On the surface a parody
of the television soap opera genre, this comic melodrama raises
deeper questions about the subservience of women in the medical
profession and in modern American society generally.
Checklist no. 31

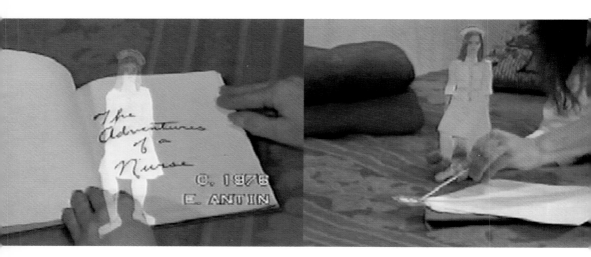

"Put your tongue out and say

'Ahhhh.'"

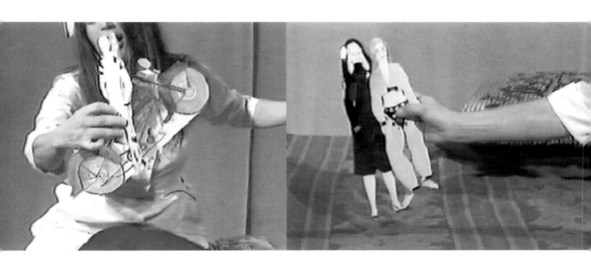

"Oh, Chick, you are so virile."

"Oh, they don't wear pants in the
♪♪ 　southern part of France . . ." ♪♪♪

"It ain't the Duke of Windsor . . ."

"Have you ever made love in zee
snow, leetle one?"

"But, Senator . . .
Jean-Pierre is my friend . . ."

"I'm so glad to be back
at work again, Dr. Caslow."

Her adventures continue in the sequel video movie, *The Nurse and the Hijackers,* 1977 (no. 32, pp. 96–99). Again, the cast is an ensemble of paper dolls. This time they perform on an elaborate set, fashioned of cardboard and shag carpet, parodying the tacky decor of the passenger cabin of an airliner. The plot is also a parody, mimicking such box-office hits of the day as *Airport* and the even-worse sequel, *Airport 1975,* *The Poseidon Adventure,* and *The Towering Inferno,* all of which featured bloated ensemble casts of Hollywood celebrities facing disaster and their destinies. In Antin's send-up a jumbo jet en route to Washington is hijacked by a liberation army that aims to save the world from technology. After flying from one Middle Eastern capital to another seeking permission to land and political asylum, which, due to diplomatic pressures, are refused, the passengers are finally rescued by an Israeli commando squad. Through it all Nurse Eleanor serves earnestly and remains something of an airhead—totally likable, even admirable, but simpleminded. Though they made for amusing satires, the exploits of Little Nurse Eleanor failed to address the deeper issues of why a woman would choose to be a nurse in the first place.

Antin knew she had to get serious. "I thought perhaps if I went back to the beginnings, to the grand woman inventor of professional nursing, I might begin to explore the choice and approach its interior meaning. Just what did Miss [Florence] Nightingale intend to invent and what had she actually invented? ... I went back and found a distinguished, intelligent, resourceful and powerful woman who had fought violently to open a great merciful, ministering space between the suffering soldiers, the doctors, the surgeons, the officers and the War Office. She had tried to open a great benevolent professional space, where before no one had seen a clearly defined space at all."[13]

In her 1977 performance piece, *The Angel of Mercy,* Antin created the mature character of *Eleanor* Nightingale, the founder of modern nursing. It was, of course, a fiction, but one based in history. And any history,

The airplane set, constructed of cardboard and shag carpet, from *The Nurse and the Hijackers*, 1977.

even the most thoroughly researched and conscientiously documented history, is a reconstruction of events that could not possibly have been experienced or perceived in the moment as they are by someone looking back. All history is an interpretation of events—a kind of fiction—not a direct, unmediated experience. In the name of art Antin makes a bold claim on history as the inspiration for powerful fiction.

The Angel of Mercy project (no. 33, pp. 101, 103–5) began as two photo albums: one, *The Nightingale Family Album*, 1977, documents the activities of the Victorian, aristocratic Nightingale family at their country home outside London, socializing, playing parlor games, and enjoying a pleasant life; the other, *My Tour of Duty in the Crimea*, 1977, consists of Eleanor Nightingale's view of life and death on the battlefield. The sixty-three images painstakingly mimic the poses, fashions, and attitudes of Victorian ladies and gentlemen and soldiers of war; and the tinted gelatin-silver prints themselves are exquisitely contrived faux antique photographs that Antin (with photographer Phel Steinmetz) made to look old with stains, creases, and scratches. The formal presentation is as much a creative fiction as the content.

The Nurse and the Hijackers, 1977

Nurse Eleanor and company return to the small screen
in a lampoon of Hollywood political thrillers and disaster
films, getting caught in the hijacking of Nurse Eleanor's
plane on the way to St. Tropez. This adventure story
proffers a wry political commentary on the motives of
terrorists and others who position themselves on
the margins of society and history.
Checklist no. 32

"You know too much. You must
be a member of the CIA."

"An honest man is a
frightened man."

"Brothers and sisters, this plane
has been liberated
in the name of the human race."

"I want a direct line to Washington."

"I'm not a surgeon;
I'm a nurse."

"Passenger morale
remains high in the
face of adversity."

"Israeli commandos move stealthily on
the plane."

Antin followed up *The Angel of Mercy* photo albums with a dramatic presentation (no. 33, pp. 106–9), a performance before an audience.[14] Echoing the Little Nurse movies, this performance enlisted paper dolls as cast members, but this time the paper dolls were painted Masonite cutouts, each about four-fifths of natural size and mounted on wheeled platforms so that Antin and two or three costumed stagehands could move them about the space. They depict some forty-two Victorian aristocrats, soldiers, field surgeons, and others. The scenario recounts the biography of Eleanor Nightingale, who grew up in a Victorian home and was surrounded by platitudinous family members who disdained her social compassion and her time-consuming activities aiding London's poor and sick. Her family, friends, and suitor smugly enjoy their wealth and privilege, and they beseech her to do the same; but she instead fulfills a moral conviction (and a courageous one for any Victorian woman), defying convention and her family's will and journeying to the battlefront of the Crimean War to minister to the physical and emotional health of the soldiers.

In the Crimea Nurse Nightingale finds her calling: she heals the wounded; she aids in gruesome surgery and amputations; she organizes classes to educate the young illiterate soldiers; she tries, unsuccessfully, to save a wrongly accused lad from being shot as a traitor; she comforts a wounded Russian prisoner who dies in her arms; she challenges the dubious morality of a British doctor who withholds anesthesia from the troops, reserving it only for the officers. Although such situations punctuate the play, much of the performance is given over to Eleanor Nightingale's debates with doctors, generals, and soldiers about class struggle and to her pensive monologues about her mission as a nurse, the morality of war, and the meaning of life and death. In her final monologue, after returning to England and receiving a medal from Queen

My Tour of Duty in the Crimea, 1977

Antin questioned how so noble a calling—caring for the sick
and dying—had become so degraded historically, and she
looked to the founder of nursing, Florence Nightingale, for
insight. In one suite of faux antique photographs, *The
Nightingale Family Album* (below and p. 103), Antin and
friends posed in period dress to represent the legendary
nineteenth-century nurse Eleanor Nightingale and her family
in the silken prison of their Victorian home. A second set of
"historical" photographs, *My Tour of Duty in the Crimea* (pp.
104–5), documents the famous nurse tending to the soldiers
on the battlefield of the Crimean War.
Checklist no. 33

Victoria for her heroic contribution to England's war effort and humanity, Eleanor Nightingale ponders the moral significance not only of nursing, but of all human enterprise:

> If I bandage a soldier and he goes back to the battlefield to kill another, and another, then I am not a healer but a double killer. . . . Still, I did not make this war. Nor is it certain that what these men would return to would be any better than this war. . . . I cannot say that to me war is an unmitigated evil. At least in wartime a soldier is a man doing his duty, giving his life for his comrades, his country, God. . . . Whence the moral: Give each man his work, but do not look too closely into the meaning of it. The soldier has his work, and I have mine. We did not choose it; it chose us. And all we can do is do it well.

In the end this heroic figure winds up describing the world rather than changing it, and Antin is deliberately ambiguous about Eleanor Nightingale's concluding wisdom: is it cynical and bitter or is it merely inarguable truth in the face of events that she does not, and cannot, control? Either way, her soliloquy is less a Victorian platitude than an existential meditation, one unbuoyed by easy moralizing and bereft of certain redemption.

The Angel of Mercy (performance), 1977;
videotaped version 1981

In addition to creating the photographs depicting Eleanor
Nightingale's personal history, Antin wrote a play in two
acts, which she performed with near life-size cut-out figures
derived from characters in the photographs. In this dark
melodrama with tragic undercurrents, Eleanor Nightingale
is confronted by political and moral issues of class and
sexual inequity, military injustice, peace, and war.
Checklist no. 33

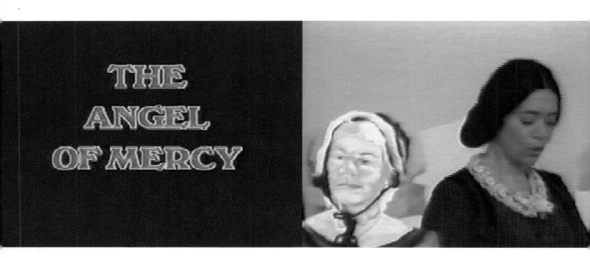

"Tsk, tsk! One eligible

bachelor lost."

"When I see a man bleeding, I
want to bandage him."

"I have a moral nature, which you
would destroy, John."

"A penny for a poor old
soldier, mum?"

The Operation

The Execution of the Deserter Mourning the Dead

On the evening of February 22, 1979, the playbill of New York's Kitchen Center for Video, Music, and Dance announced the world premiere of *Before the Revolution: A Ballet Designed, Costumed, Painted, Choreographed, Written, and Performed by the Celebrated Black Ballerina of Diaghilev's Ballets Russes, Eleanora Antinova* (p. 115). Doubtless, most of the audience knew of the great modern ballet impresario Sergei Diaghilev and of his revolutionary choreographic principles, which stressed endless movement and asymmetry. They probably knew that Maurice Ravel, Claude Debussy, and Igor Stravinsky wrote music for his productions and that his scenic designers included the likes of André Derain and Pablo Picasso. But who was Antinova?

She was none other than the (iconic) Ballerina of a few years earlier revived as a remarkably complex figure, Antin's most sophisticated, richly realized persona and the character through whom she has most fully explored her mission of a life in art. Strangely, the Ballerina returns as a black woman—the only black woman who had succeeded in breaking into the orthodox, closed congregation of classical ballet. Antinova's history is a thicket of impossible circumstances and irresolvable contradictions. Diaghilev's innovations notwithstanding, the Ballets Russes was still a classically trained Russian dance company. Antinova, by contrast, is an American, a self-taught would-be ballerina, who learned to pose—not to dance—from picture books. She is a politically radical black woman— "the other"—who, as Diaghilev fictitiously observes, stands out in the troupe as "a black face in a snowbank . . . black as the Ace of Spades . . . our Black Pearl, our Black Diamond, our Black Beauty."[15] Antinova aspires to dance the legendary roles of Giselle and Odette, but Diaghilev sees her as "an animal. A splendid beautiful beast . . . primitive, mindless, fierce . . . [with] the natural nobility of the beast," and he prefers that she play such "roles of great passion" as the Queen of Sheba, Cleopatra, the murderous Hagar, Atala, even Pocahontas—what Frantisek Deak perceptively identifies as "female versions of the male noble savage."[16]

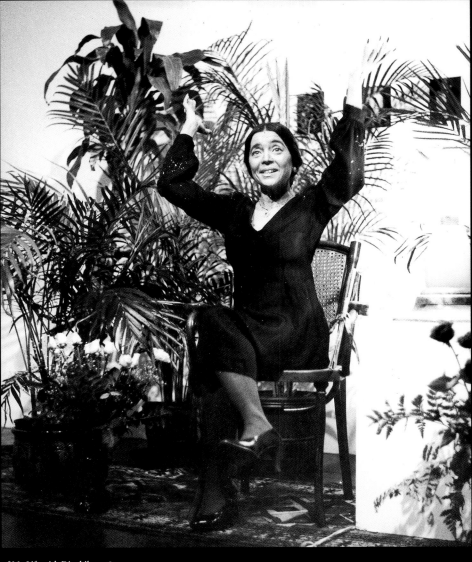

...of My Life with Diaghilev, 1981

...c Ballerina returns to the stage, now as a fully
...aracter with a name and a personal history: she is
...inova, the legendary (albeit fictitious) black
...ina of the celebrated Ballets Russes, whose life
...ocus of Antin's art in performances, installations,
...photographs, drawings, plays, and memoirs from
... Antinova is shown here in the 1981 exhibition-
...nance, collectively titled *Recollections of My Life*
...*ev,* at Ronald Feldman Fine Arts, New York. The
...of Antinova's memorabilia centers around a suite
... studio photographs portraying the prima balle-
...ostume in her "Great Roles" (pp. 11–14) danced for
...usses. In performance Antinova reminisces about
... her European career and her subsequent decline
...e death of the impresario and her champion Sergei

In the course of the play, which, like *The Angel of Mercy,* is acted by Antin with a troupe of nearly life-size painted Masonite cutouts, Antinova tells Diaghilev that she wishes to dance the role of Marie Antoinette, and she relates a vision she has had on a visit to Versailles of Marie Antoinette as a black woman. Plainly, Antinova sees herself as a noblewoman, not as a savage. She longs for a social condition commensurate with her artistic aspiration, but it is, of course, just a dream. When in *The Angel of Mercy* Eleanor Nightingale's suitor suggests that she put her energies into writing books, she responds, "I do not want to describe the world, I want to change it." In *Before the Revolution,* Antinova likewise strives to reorder the world, or at least her part of it, and experience a new reality. She must do this through art: art is the realization of her desire. There is a brief scene in *Before the Revolution* in which Marie Antoinette and her maid Suzanna trade places, each taking on the life role of the other. This leads to repeated conflations of life and its imitation, which is art, and a repeated need to clarify the situation to one another: Suzanna reminds Marie Antoinette, "Really, Madame, this is not a melodrama. It is life"; and a few moments later Marie Antoinette prompts Suzanna, "This is not the theater, Suzanna. This is life." Shortly afterward Mozart, who has a cameo role, tries to restore some order to the scene (after Nijinsky and Stravinsky have also put in appearances), admonishing that "you are interrupting the rehearsal. This is art, not life." And all of this transpires as the characters are trading the fictional roles of actual historical figures, who are cast in a theatrical performance that involves a play within a play. This is perhaps the most layered and well-articulated example of the interpenetration of art and life in Antin's oeuvre, but its essential significance is reiterated throughout her art. Changing the world (even one's small part in it), rather than describing it, is the noble (if often futile) aspiration and moral commitment of the artist.

Indeed, Eleanora Antinova demonstrates in her debut appearance that when conflations of art and life occur, confusion—as much as

edification—is the result. Antinova's reality is an artificial one; yet for Antin it rates the same credit and credibility as any other reality—perhaps all the more credit *because* it is consciously mediated and not merely experienced. The center of *Before the Revolution* is "An Argument," an extended aside in which Antinova addresses the audience while perched on a swing, which goes back and forth above their heads. She muses on Diaghilev's role as a "borrower" of other people's talents, not as an artist himself. Then, quite unexpectedly, she asks:

> And who is not a borrower? Didn't we get our face and our name from our parents, the words in our mouths from our country, the way we say them from the children on our block, our dreams and images from the books and pictures other people wrote, painted, filmed? We take from here, from there and give back—whatever we give back. And we cover what we give back with our name. John Smith, Eleanora Antinova, Tamara Karsavina, Sergei Pavlovitch Diaghilev, and somewhere each one of us stands behind that name. Sort of.
>
> Sometimes there is a space between a person and her name. I can't always reach my name. Between me and Eleanor Antin sometimes there is a space. No, that's not true. Between me and Eleanor Antin there is always a space. I act as if there isn't. I make believe it isn't there. Recently, the Bank of America refused to cash one of my checks. My signature was unreadable, the bank manager said. "It is the signature of an important person," I shouted. "You do not read the signature of an important person, you recognize it." That's as close as I can get to my name. And I was right, too. Because the bank continues to cash my checks. That idiosyncratic and illegible scrawl has credit there. This space between me and my name has to be filled with credit.

What of me and Antinova? I borrow her dark skin, her reputation, her name, which is very much like mine anyway. She borrowed the name from the Russians, from Diaghilev. I borrow her aspirations to be a classical ballerina. She wants to dance the white ballets. What an impossible eccentric! A Black ballerina dancing *Les Sylphides, Giselle, Swan Lake.* She would be a "black face in a snowbank"! The classical ballet is a white machine. Nobody must be noticed out of turn. The slightest eccentricity stands out and Grigoriev hands out stiff fines to the luckless leg higher than the rest. So Antinova designs her own classical ballet. She will dance the white queen Marie Antoinette. She invests the space between herself and the white queen with faith—that they will come together.

Antin(ova) is describing the space of art—the place where real life and the imagination come together in faith, in credence, in the life of the mind, in the body of art. Every artistic manifestation, she seems to say, is a radical act of faith—in one's self, in one's beliefs, in one's audience, and in the capacity of art to fill that space for all the participants. *Before the Revolution* concludes as Marie Antoinette and Louis XVI, in a parody of Voltaire's *Candide,* decide to sell the palace at Versailles and go to live a simple life, where they cultivate their own garden and raise vegetables, hardly the fate that Marie and King Louis actually met. This final section of the play is titled "The Truth," but Antin's meaning is equivocal. She may be suggesting that this conclusion describes how most people in truth live their lives—that is, by putting their dreams and aspirations in abeyance while tending practical and manageable gardens. On the other hand, Antin may be asserting that by creating her personae, by living her life in art, she is, in truth, cultivating her own life, within its limits, and making it thrive. These interpretations are not truly at odds, for she plainly

Before the Revolution, 1979

In her public debut in *Before the Revolution,* Antinova
desires to dance the classical "white" ballets but, confronting
the ballet world's inherent racism, creates her own ballet in
which the French and Russian revolutions intersect. This
image documents Antin's original solo performance (assisted
by a cast of life-size cut-out figures) at New York's Kitchen
Center for Video, Music, and Dance in 1979.

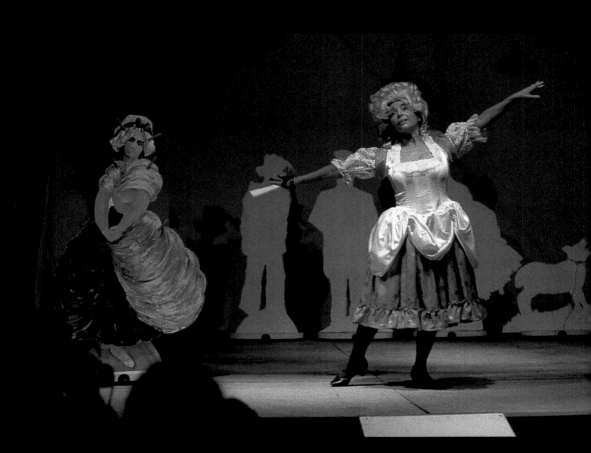

believes that art embodies the highest truths. For Antin, confusing and conflating art and life may be the highest means of realizing both.

Antin's next project was to do exactly that. For about three weeks in October of 1980, Antin went to New York City and lived as Eleanora Antinova (pp. 118–119, 183). Each day she applied dark makeup to her face and hands and set about "being Antinova"—from shopping for the simple staples of everyday existence to socializing in the opulence of the Russian Tea Room, Antin lived with no separation between herself and her other self. She documented the experience in memoirs that were published in book form in 1983.[17] In living out Antinova's identity, Antin experienced three weeks as another woman, a black woman, and she encountered everything from racism—finding it difficult to get a taxi to stop for her— to sexism—enduring the sexual advances of the one driver who did pick her up—to the myriad ambiguities of daily encounters with other people, both white and black. This life performance was primarily a private activity, but it had enormous resonance within Antin's art, notably for its emotional and political riskiness (Antin had already generated some minor controversy for appearing in blackface, and she was criticized for presuming to be black), as well as for its artistic integrity and commitment.

Being Antinova, as this project was titled, also had a public component—an exhibition and performance, *Recollections of My Life with Diaghilev*, 1981 (no. 37, pp. 111, 121–25)—featuring Antinova as an elderly doyenne, the former prima ballerina. A few nights each week that October, an audience would gather at Ronald Feldman Fine Arts, Antin's gallery, which was set up to resemble a salon of the 1920s, complete with potted palms, an Oriental rug, and a bentwood chair, where Antinova would sit and reminisce. The gallery walls were filled with vintage sepia photographs of Antinova in her most famous roles in the (fictitious) Diaghilev productions of *Pocahontas*, *L'Esclave* (The slave), *The Hebrews*, *The Prisoner of Persia*, and *Before the Revolution* (pp. 11–14), and with

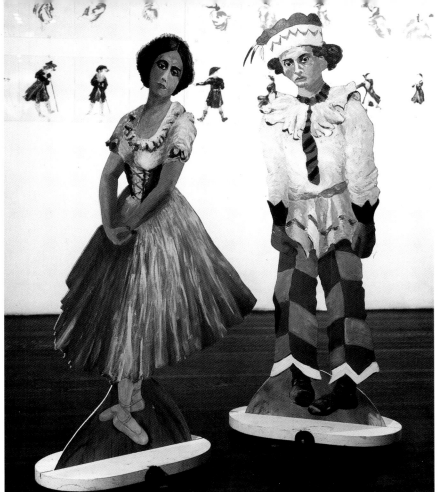

from *Before the Revolution*, 1979

Antinova's own watercolor sketches. Descriptive texts of the ballets were also displayed in this public tribute to the great ballerina. The performance began, as it has on the many occasions when it has subsequently been presented around the country, with a critic who provides a brief background: on the Russian ballet and the very special position it occupied in the role of early modernism; on the achievement and prestige of the celebrated Ballets Russes; and on Antinova's acclaim as Diaghilev's prima ballerina. Antinova enters, acknowledges the warm reception of the

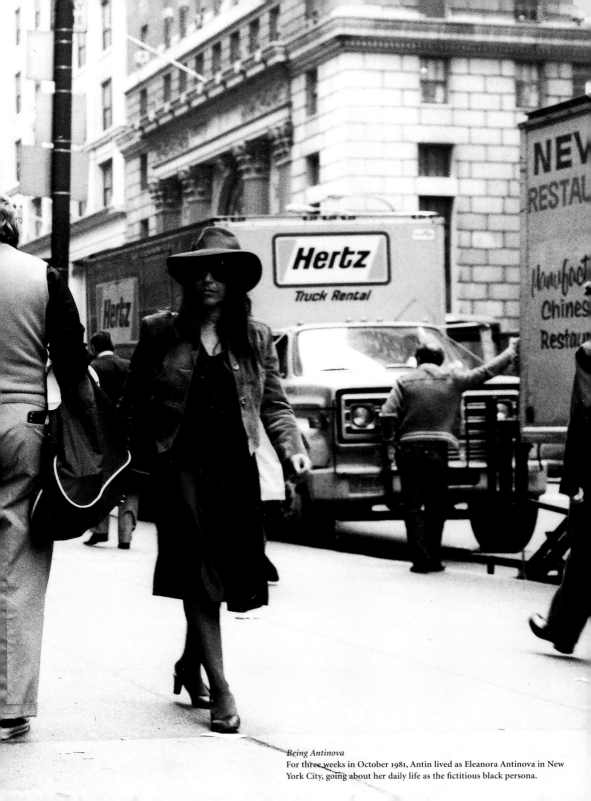

Being Antinova
For three weeks in October 1981, Antin lived as Eleanora Antinova in New York City, going about her daily life as the fictitious black persona.

audience, and sits down to pour herself the first of several glasses of sherry that she consumes throughout the evening. She begins by recounting the history—rich in detail, fascinating in comic intrigue, and full of an underlying pathos—of how she made her way from the back row of the corps de ballet to the rank of prima ballerina.

About midway through the piece Antinova shows slides of her performances, providing synopses and insights, such as "*Pocahontas* was the first ballet I choreographed for the Ballets Russes. The role of the ill-fated Indian princess was chosen for my debut, because it appeared to address itself to both my darkness and my Americanness. Unfortunately the scenario was Benois' fantasy of primeval forests and Elizabethan England—more Petipa than Longfellow."[18] As the evening progresses, Antinova, having imbibed too much sherry, loses her poise, begins to ramble, and gives in to sentimental despair:

> One winter I lived in a small hotel with white columns off *le Pont de Saint Cloud.* I would feed the swans in the neighboring *Bois de Boulogne.* . . . I wonder if there are still swans in Paris . . . my friends are dead, of course. They're all dead except the ones who are still dying. . . . Art is not generous to her children. The truth of the matter is we're all dying. There's no hope for it. A young man asked me recently how one knows that a work of art will last. Nothing lasts! All those years I worked and dreamed. . . . Some mornings I woke up famous. . . . I don't think I ever woke up feeling understood. . . . Sometimes I wake up in the dead of night and can't remember where I am. . . .[19]

The evening ends with unsettling pathos as Antinova attempts to pull herself together. The lights come on and she feebly offers autographed portraits for sale, reminds the audience that she is "available for salons and

RECOLLECTIONS
OF MY LIFE
WITH DIAGHILEV

1919-1929

by

ELEANORA ANTINOVA

Illustrated

Black Stone Press

San Francisco

from *Recollections of My Life with Diaghilev*
Antinova's drawings of *Stravinsky and Friends* and *The Flapper*.
Checklist no. 37

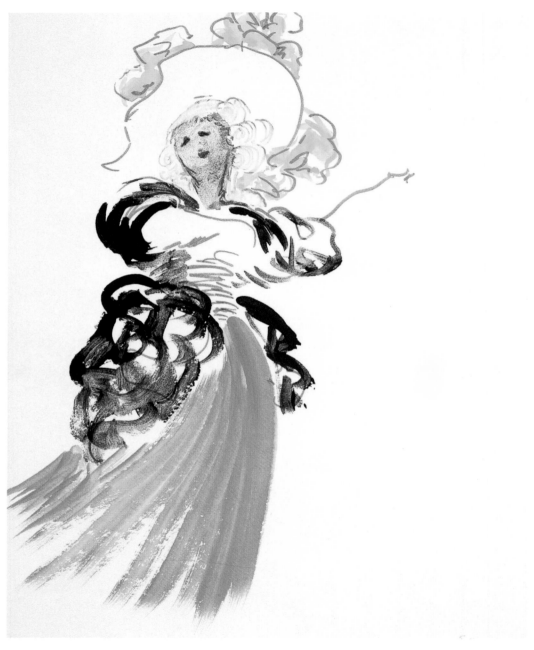

from *Recollections of My Life with Diaghilev*
Antinova's costume drawings from *Before the Revolution*.
Checklist no. 37

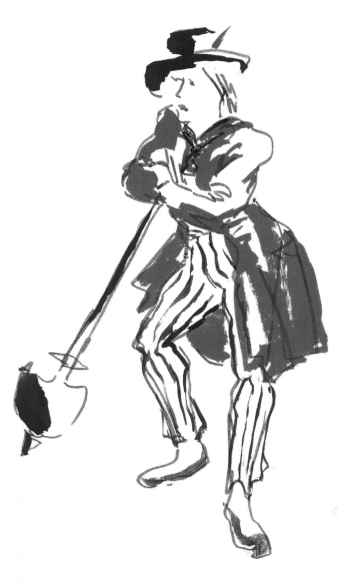

Corps de Ballet.
from Before the Revolution
(American Version)

Eleanor Antin 1998

parties," and thanks them for coming. It is unclear whether her hopeless speech is a meditation on Antinova's destiny or Antin's. But then again Antinova's plight and future could be those of anyone.

The fiction of Antinova makes a powerful claim on the imagination. Ronald Feldman, Antin's gallerist in New York, is fond of recalling an elderly gentleman who made special arrangements to attend the debut performance of *Recollections* because he remembered having met in his youth all of Diaghilev's dancers except Antinova. Feldman also recounts that the fiction was so convincing that some well-intentioned would-be benefactors, moved by Antinova's sad story and especially by her poverty, approached him after the performance to arrange to send her some money. The audience also plays a role in Antin's confusion of art and life.

Loves of a Ballerina, 1986 (no. 38, opposite), an amusing and poignant installation with films, retraces some of Antinova's middle history—before she became the morose ballerina manqué, but after Diaghilev's death in 1929—and the following period, when she is left out of the history of the Ballets Russes by the critical establishment. *Loves* picks up Antinova's story in the United States during the Depression. Without prima status she has been reduced to performing novelty dances, such as the tango, the flamenco, and even the hootchy-kootchy in seedy vaudeville houses. It is rumored that—strictly to survive—Antinova has even made a blue movie or two.

Viewers enter the space and encounter a theater marquee advertising the current feature, *Loves of a Ballerina*. Looking through the round windows in the doors that lead into the theater auditorium, we see the (cardboard cut-out) silhouette of a sparsely populated audience, which is watching several short black-and-white silent movies, starring Eleanora Antinova. Especially winsome is the four-minute *Swan Lake* (one of Antinova's movies of a "questionable nature," and a marvelous spoof on backstage ribaldry), in which the flirtatious Antinova's innermost wish is

Loves of a Ballerina, 1986

This multimedia installation dramatizes Antinova's American career as a fallen artist who tries to eke out a living by performing in seedy vaudeville houses and acting in silent films. Three of these silent films are shown continuously inside a mock movie theater; backstage, the face of the contemplative Antinova at her dressing table is reflected (by video projection) in the mirror; and a bedroom farce transpires (by rear-screen video projection) in two compartments of a Pullman car on railroad tracks opposite the theater.
Checklist no. 38

fulfilled when the head and long neck of a plush toy swan emerges from the tights of her male dance partner. This jocose little skit is about as subtle as burlesque gets, but it is a sophisticated bit of moviemaking. Another brief movie, in a more genuinely romantic vein, shows Antinova visiting the garret of a poet who is sorely in need of poetic inspiration. The ballerina seductively dances for him, he embraces her, they fall into bed, and he makes passionate love to her. But when the ballerina awakes, the poet is at his desk, engrossed in a fit of inspired writing and altogether oblivious to her presence. She slips out the door and into the night.

These short films, and several others, were later anthologized into a single, twenty-four–minute videotape titled *From the Archives of Modern Art*, 1987 (no. 39, opposite). According to the film's credits, these artful little "filmettes" were purportedly rescued from the oblivion of a Culver City warehouse that was slated for destruction. Some half dozen vignettes survived, each directed in a different cinematic style, ranging from generic early Hollywood to German expressionist, and each of which stars Eleanora Antinova. Antin herself was the unnamed and versatile director of these movies, and once again she proved to be quite adept at fusing fantasy and verisimilitude into a reasonably convincing facsimile. Not only are the petite cinemas fictions (like Antinova herself), faux too are the cinematic styles in which they were directed, their specious history, and the "archives" into which they were supposedly reposited.

Elsewhere in *Loves of a Ballerina* are two more "filmic installations"—works of stagecraft that incorporate the illusionism of rear-screen projection and mirrors. Across the street from the theater marquee sits a Pullman car on top of railroad tracks. Through the window of one of the private compartments, viewers see a well-heeled gentleman. Eleanora Antinova enters via the sliding door in tutu and pointe shoes. The two begin to flirt and quickly proceed to exchanging amorous advances.

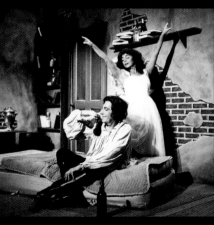

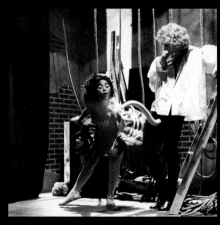

...he Archives of Modern Art, 1987

...short silent movies starring Eleanora Antinova,
...g those shown in *Loves of a Ballerina* (no. 38) with
...anthologized in this video transcription. They are
...variety of styles, ranging from Chaplinesque slapstick to
...rman cinematic expressionism.

39

Almost as abruptly as she came in, Antinova is out the door, only to return a bit later to resume the romantic encounter. Suddenly, Antinova exits again. The puzzling cycle of entry, flirtation, and withdrawal continues. As viewers make their way around to the other side of the railroad car, another window of another private compartment, obviously just across the aisle from the first one, comes into view. Antinova enters, flirts for a few moments with another gentleman, then leaves, then returns, and so on. It becomes clear that the dancer is shuttling blithely between the two roomettes, carrying on simultaneous and mutually secret affairs with their occupants. In a clever formal invention Antin replaces the conventional, temporal structure of cinematic narrative with a spatial artifice, thus revealing the two-timing escapades of her arch heroine, much to the amusement of the viewer/voyeur.

The mood of wanton gaiety evaporates, however, when further exploration of the space of *Loves of a Ballerina* brings viewers upon the haunted dressing table of Eleanora Antinova. The degraded prima ballerina appears in the mirror, wordlessly lamenting her fall from the zenith of classical ballet, a true and noble art, to this hollow charade.

Antinova had no place to go but down. Her nature, so suffused with aspiration and idealism, was doomed to disappointment, displacement, and unrequited desire. In the imagined history of Antinova, the last episode is the one-act drama *Help! I'm in Seattle* (p. 133), which premiered at Los Angeles Contemporary Exhibitions (LACE) in 1986. This time Antinova, now truly wretched, is living in a squalid, vermin-infested rooming house in Seattle. The brief play is a disturbing expression of bitterness mixed with undying nostalgia that is at once pathetic and beautiful; for, even while flicking a cockroach from her clothes, Antinova manages to keep alive her ideals, her love of beauty, and her dream of art. Her despair is a credible and, in some sense, reasonable response to her surroundings and her fate. She is, for all her art and artistry, a flawed and intensely human figure. The night-

marish vision of Antinova's dismal end does not constitute Antin's repudiation of her dearest other self's history; rather, it may be Antin's own affirmation of the nobility of Antinova's life and art in a shabby, indifferent world. The romantic yearning of Eleanora Antinova is nothing more than Eleanor Antin's fondest caprice and nothing less than humankind's profoundest dream.

<div align="center">ACT III</div>

Antinova may have been the consummate postmodern creation. Her life refutes not only entire tenets of radical modernist thought but virtually every essentialist practice invented by radical modernism—its valorization of formalist values and formal strategies of art making; its exaltation of reductive principles; its distaste for artificiality and "literary" qualities; and most of all its prejudice for puristic, unified aesthetics. All of this was contradicted in Antinova. Her art is formalistic to the extent that it freely defies established hierarchies and willfully skips across genres; it appropriates and co-opts art forms, synthesizing and embellishing them as it does so; it revels in elaborate literary conceits and a nostalgia for high culture. Hybrid, impure, and unruly, Antinova's art embodies the aesthetics of synthesis, of montage. If radical modernism strove for an empirical truth and a unity of form and content, Antinova's art is steeped in an anxious commingling of total, blind idealism and hard-boiled irony. Indeed, Antinova's history was patently fictitious, her character decidedly faux. All the parts of Antinova's world, like those of Antin's other personae, are brought together as simultaneous, anarchic fragments. In Antin's art, just as in anyone's life, whatever wholeness one conjures up is strictly in the eye of the beholder.

Why, after laboring for more than a decade to create and develop her several personae, did Antin allow these marvelous artifices to die? The answer is complex, but not difficult to understand. Put simply, the

personae had done their work; and *their* work and *their* lives were never intended to replace Antin's own. Antin had developed them as much as she felt she could or needed to, and other projects were in the offing. Doubtless, maturity was another factor. Just as each of Antin's personae had his or her own evolving history, so had their author. Antin's projects from the 1990s are far less concerned with discovery and imaginative pursuit of the possibilities of the self than they are reflections on how lives are lived, or destroyed. Unless Antinova were to make a miraculous and anticlimactic comeback following *Help! I'm in Seattle,* Antin felt it best to retire the persona—either that, or inhumanely kill her off. Antin accorded Antinova the dignity—albeit the somewhat pathetic dignity—that she had aspired to and that she had earned.

In the aftermath another persona did appear, at least in name. He was Yevgeny Antinov, Eleanora Antinova's reputed lover and a great director of silent films. Antinov, in fact, counts as only a demipersona, for while he is known through his art, he never makes an appearance in Antin's art. What little is known of his personal history is apocryphal, gleaned from the crawler, or scrolling text, that prefaces his "recently discovered" film, *The Last Night of Rasputin,* 1989 (no. 40, pp. 134–37).[20]

Rasputin, the first of Yevgeny Antinov's films, a black-and-white silent movie with a music sound track, is a melodrama in which Eleanora Antinova nominally plays a leading role, but in which little of Antinova's character or history figures prominently. Antin herself seems to have moved into a different mode, dealing much more with plot and the aesthetics of filmmaking in this transitional work. The story portrays Tsarist Russia in the last days of the Romanovs, under whose rule the country has passed, the film's printed captions tell us, "from barbarism to decadence without the intervening stage of civilization. . . . But even in the dark night of Tsarism, the flame of idealism burnt in the ardent hearts of three friends from the productive classes—a worker, a student, and a ballerina."

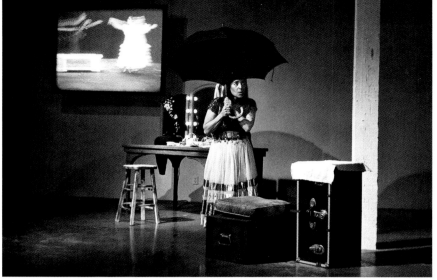

The film opens at the home of the mad mystic Rasputin, spiritual advisor to the Tsarina and a debauchee himself, where the corruption and decadence of the Petrograd regime run rife: gambling, drinking, gourmandizing, lascivious games, and licentious liaisons are wantonly orchestrated for the crowd of courtiers and dignitaries who shamelessly use one another. Rasputin, momentarily tired of lewdness and yearning for beauty, orders his henchman Igor to bring him "a real dancer." At the ballet theater Igor abducts the most graceful, beautiful, talented dancer he can find—Eleanora Antinova. Rasputin orders Antinova, who is shocked by the human degradation she witnesses, to dance for the guests, which she does, but she dedicates her dance to the oppressed people of the world. Briefly, even the debauchers are moved by her performance, but after she collapses in exhaustion, they try to take advantage of her while she sleeps. Seeing this, Rasputin becomes outraged and demands their repentance. Chaos ensues. In the nick of time, however, Antinova's friends appear on the scene to rescue her, and the debauchers kill Rasputin. The rest—anarchy and revolution—is history.

The film, like so many of Antin's previous projects, evokes the morality and ethos of a civilization and shows how these are manifest in

**The final orgy and dreadful end
of the notorious monk, Rasputin,
on the eve of the Russian Revolution**

ELEANOR ANTIN presents
THE LAST NIGHT
OF
RASPUTIN

THE 1924 FILM OF YEVGENY ANTINOV, CONTROVERSIAL SOVIET SILENT FILM DIRECTOR

In Person
The Leading Lady, **ELEANORA ANTINOVA,** will introduce the film

**May 9–May 16, Daily Matinees 1:15 PM
On Tuesdays an additional showing at 6:30 PM**

Whitney Museum **1989 Biennial**

poster from the 1989 performance at the
Whitney Museum of American Art, New York

ГОСКИНО

представляет фильм

" Пследняя ночь Распутина"

The Last Night of Rasputin, 1989

A classic film by the fabled Soviet silent
film director (reputedly Eleanora Antinova's
lover) Yevgeny Antinov, this production also
marks the last appearance of Antinova in Antin's
oeuvre. Antin made this film to resemble an
authentic 1924-vintage silent movie, employing a
music sound track, printed titles (to indicate
dialogue), and antiquated cinematic and acting
techniques of early movie melodramas. The film
dramatizes the political intrigue, the decadence,
and the dreadful end of the notorious mad monk
Rasputin on the eve of the Russian Revolution

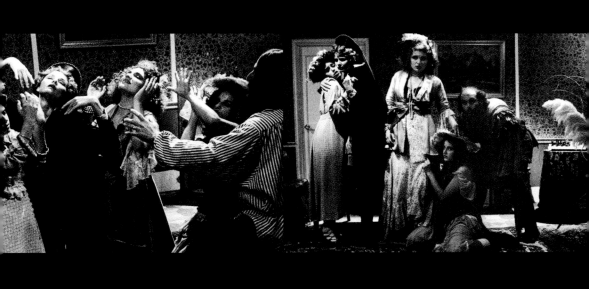

the lives of individuals. But a subtle shift had by now taken place in Antin's art. In *Rasputin* the individual characters are sketchily delineated at best, and the drama itself is more of a morality play and an allegory than it is an exploration of a personal history, fictitious or otherwise. There is conflict here between art and philistinism, between good and evil, between life and death—none of which is new to Antin's art—but now the conflict results not simply in personal victimization but in moral judgment and real consequence. Antinova escapes with her life; and Rasputin and the Romanovs perish at the hands of a new social order. Antin has shifted her imaginative focus from the individual to the culture and from the exploration of new and future possibilities in the lives of her personae to a consideration of the consequences of roads taken, and of roads not taken.

Yevgeny Antinov's next film, his masterpiece, is the feature *The Man without a World* (1991; no. 42, pp. 139–41). A 16-mm black-and-white silent film with a music sound track, it was commercially distributed and is still widely screened in festivals and university film programs. The film is a rich and darkly melodramatic work set in Poland just before World War II. The complexities of village life—the political and religious factionalism of its Jewish population, the arrival of a Gypsy caravan, the clashes of tradition with changing realities, rapes, weddings, funerals, and even an exorcism—form the tapestry against which the central story plays out: the doomed romance of Zevi, a Yiddish poet, and Rukheleh, the maiden who wants to marry him. Zevi, an active young intellectual who frequents the town's bar to argue politics and religion, encounters the Gypsies and is allured by their exoticism, their artistry, their freedom to move and act. He dreams of living a bohemian life in Warsaw, but miserable conditions at home beset him: his sister, having been raped by Polish peasants, goes mad; his mother literally suffers to death; and his pregnant girlfriend, Rukheleh, insists upon marriage. Things get worse. A mystical sect of Jews tries to exorcise the evil spirit from Zevi's sister and succeeds

The Man without a World, 1991

This silent movie with titles (text) and music sound track is the work
of the imaginary director Yevgeny Antinov. (Thanks to glasnost, a
brief textual prologue to the film informs us, a perfect print of this
suppressed movie was recently discovered in an Odessa archive and
released to the world as a newfound masterpiece.) Set in a typical
Jewish shtetl in Eastern Europe, this dark melodrama relates the tale of
the doomed romance of Zevi, a bohemian Yiddish poet, and Rukheleh,
the nice Jewish girl who wants to marry him. The make-believe of the
silent movie and the artifice of its mock pedigree notwithstanding, the
drama is an existential tragedy in which only the figure of Death
prevails (below and pp. 140–41).
Checklist no. 42

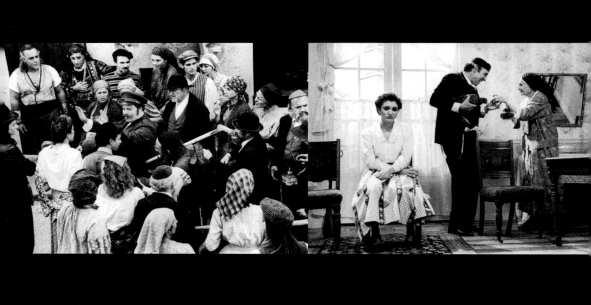

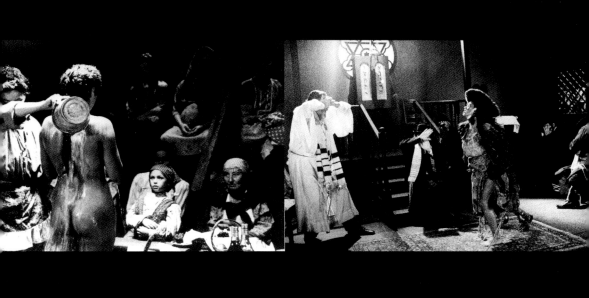

only in bringing about her death; and at his wedding to Rukheleh, Zevi himself becomes a killer when a spurned suitor shows up to make trouble. Leaving Rukheleh behind, Zevi runs away with the band of Gypsies. The figure of Death follows them down the road. Fade-out. The end.

Antin presents the image of a world in which the wisdom of religious tradition and the timeless certitudes of shtetl life are undermined—indeed, ruined—by vagabond artistic dreams that insinuate themselves into the imagination of the central figure, a poet. The dream of art once again in Antin's oeuvre precipitates unhappy, nightmarish, and in this case tragic consequences. Death, who first appeared in *Rasputin*, looms large and aggressive here, going so far as to virtually copulate with Zevi's dying mother. Mortality becomes a central issue in Antin's later works, and it is not the mortality of the Holocaust, or of AIDS, or any other unnatural epidemic. It is the mortality of the most natural and endemic kind. Little wonder that the shtetl and most of its inhabitants appear to be, as Jeffrey Skoller observes, "a world of ghosts. The film opens with a figure who comes to be known as Death and who conjures up the world we are about to experience simply by snapping his finger. These are no longer real people who have all the complexity of human beings. Rather they are cultural archetypes and victims with whose ultimate fate we sympathize. . . ."[21]

The motifs of Eastern Europe, the impending World War II, and the specter of mass destruction also inform Antin's next work, the filmic installation *Vilna Nights*, 1993 (no. 43, pp. 143, 145–47). Viewers in the gallery space happen upon a white wall with a large chunk blown out, as if a bomb had struck it. Peering through a gaping fissure, we see the rubble of a neighborhood square, an intersection of backstreets in a once thriving city. Three windows in the bombed-out buildings front on the square, and through them we see what Antin describes as "the ghosts of the vanished inhabitants as they continue to live out their interrupted lives."[22] In this filmic installation Antin wreaks havoc on traditional film

Vilna Nights, 1993

The gallery space is filled with a stage set representing the
bombed-out ruins of the Jewish ghetto in Vilna; a ghostly
afterlife persists among the ruins, however, in three
vignettes glimpsed through windows in the rubble.
Rear-screen video projections embedded in the stage set
provide the action, the highlight of which is the fantastical
and brief visitation of a holiday feast, to the astonishment
of two orphaned and hungry children. A stark, elegiac
mood pervades this work (below and pp. 145–47).
Checklist no. 43

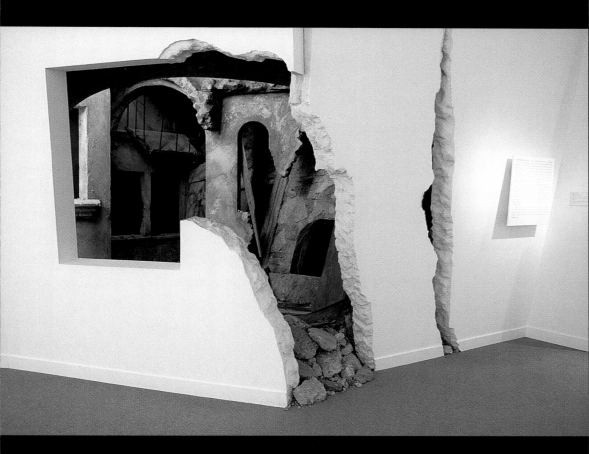

narrative, raising it from expository storytelling to something approaching timeless ritual.

In one of the windows a distraught, middle-aged woman clutches a passel of love letters, which she finally thrusts into the wood-burning stove; through another window a sobbing old tailor at his sewing machine persists in the vain task of mending the clothes of children who, it is inferred, have been killed in the bombing; through the third window two orphaned children, a lad and his younger sister, huddle in the darkness and share a dry crust of bread. This last window offers one of the most poignant episodes in all of Antin's art. A glow suddenly appears in the room, frightening the children. It brightens and reveals itself to be a menorah, floating in the air, with all the candles lit. Moments later it illuminates a large, empty table. A tablecloth magically floats into the room and sets down on the table; dishes and silverware for two place settings follow. The children's fear gives way to awe and delight as a loaf of challah bread sails in and is swiftly followed by the makings of a complete Hanukkah feast, all settling to their proper places on the table. The dazzled and hungry children gingerly approach, but just as magically and suddenly as the feast had appeared, the bread, the food, and the place settings lift up and fly away whence they came, leaving the children alone. Only the menorah remains, and one by one its candles go out, leaving the children cowering again in the near darkness. Each of these three vignettes repeats continuously, as if the moments they capture are doomed to be repeated for eternity. They comprise an endless, ritualized narrative of loss.

A profound sense of sorrow and tragic loss suffuses the tableau of *Vilna Nights*. Vilna, or Vilnius, is currently the capital city of Lithuania, but since its founding in the tenth century it has been one of the most fought-over and devastated cities in Europe. It was also, for much of the eighteenth and nineteenth centuries, the major European center of Jewish culture and learning, which flourished there, culminating in the Haskalah,

or Enlightenment, movement. Vilna, home to the largest population of Jews in Europe, was severely damaged by Germany in World War II, and its Jewish population was virtually exterminated. Today, little Jewish culture remains there. Without ever specifically mentioning the Holocaust, Antin evokes, through the three brief, simultaneous vignettes of *Vilna Nights* (as she does in the tale of *The Man without a World*), the demise of a culture, a way of life, and the millions who had lived it.

from *Vilna Nights*

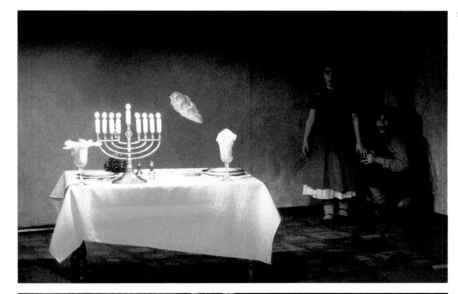

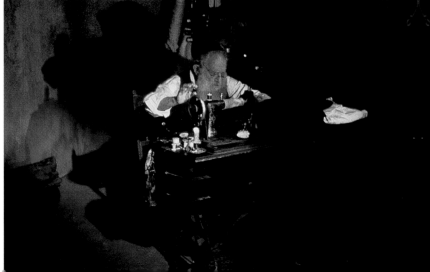

from *Vilna Nights*

A culture represents the beliefs, the ideals, and the morality of its members, much as art represents these attributes to Antin. Turning her attention outward to her inherited culture, to modern history, and to the specifically Jewish tradition that dates back nearly six millennia, Antin incidentally reflects on her personal history but, much more important, locates it in a tradition that far transcends individual experience. Antin's art of the 1990s is no longer much about Antin, or any of her other selves; it is the natural evolution from such concerns to a comprehension (or an effort to gain comprehension) of things so much larger than any one self and so much a part of our collective experience of modern history that it may rightly be described as universal.

As if loss and sorrow were not dolorous enough, in Antin's most recent works there is a salient suggestion of misgiving, spite, and anger. Her filmic installation *Minetta Lane: A Ghost Story*, 1995 (pp. 149–51), represents a street in New York's Greenwich Village that was home to artists, poets, and other bohemians in the 1950s. Antin describes it as "a low-rent district where there was already an established artists' community. Studios were cheap, so were paints and canvases, food and booze, and cigarettes. All over the Village young people were writing, painting, getting psychoanalyzed, and fucking the bourgeoisie. Love and life were free, experimental—and safe. An age of innocence, a little breathing room before the fall."[23]

Viewers approach *Minetta Lane* as if it were a stage set; we encounter it from the outside and are immediately aware of the construction as stagecraft, buttressed with unpainted two-by-fours on the outside and rendered veristically on the inside. We enter the set through a vestibule of rubble and dust as if stepping into the remains of a demolished urban apartment house. The passage leads to a room that looks out on a life-scale reproduction of a fragment of Minetta Lane. Across an alley we can see into the windows of three apartments and watch some interconnected moments (again through the illusionism of rear-screen video

from *Minetta Lane:*
A Ghost Story

Minetta Lane: A Ghost Story, 1995

Viewers enter a trompe l'oeil stage set representing the rubble of a
demolished apartment in New York's Greenwich Village. Looking
into the windows of three other apartments across an alley, viewers
espy the ghostly images of their respective former occupants—a
woman painting abstract expressionist canvases, a young interracial
couple in love, and an elderly gay gentleman—all of whose isolated
activities are disrupted by the uncanny appearance of a disturbingly
mischievous young girl. The work is Antin's paean to a fabled, now
lost, bohemian way of life in the Village; and the mischief-maker
who haunts the set is the negative force that undoes it all.

projections) in the lives of their long-gone inhabitants. Through the basement window we watch a couple of young interracial lovers, nude, frolicking in an old-fashioned bathtub. Another window directly across the way opens onto an artist's studio, and we see the painter busily at work on her abstract expressionist composition, taking an occasional swig from a brandy bottle. The third window is on an upper floor, where an elderly gay man wearing an ornate old kimono shuffles into view beneath an elaborate chandelier. His apartment is filled with birdcages. With obvious pleasure he attends to the care of his many caged birds. Into each of these three tableaux, and at various times, an interloper appears: a young girl, perhaps eleven years old and apparently invisible to the occupants of the apartments, who mischievously—maliciously—disrupts their lives. She interrupts the lovers, causing them to argue; she paints over the artist's canvas, ruining the composition; she enters the old man's room, and he suddenly clutches his heart, slumps into a chair, and dies as the child cruelly jolts each birdcage and gloatingly puts out, one by one, each of the lightbulbs in the chandelier.

The melodramatic aspects of *Minetta Lane* are touching, and overall the work suggests a plaintive, tender nightmare. The poltergeist-like child (whom Antin calls Miriam, after an imperfectly remembered character in a Truman Capote story she had read many years before) is not meant as a true spirit but is another in a series of metaphors Antin has been using in recent years to evoke all that can go wrong in life, from the most banal household slipup to death and abandonment. Miriam is a spiteful, unfunny creature, who misanthropically mucks things up for the mere sake of doing so. She may represent to Antin the aspect of the human psyche that is deliberately destructive of happiness, of hope, of life itself.

Such is the gentle hysteria of Antin's recent works. Her latest film, *Music Lessons,* 1997 (no. 44, opposite), a collaboration with David Antin, is a fable set in a small Southern town. Jeanie Quinn, a teenager in a working-class family, is beset by a demon, a figure in the mirror who returns

Music Lessons, 1997

This color film—a troubled psychological fantasy produced in collaboration with poet David Antin, the artist's husband—tells the tale of a beautiful anorexic young woman from a working-class Southern family who dreams of becoming a glamorous model and concert violinist. Her family, who cannot afford music lessons, worries about her increasing frailty and her preoccupation with a haunting figure whom she sees in the mirror. After an attempted rape her family turns against her, and she seeks refuge in the mirror, where, finally free, she plays a dazzling virtuoso violin in a disastrous artistic triumph, as the family watches in horror.
Checklist no. 44

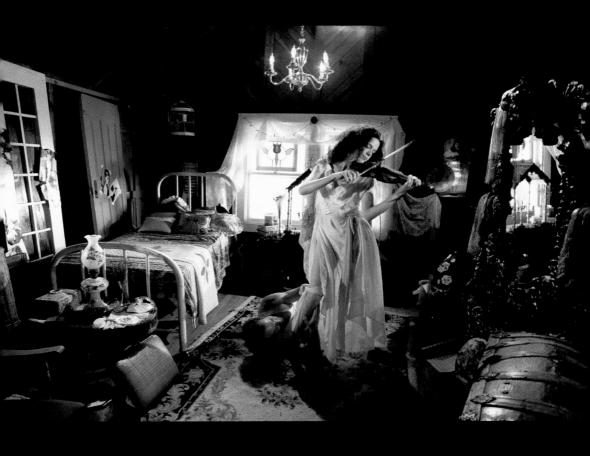

again and again to beckon her to a realm of art and beauty, where she will become a virtuoso violinist. Jeanie asks her parents to pay for music lessons, but they dismiss her aspirations and tell her they cannot afford them. Genevieve, the spirit in the mirror (who is played by the same actress who plays Jeanie) continues to haunt her. Frightened, angry, misunderstood, Jeanie becomes anorexic and grows thinner and thinner. Her older sister's boyfriend, however, is intrigued by Jeanie, and he attempts to seduce her. She resists and he rapes her. The family blames Jeanie for the event, and they shun her. Genevieve comes to her again, and now Jeanie decides to follow her, escaping into the mirror as her family gapes in horror.

Jeanie fulfills the anorexic's ultimate, fatal dream—to become immaterial, a being no longer of this world, a traveler to a finer realm. Antin purposefully begs the question of whether Jeanie's voyage into the world beyond the surface of the looking glass is salvation or suicide. Like Narcissus, fatally transfixed by her own image, Jeanie perishes. Jeanie, like Antinova before her, pursues the dream of art; and like Zevi, she leaves destruction and despair in her wake. Art has triumphed over life, and there is a grievous loss all round. In Antin's late works it is as if she is expressing serious doubt about the ideal of a life in art. In truth, Antin's own youth is gone and like any mature person contemplating her future, she may well be asking what remains, either of the future or of the past. There is something unforgiving about art and the passion that is spent making it. In the end it becomes the measure whereby the artist and history shall judge the significance of an artist's life. Hence Antinova's bitter recollection in *Before the Revolution* that art is a cruel mother to her children.

EPILOGUE

What might appear to be egoism in Antin's art—the sustained presentation of autobiography—emerges as something quite the opposite: the attempt, through art, to shed the self, or the limitations of the self, and to transcend the confines of the present and what is already known. It is an act not of contented self-worship but of aching desire, of wanting, wishing, dreaming. Antin's protagonists are always the dispossessed, the disenfranchised. The King, her male self, is hardly the figure of power that his maleness and kingliness lead one to expect: he is, after all, deposed and exiled. Her short-lived Black Movie Star is an outsider, an oddity, a highly visible interloper, someone who doesn't quite belong. Nurse Eleanor, unlike the Black Movie Star, plays an integral role in society, but her noble calling is denigrated and derogated through the course of a century. Eleanora Antinova, prima ballerina, is forgotten and lives in the memory of her degraded dream. Even Antin's protagonists who are not ostensibly her other selves—Zevi in *The Man without a World,* the weeping tailor or the hungry children in *Vilna Nights*—are doomed outsiders even within their own closed society: they are all without a world. So even are the 100 BOOTS, ever-searching, always marching, marching, marching, like the Israelites in the wilderness. When they finally do arrive at their destination, it is not the land of milk and honey, but a seedy crash pad somewhere in marginal Manhattan. And in the rest of Antin's oeuvre—such as in the *Movie Boxes,* the *California Lives,* and the *New York Women*—her subjects are evoked by their absence. The movies, the people, the events are evinced by mementos and residue. Little wonder that Antinova was always pining to write her memoirs. Antin's art, full of loss and yearning, is the expression of memory, of dream, of desire. It is the art of elegy, a tragicomic prologue to what lies waiting in the wings.

1. Owen F. Smith, "Fluxus: A Brief History and Other Fictions," in *In the Spirit of Fluxus,* exh. cat. (Minneapolis: Walker Art Center, 1993), 24.

2. Ibid., 30.

3. Ann Goldstein, "Eleanor Antin" entry in *Reconsidering the Object of Art: 1965–1975,* exh. cat. (Los Angeles: Museum of Contemporary Art, 1995), 52.

4. See "A Dialogue with Eleanor Antin," in this volume, especially pp. 199–200.

5. "An Autobiography of the Artist as an Autobiographer," *L.A.I.C.A. Journal* 2 (October 1974): 20.

6. Arlene Raven and Deborah Marrow, "Eleanor Antin: What's Your Story?" *Chrysalis: A Magazine of Women's Culture* 8 (summer 1979): 44.

7. Ken Friedman, "The Early Days of Mail Art: An Historical Overview," in *Eternal Network: A Mail Art Anthology,* ed. Chuck Welch (Calgary: University of Calgary Press, 1995), 8.

8. "An Autobiography of the Artist as an Autobiographer," 20.

9. Many performance artists and historians distinguish between audience-oriented performances and so-called life performances. A performance is usually an announced event intended for an audience, generally in some appointed gathering place. The audience, even in an unannounced public action, like "guerrilla theater," is made to understand that they are observing a public event. Examples of performance pieces run the gamut from the mid-1960s improvisational Judson Dance Theater concerts to Chris Burden's 1971 event *Shoot.* A life performance, by contrast, is usually a private or unannounced activity that may be carried out in a private or a public place, but without an audience. Casual observers, or people with whom the performer may happen to interact, may not even realize they are witnessing a performance. In Vito Acconci's 1969 *Following Piece,* for example, the artist followed randomly chosen people, unbeknownst to them, through the streets of New York until he lost them or they entered a building. Performance pieces and life performances alike may be documented.

10. Unpublished manuscript by Eleanor Antin.

11. *The Angel of Mercy,* exh. cat. (La Jolla, California: La Jolla Museum of Contemporary Art, 1977), 2.

12. Unpublished manuscript by Eleanor Antin.

13. *The Angel of Mercy,* 2.

14. In 1981 a videotape version of the performance, without an audience, was produced for exhibition and broadcast. The videotape is included in this exhibition, as are many of the cut-out figures that were used in the performance.

15. All quotations from *Before the Revolution* are taken from *Eleanora Antinova Plays* (Los Angeles: Sun & Moon Press, 1994), pp. 91–131.

16. Frantisek Deak, "Acting As an Art Paradigm," *Images & Issues* 4 (January–February 1984): 22.

17. *Being Antinova* (Los Angeles: Astro Artz, 1983).

18. *Eleanora Antinova Plays*, 79.

19. Ibid., 87–88.

20. In its ideal presentation, as it was shown at the Whitney Museum of American Art in 1989, this movie is introduced in person by Antinova, looking like Lillian Gish. Antin's performance piece is revived for this 1999 retrospective exhibition.

21. Jeffrey Skoller, "Reviews: *The Man without a World*," *Film Quarterly* 49 (fall 1995): 30.

22. Unpublished manuscript by Eleanor Antin.

23. Ibid.

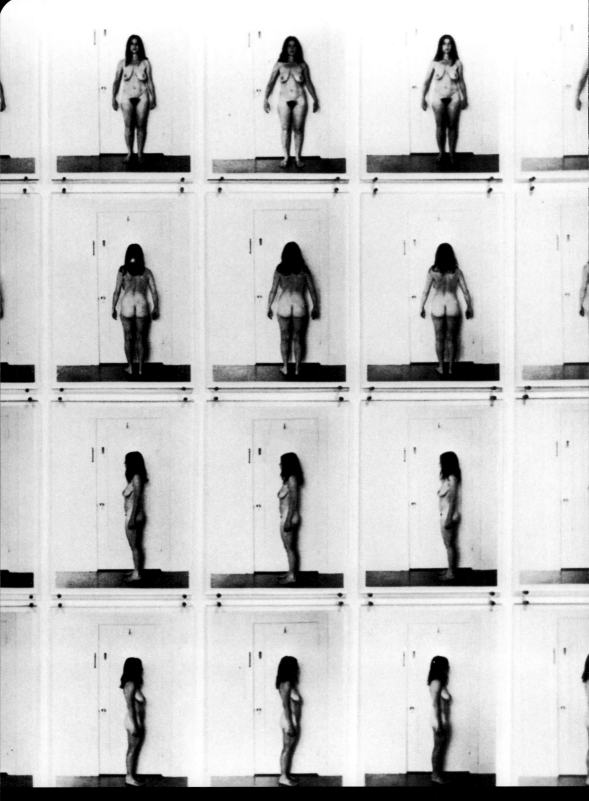

detail of *Carving: A Traditional Sculpture*, 1972
Checklist no. 19

Rewriting the Script: Eleanor Antin's Feminist Art

Lisa E. Bloom

In 1974 a group of young women from the Feminist Art Program in Los Angeles invited Eleanor Antin to write a letter addressed to "anonymous young women artists" about what it meant to make art from a woman's point of view. The resulting project, titled *Anonymous Was a Woman,* was part of a seven-day arts festival that "celebrate[d] the emergence of [women's] new spirit of visibility and vitality in the arts."[1] The seventeen younger women artists who helped launch the project under the auspices of the Feminist Art Program and the direction of Miriam Schapiro succinctly expressed the sentiments of the group in their letter to Antin and the other contributors:

> Your personal vision and achievements have moved us and enriched our development as young women artists. You are a model to us. . . . We would be deeply honored to include such a letter from you about your experiences, or advice, or whatever feelings you might wish to express. . . . Your letter would be an invaluable contribution in our efforts to build a strong identity for women.[2]

The responses to the organizers' letter explored not only what it meant to be an artist from women's points of view, but also the ways women artists were often hindered from reaching their potential. The hope of many of the older women was that the younger ones would come to believe in their own abilities. As contributor Rhys Caparn puts it: "You must believe in yourself, and in other women as artists. This conviction is the first and most important step in building a strong identity for women in art."[3] Eleanor Antin's response, however, is somewhat at odds with those of many of the other contributors. On the one hand, she supports the goals of the Feminist Art Program's project. She writes that women need not be "a supporting player in somebody else's script" and even advises "rewriting the script," because the standard one is obsolete. On the other hand, Antin's perception of the realities of everyday life is too complex for her to advise that such a program would be easy to follow. She cautions that this is "not a comfortable way to proceed," because it "means you have to defend your right to be there." Even if you are successful, she claims, you still risk being alone. In the end that can be fatal, for "art is the most communal activity in the world."[4] Antin indirectly suggests that women artists are often oppressed by having to compete for, and live up to, an idealized male image of what women artists should be like, but her response departs somewhat from the optimism of most of the other contributors. For Antin, building a "strong identity for women" is not a simple matter of solidarity. Though she recognizes the importance of sisterhood, she claims that it is not always comforting or empowering. She ventures that the script might have been written not only by men, but also by women who have power over other women.[5]

Many years passed before the questions Antin raised about sisterhood in her 1974 letter were taken up by other feminists in a concerted way. Explaining why this was the case requires a backward glance at feminist art and art history. This brief overview will then allow us to return to

Antin's work and to rethink it in terms of a different trajectory from the one given in conventional histories of the period.

In the mid-1970s the members of the Feminist Art Program in California felt that feminists should concentrate on how men oppress women, and not on how unfairly women treat one another. The project *Anonymous Was a Woman* was conceived apropos of that sentiment, with the express purpose of contesting the masculinist nature of what had previously, exclusively rated as art, artistic genius, and art education. As Miriam Schapiro put it in the introduction to *Anonymous Was a Woman*, "I did not want Rembrandt as a role model—he had a penis....I wanted to learn from *women* what it felt like to want to be an artist."[6] Such feminist art projects in the U.S. and the U.K. subsequently inspired related efforts to build and maintain feminist intellectual space in art schools and universities. One major goal was to raise the questions of why and how women had "disappeared" from the history of art.[7] This in turn stimulated further creative activity: critical concepts and theories, art-historical research projects, explanatory frameworks, as well as new kinds of art that attempted to redress the situation.[8] Assumptions were questioned, and women-centered art-historical scholarship, art criticism, and art developed.[9] But reconstructing the arts entailed reevaluating and redesigning the terms and topics that had dominated the practices of art schools and art history programs in the first place. Indeed, beginning in the mid-1970s, art and art history were forever altered by such "reconstructive" feminist projects. The critical energy involved in challenging gender-blind and gender-biased art and art history reinvigorated the field and led to the growth and diversification of what came to be known as feminist art and art history.

Reconstruction also generated reflexivity—that is, self-awareness and self-criticism—among practitioners in feminist art and art history. This led to serious conceptual and theoretical debates about such issues as

the relationship between gender, power and inequality, and other forms of institutionalized domination and exploitation.[10] It has also raised questions in the minds of African-American and other women of color, Third World women, and lesbians, who are making important criticisms of their exclusion from mainstream-U.S. feminist concerns.[11]

The fact is that feminist art history and feminist art practitioners, as a result of their growing self-awareness and self-criticism in the U.S. and elsewhere, are very different now than they were in the mid-1970s when Eleanor Antin inquired in *Anonymous Was a Woman* about the tensions between women's commonality and difference. Among the changes that have been crucial are the growing awareness of the diversity among women; the significance of groundbreaking conceptual philosophies of difference and postmodernism on feminist art history; feminist art's intersection with models emerging from Jewish studies, gay and lesbian studies, as well as the postcolonialist and antiracist debates. Despite the positive changes over the past two decades, there have also been signs of the demise of feminism as a political movement in the arts. In the past decade, for example, we have seen the emergence of "postfeminism" and the backlash against feminist art in the media; the attack and dismantlement of affirmative action in public universities; and the end of a feminist art movement that was oriented primarily toward concerted public action.

ANTIN, FEMINISM, AND WHITE ETHNICITY

My particular interest in feminist art that deals with gender, racial, and ethnic differences has led me to revisit the work of Eleanor Antin, who stands out as one of the few artists from the 1970s who actually foregrounds these issues in her work. Providing a critical account of what it meant for Antin to be a white, Jewish, feminist artist is important, since it contributes to a more meaningful understanding of white ethnic feminist

artistic practices in the U.S.[12] Moreover, many well-known feminist artists, poets, and critics who were prominent during the 1970s in California, such as Antin, Kathy Acker, Martha Rosler, Judy Chicago, Joyce Kozloff, Lynn Hershman, Miriam Schapiro, among others, were Jewish and emerged from households in communities in New York and Chicago that were heavily marked in terms of ethnicity, race, religion, and class before they made the move (permanently for some, temporarily for others) to California in the 1960s.[13]

Since readers are also ethnically constituted, such a study may interest younger viewers of this retrospective exhibition, for it attests to the difference and diversity among feminists along these axes of identification, not simply racially and ethnically, but also generationally. A younger contemporary feminist academic community might be especially alert to certain ethnic references in Antin's work, familiar as many of them are likely to be with theorists such as Sander Gilman, Ann Pellegrini, and Richard Dyer, whose work examines how ethnicity, gender, sexuality, and race have signified different relations between the body and society at various historical moments.[14]

How I situate myself as a feminist has been in part shaped by such writings. Though I am of a younger generation than the artist whom I am writing about here, my own Jewish family's trajectory—from Eastern Europe and Russia to the U.S., then from New York to California, and finally (in my case) from California to Japan—shapes how I perceive myself in relation to U.S. culture. In rethinking Antin's work along such lines I am interested in setting up a new history of feminist work from the 1970s. This history would establish space for other divergent and competing histories of the Jewish immigration. These competing histories, in turn, would allow us to follow how Jews shaped, and were inflected by, the models and lifestyles that dominated Southern California feminism of the period.

The concerns and passions that inform one of the few major publications on 1970s feminist artistic practice, *The Power of Feminist Art: The*

American Movement of the 1970s, History and Impact, alerted me to some of the specific directions and priorities of the 1970s generation. In their introduction the authors write:

> How then do we situate the Feminist Art Movement on the broader stage, conceptually and historically? Is it merely another phase of the avant-garde? Or is it not, rather, to borrow a phrase that has been used to describe the cultural climate of the 1960s, "one of those deep-seated shifts of sensibilities that alter the whole terrain"? The feminist critic Lucy R. Lippard argued persuasively in 1980 that feminist art was "neither a style nor a movement," but instead "a value system, a revolutionary strategy, a way of life," like Dada and Surrealism and other non styles that have "continued to pervade all movements and styles ever since." What was revolutionary in feminist art, Lippard explained, was not its form but its content. Feminist artists' insistence on prioritizing experience and meaning over form and style was itself a challenge to the modernist valorization of "progress" and style development.[15]

Because women of my generation no longer face the same kinds of highly structured resistance from patriarchal institutions, it is easy to forget the force that feminism had at that moment when women were engaged in activist movements and aimed to alter their personal lives as well as their art practices and teaching. The feminist commitment to revolutionary socialist ideals was an important part of the idealism of the 1970s.

However, if we are to have a greater understanding of generational differences within feminism now, some of the older histories and antagonisms of the past must be revisited and rethought. Given the example of the last twenty-five years of work theorizing differences in many other fields, it seems that one of the key strategies in revisiting this period should

be to examine how race and ethnicity have operated within the U.S. feminist art movement as it has been conceived from the 1970s to the present. Responding to such a concern, Yolanda M. López and Moira Roth write:

> There is a dramatic inequality of information on women of color as opposed to Euro-American women. The feminist art movement . . . suggests an identity prioritized by gender not race. For women artists of color—despite their concern with women's issues—ethnicity more than gender has shaped their primary identities, loyalties, and often the content of their art. Also from the start the women's art movement has been dominated by Euro-American leadership.[16]

López and Roth provide a means of describing the larger cultural issues that have conditioned the development of North American feminist art up to our current historical moment. Their emphasis on the need for a complex understanding of the way that gender and ethnicity are interarticulated is important, but I would extend their discussion to include not only women of color but also white ethnic women, who have also had an uneasy allegiance to a feminism that erases the consideration of other differences beyond gender. Thus, for example, there still remains a great need for an examination of how Jewish women's identities are tied to other social identities and are mediated through institutional discourses of art history and modernism. Such a study would have to take into account the uneasy terms of Jewish women's dominant position in the feminist art world, which they themselves helped to shape and define.[17] Furthermore, it would be a mistake to believe that ethnicities could be understood in isolation, without considering the ways in which they are part of a complex matrix of differences among women.

There is no point at which she suddenly stops being Eleanor Antin. What she becomes is already part of her, and she never ceased to be what she is to begin with. There are no borders, no precise contours, no center.

—Jonathan Crary, *The Angel of Mercy*, La Jolla Museum of Contemporary Art, 1977

Eleanor Antin's work is particularly appropriate for the purposes of this study, since it reveals some of the ways a unitary history of U.S. feminism, in which gender is the sole emphasis, is inadequate for dealing with the complexity of many artists' work. The importance Jewishness poses for Antin is evident throughout most of her oeuvre despite the fact that her artistic practice has not been written about from such a perspective previously. Instead, her art has been praised mostly for its rejection of formalism, or for the way the autobiographical pieces brought back a "renewed focus onto the self in all its aspects."[18] Even more recently, early feminist work such as Antin's is primarily seen as significant by feminist critics for its innovative subject matter, such as "language and personal narrative, discussion of the self, sexuality, women's experience in the world, and the presence of everyday life."[19] Somehow, however, self, experience, and everyday life have not included ethnicity.

A key figure in the body and performance art of the 1970s, Antin still remains best known for her live performance work, published memoirs, and photographic and video work in which she takes on the personae of the King, the Black Movie Star, the Nurse, and the Ballerina. For Antin these invented personae provide what she calls a "mythological machine . . . capable of calling up and defining my self. I finally settled upon a quadripolar system, sort of a magnetic field of four polar-charged images."[20] Antin's presentation of these four characters has changed over time, and they have frequently been re-presented in videotapes, photographs, stage props, live performances, and everyday life. The Nurse, for

example, began as a bawdy contemporary American and later became Eleanor Nightingale, a Victorian "Angel of Mercy" on the Crimean battlefield. Similarly, her other personae have had different ethnic, racial, and historical identities as well as different nationalities. On occasion she has adopted, in public and in private, the manners and worldview of her personae. She has also written and published their "memoirs," documenting their "experiences." In addition to these compelling characters, Antin is also well known for her 1971 black-and-white video, *Representational Painting* (no. 14, p. 45) in which she spends nearly forty minutes applying makeup to her face. The work questions prevailing notions of what constitutes ideal femininity and female beauty. This work is something of a companion piece to a video made the following year, *The King* (no. 21, p. 63), another lengthy work about making up. In this piece, however, Antin transforms her face to assume the male character of the King. Another extremely influential work that deals with gender issues is her postcard piece, *100 BOOTS*, 1971–73 (no. 12, pp. 52–57). This work centers on one hundred black rubber boots, Antin's male picaresque "hero," and "his" travels from suburban San Diego to New York City. The project itself is composed of fifty-one photographic postcards, depicting the BOOTS trip, which she mailed to one thousand people over two years.

Like other feminist performance artists from this period, such as Adrian Piper, Carolee Schneemann, and Lynn Hershman, Antin uses her own body and experiences as the subject in most of her works, and in so doing she begins to explore what it means to be both an embodied female and an intellectual ethnic woman. In this respect her work references other modes of identification, for instance those grounded in ethnicity as well as in gender. In *Carving: A Traditional Sculpture,* 1972 (no. 19, pp. 47, 158), which began as a sculpture-in-process piece that Antin performed from July 15 to August 21, 1972, the artist had herself photographed every morning over the course of a strict thirty-six–day dieting regime. This piece in its final version as a photographic document was seen at the time

and continues to be interpreted as the work of a white woman making an ironic comment on how the ideal of the generic nude has been gendered in the history of art. Emphasizing its feminist importance, a 1975 essay by art critic Cindy Nemser claims that *Carving* is about "how women are always concerned with the need to improve their bodies."[21] Here Nemser is referencing all women and focusing on how female desire in general is courted by the promise of future perfection through the lure of the ideal—whether it be that of the classical male nude or that of an emaciated female body, achieved through dieting. According to Nemser, Antin shows that the ideals on offer don't actually exist for women. Similarly, Joanna Frueh writes on *Carving* that "just as the Classical Greek nude occludes women's bodies in this kind of aesthetically rigid form, so the socially correct beautiful body disciplines and punishes women, through frustration, guilt, anxiety, and competitiveness with other women."[22]

However, these arguments overlook a crucial aspect of *Carving*, namely the ethnic subtext. Antin's photographic self-portraits depict an attractive, short Jewish woman. Thus, her body is far from being the generic female body. In my view, *Carving* sets up a challenge to the unacknowledged racial and ethical assumptions underlying Kenneth Clark's *The Nude: A Study in Ideal Form*.[23] Antin herself acknowledges that she was drawing on this study's account of the differences between the naked and the nude in the Western European painting tradition to bring the embattled subject of the unclothed body to a head in contemporary and feminist terms.[24] The piece plays off what Clark identifies as "the ideal"—the Greek, classical, white, male nude—and what he describes as the "alternative convention"—the Germanic, medieval, dark, naked female. Antin can be seen as inverting Clark's ideal nude by presenting herself in four different views and, as she puts it, "without my life, history, or achievements to give me courage, barely awakened from sleep, hair uncombed, not yet with a face to present myself to the world."[25] With the

reversal of Clark's opposition, "the naked" becomes a positive term, and it is here that Antin alludes to her Jewishness.

Carving's repeated photographic views also deliberately reference police or medical photographic and cinematic practices of the early twentieth century. These practices, in which discourses of physiognomy, photographic science, and aesthetics coincided and overlapped, targeted ethnic and social marginals, including many Jews. This connection between Antin's work and these practices is established through her use of a sequence of photographs that appear almost as film stills: the stills present her isolated body, which changes slightly from frame to frame, standing in four different poses against a stark white background in a seemingly exhaustive catalogue of her physical appearance. In this regard Antin's attempt to exert formal control over her own body in order to achieve the aesthetic ideal has also a great deal to do with societal constructions built upon body differences, a legacy not only of art history but also of the physiognomically based racial theories of the last century.

Antin plays off these early traditions in order to mark herself as Jewish. Cultural critic Sander Gilman, writing on the difference of the Jewish body, explains how medical theories of the nineteenth century included the notion of adaptability: "One form of that difference was [Jews'] uncanny ability to look like everyone else (that is, to look like the idealization of those who wanted to see themselves as different from the Jew)."[26] In this sense Antin's project can also be seen as a willful failure to adapt to the ideal feminist subject and thus a failure to assimilate as a generic subject. Antin doesn't offer an easy solution to the dilemma of being both Jewish and female, but she points to the limits of fitting in by presenting a series of anti-aesthetic photographic self-portraits that refuse to offer a neutral and undisturbing aesthetic experience.

Though less well known than *Carving*, Antin's *Domestic Peace*, 1971–72 (no. 16, opposite and pp. 40–41, 173), operates in a similar way, offering no easy closure to the problem of marked identities. Moreover, unlike other renowned works from the period, such as Judy Chicago's *Dinner Party*, 1979, which comfortably frames women within the spaces of dominant cultural aesthetic practices and Christian iconography, *Domestic Peace* allows Antin to explore the loaded subject of conflict in mother-daughter relations within the context of her own Jewish family. The piece consists of a written record, complete with oscillations on graphs, that Antin made of "interactions" with her mother during a weeklong visit. Given the fact that art-historical discourses tend to privilege references to the history of art and high culture over the popular and the everyday, it is not surprising that this project has received relatively little critical attention. According to Cindy Nemser, "The art world did not like it because it disrupted the whole romantic myth of the artist as someone who doesn't have the same everyday family connections as everyone else."[27]

At the time, avant-garde artists felt uneasy with *Domestic Peace* because it dealt with the taboo topic of bourgeois (Jewish) familial relations. Feminists also kept their distance because the piece was at odds with the then accepted feminist view of the mother-daughter bond as an unproblematic relation that was not threatened by feminism. Antin's description of her mother in this conceptual work highlights the fact that generational differences between Jewish women are not so conflict-free, and, indeed, the kind of independence that feminism offers women artists can become a divisive force, separating certain mothers and daughters:

> I live in California and from Nov. 29th to Dec. 15th, 1971—a period of 17 days—I planned to visit New York City with my husband and small child. We planned to stay with my mother in her Manhattan apartment. It would serve our economic and domestic convenience but was also an opportunity for me to discharge

REPRESENTED DURATION: 60 min.

me

S

mother

Nov. 29,
Recently we bought a green velvet love-seat.

from *Domestic Peace*, 1971–72
Checklist no. 16

familial obligations. However, though my mother insists upon her claim to the familial she is not at all interested in my actual life but rather in what she considers an appropriate life. No matter what kind of life a person leads he can always, by careful selection, produce an image corresponding to anyone else's view of appropriateness. By madly ransacking my life for all the details that suited my mother's theory of appropriateness and by carefully suppressing almost all the others, I was able to offer her an image of myself that produced in her 'a feeling of closeness'. It should be kept in mind that this closeness was a closeness to her theory rather than to her life but appeal to her didacticism was the only way to give her sufficient satisfaction to ensure the domestic peace necessary to free me for my own affairs. I planned a daily set of conversational openers consisting of carefully chosen stories. Several of these stories contained slightly abrasive elements which might be expected to mitigate peace. I considered these to be alternates for use only on 'good' days. For those hectic times when I would be forced to remain in the apartment for fairly long periods, I kept a set of reserves I could throw in to hold the line. Hopefully, these stories would act as gambits leading to natural and friendly conversation.

Antin's desired "domestic peace" could never be on her own terms nor could it ever conform to nostalgic feminist notions of harmony between mothers and daughters. Neither does it follow the more conservative, mythic script of the gifted (male) artist who does not need domestic peace, since he is seen as separate from economic, social, familial, sexual, and social relations. Antin provocatively casts mother-daughter relationships as the private sites of warfare, where female conflict is expected. Thus, in order to achieve "peace" whenever she was forced to remain in the house for long periods of time, Antin would stage conversations that

REPRESENTED DURATION: 7 hrs.

s
↓

me

mother

Dec. 15,

There arent any Salvation Army stores in California. The nearest
equivalent is Good Will, a disabled veterans outfit, but they're
expensive and the stuff is low class. Even if they had bargains
you wouldn't want them.

from *Domestic Peace*, 1971–72
Checklist no. 16

she believed would best coincide with what her mother considered revealing of an appropriate middle-class life—for example, a sixty-minute discussion of the artist's purchase of a green velvet love seat (p. 171).

These conversations, which specified a white Jewish ethnicity situated in middle-class affluence, were short and peaceful in comparison with others that deviated from her mother's notion of middle-class success. The latter type is exemplified by a seven-hour agitated interaction between the mother and daughter (p. 173): Antin discourages her mother from shopping at Goodwill stores because the "stuff is low class." Trying to gain her mother's acceptance, she ventures, "Even if they had bargains you wouldn't want them." The conversations that incite the strongest disagreements between mother and daughter, however, explore ideological conflicts in the workplace between middle-class Eastern European Jews and African Americans or that delve into class and even racial tensions within the Jewish community.

Domestic Peace reveals how harmony and calm between mother and daughter come only at the price of the artist's own "silence." Yet, the comic form of the project—the pseudoscientific way it meticulously records Antin and her mother's reactions—enables the artist to lighten the oppressiveness of the relationship.

In this respect *Domestic Peace* has much in common with *4 Transactions*, 1972 (no. 17, p. 39), which also deals with the problematic bonds between women but this time in a setting that ordinarily would not allow much space for the examination of their differences—a feminist group of working women artists in San Diego in 1972 and 1973. The performances consisted of four meetings in which Antin had decided on a particular course of action in advance. The artist also had a text description of her preplanned actions notarized before attending the meetings. *Encounter # 1* provides an example:

At the February 20th meeting, I shall take on the job of ombuds-man. This will necessitate my pointing out to each member of the group, and in any manner I choose, a particular failing she displays in relation to the others. These may be of an ephemeral sort such as personal bugginess taken out on someone else or of a more seri-ous nature like, say, a rip-off of the entire group. I must always keep in mind that my statements are intended to bring about more satisfactory behavior from the others and are never used for ego-tistical purposes of my own. I must complete these 8 tasks before the group normally disperses, otherwise I must keep the session going by whatever means I can until I do complete them.

What makes this piece unusual for the time is the way in which Antin perversely performs the problem that she claims to identify and remedy. At first glance the use of the official rhetoric of the notary docu-ment, with its seal and signature, seems to suggest female authoritarian behavior referencing a legal discourse that subjects the women in the group to unexpected scrutiny and observation. In fact, Antin's use of such a device has the effect of dislodging the women from the pretense of a safe utopian environment and reestablishing them within the context of the more complex pressures that the art world and academia present for fem-inists such as Antin (a university professor): hierarchy, competition, and distrust on the one hand; coalition, mentorship, and respect on the other. Moving beyond simple utopian feminist art projects of the period, Antin's piece stages the complex relations of betrayal, knowledge, and power between women and reminds the viewer of the more unsightly side of feminism. The fact that the text pieces were done in secret and have never been publicly shown before this retrospective exhibition is revealing: it suggests that even within a progressive social movement such as femi-nism, many issues could be examined only with great difficulty, if at all.

Despite the rhetoric of openness that seemingly prevailed, problems and imbalances within the movement were not addressed, and thus women artists like Antin were not willing to risk being misunderstood or being perceived as disloyal to their peers or to the larger feminist public audience.

Antin's sculptural series *Portraits of Eight New York Women*, 1970 (nos. 9–11, pp. 33, 178–79), which combined text with objects to offer biographies of eight New Yorkers, also confronts one of the seemingly insoluble dilemmas presented by women's relations with other women: that is, how a woman artist's use of other women as the subject of portraiture can itself become a source of tension. In these portraits Antin addresses the certainty that women are confronted by dual, if not multiple, allegiances. For women artists to take feminism seriously, they must be committed to a policy of transformative representation, but given the male-dominated New York art world and the fact that Antin was then teaching at the University of California, San Diego, it is clear that she was obligated to please mostly male reviewers and exhibition curators (even if her art projects to a certain extent did entail the transformation of those very institutions and galleries that she depended on for her success).

Writing on *New York Women* in *Artnews* in 1971, Antin provides some insight into her process. She does not insist on a sisterhood grounded in a sense of common oppression; rather, her interest lies in the different and complex activities and functions generated out of women's lives:

> I am determined to present women without pathos or helplessness. Since a life style is the ability to recognize in the morning the same person who went to bed at night, it can be said to be a person's most important decision. My women had all chosen life styles independent of men's. It is true that some life styles proved more successful in practice than others, but they were all interesting and complex enough to be worth the try.[28]

Citing Linda Nochlin's pathbreaking essay, "Why Have There Been No Great Women Artists?" Antin writes, "I agree with Linda Nochlin that the question 'Why have there been no great women artists' is a useless one and that there are very real questions to be considered about the relation of women to the arts."[29] Though the questions that concern Antin are the same ones that concerned most female artists of the period, including how to present women differently so as to challenge their construction in canonical histories of art, what made her work especially unusual was its ethnic inflection and its insistence on presenting women "without pathos or helplessness." In *New York Women,* Antin wants to tell a different tale about the women of that time and place, one that deals directly with the influence of the U.S. media on issues of assimilation, glamour, Americanness, and ideals of female beauty. For this exhibition, she writes, "I deliberately chose expensive, shiny, glamorous objects. I chose bright colors, reds, and pinks. And as much chrome as possible. I didn't want the viewer to come too close. We women have had enough love. Frank O'Hara said once that he loved Marilyn Monroe. Protect us from such love!"[30]

Antin's comment about Marilyn Monroe evokes the underlying ethnic theme of her project; it reveals the ambiguous boundaries between Marilyn, *the* American sex symbol of the early 1950s, and the more marginal, mostly Jewish white women artists, gallery workers, and critics whom Antin represents in *New York Women.* By building up images of these women from carefully chosen "brand-new American manufactured goods,"[31] Antin is also referencing the influence of U.S. mass media, which attempted to secure white, American middle-class values through the marketing of model homes and new consumer goods in the formative years of the post–World War II era.

Antin's *New York Women* ironically examines the process through which a generic home and its shiny objects become signifiers of national and familial identity as well as female beauty and proper behavior, a

Naomi Dash, from *Portraits of Eight New York Women*, 1970; replicated 1998
Checklist no. 9

Lynn Traiger, from *Portraits of Eight New York Women*, 1970; replicated 1998
Checklist no. 11

Photograph by Peter Moore

Photograph by Peter Moore

Ruth Moss used to live in an old house on Cornelia
Street. There were still slave quarters rotting in
the backyard. Whenever she heard the fire engines
(usually in the middle of the night) she would grab
Rasputin with one hand, her box of sterling with the
other and still dressed in her night clothes rush
down the 5 flights to the street.

Her friend was dying so she took a
Greyhound Bus to Guadaloupe. But
first she stopped off to visit with
us. We talked most of the night. She
used to open her heart in this way
to Frank O'Hara when they were both
at the Museum of Modern Art. Once he
grabbed her in the middle of a
crowded party, forced back her head
and planted a passionate kiss on her
mouth. It lasted perhaps several
minutes. He always singled her out.
She missed him.

Photograph by Peter Moore

One summer Hannah bought a lot in Springs. An Art Director had bought the adjoin-
ing lot next door. Martin Carey was considering buying on the other side but
changed his mind, and several years later moved to Woodstock. A few miles away
Armand Schwerner owned 1/3 of a lot and was in the process of buying out his part-
ners. They all told her it was a great buy. She couldn't lose. All the lots were
covered with scrub, pink oak, swamp maple, white pine. Everyone was going to clear
off just enough to build. Hans, who lived in the marsh, bought some wooded proper-
ty, got married, and began building a 2-story house with an open porch on the top
level. Allan and Sylvia D'Arcangelo drove around looking and pricing. Tania and
her husband were rebuilding an old barn in a small weed while Aaron Kuriloff had
just completed his cinder-block and glass house on the other side of Springs.
Allan Planz bought a place in the swamp between Sag Harbor and Easthampton and
David Ignatow bought one over on Gardiner with his Guggenheim money. There were
other people who had bought long ago and were now sitting pretty. Paul Georges
painted mornings and played chess in the afternoons with Paco Sainz on the Coast
Guard Beach. Manufacturer and gallery owner Sam Dorsky played a wild game of
poker. There was a rich woman named something like Jean-Christophe who gave par-
ties sometimes and sponsored events. In an important baseball game - writers
against artists - the writers turned out to be ad men. They were in their 30's and
won because the artists were in their 50's, with the exception of Jim Dine who
played for keeps. Esteban Vicente wandered under a pop fly and made a double play
when the ball fell out of his hand. Pink-trousered Harold Rosenberg was nearly hit
by a foul. Various attached women walked in and out of the house. The plan was
that Hannah would build later when she could raise the money. The Art Director
set up a tent under his trees and lived there with his children and girlfriends.
Hannah continued to live in a rented house in Amagansett but her mortgage payments
were very low so she was able to pay them out of her unemployment insurance.

process through which toiletries are the stuff of dreams of assimilation, national belonging, and female desirability. Although most of the women in this project were single, urban, white ethnic women, pursuing independent careers in the arts and living in modest New York apartments with little room and few modern conveniences, Antin captured their complex lives using consumer goods. The kinds of consumer objects Antin used were similar to ones that are typically associated with more traditional women, yet Antin's subjects make these otherwise mute objects their own in unexpected ways. In her portrait of Yvonne Rainer, for example, Antin chooses a new chrome exercise bicycle that might have comfortably existed in a suburban basement or garage. Such a stationary object—especially one with a superfluous basket and horn—takes on a completely different meaning in its connection to Rainer, who was one of the best-known postmodern dancer-choreographers with Judson Dance Theater. Rainer was known for her early experiments with vernacular movement and repetition as a means to break down the traditional vocabulary of classical modern dance.

Antin's portraits go against the grain of the period, for while she renders likenesses among the women, she does not necessarily propose that their experiences are identical, in kind or degree. Moreover, her portraits tend to focus neither on women's oppression nor on women's heroic and exemplary qualities. They are more everyday. What distinguishes the women are their idiosyncrasies. In several of the more disturbing portraits (say of Hannah Weiner or of Lynn Traiger) Antin presents women who are ill armored against the difficulties associated with trying to create interesting, independent lives for themselves. Weiner, a lingerie designer and poet, is represented by a perfect little breakfast nook, with striped upholstered chairs, a teapot, and an elegant wrought iron gate outside a window (p. 179). Antin conveys Weiner's vulnerability and repressed anger by placing a large hammer on the dainty breakfast table, introducing a disturbing flaw in the otherwise perfectly appointed interior.[32]

In certain ways Antin's work reveals her interest in addressing the discourse of modernism, even if only to critique and occasionally reference it, as she does in her late-1970s invented autobiography of the black ballerina Eleanora Antinova from Diaghilev's Ballets Russes. Moreover, there is a tendency in Antin's work to mime and parody whiteness, as in the bright, perfectly immaculate but empty spaces of her portrait of Hannah Weiner in *New York Women,* and this tendency complicates the relations between the universalizing discourses of feminism and modernism that she is in part situated within. Spareness and coolness in Antin's work distance it from the typically cluttered interiors and traditionally melodramatic theatrical gestures of immigrant Eastern European Jewish culture and from the presumed high emotional content of Jewish ethnic relationships. Conflict, anger, and disagreement among women are literally mapped by codes, graphs, notarized documents, or the perfectly cool interiors and objects in *New York Women.* Official documents and stereotypical domestic interiors stand in for the pressure to assimilate and adopt the relatively more controlled body language of Anglo-American Northern European culture, which has stigmatized expressive gestures and clutter as signs of backward, uncultivated societies. Antin's projects satirize bourgeois codes of American etiquette, privacy, politeness, and good manners in a way that reduces these conventions to their hypocritical core. Even the U.S. women's movement does not escape Antin's critical scrutiny in this regard.

Not surprisingly, the intersections of race with ethnicity and gender do not appear in the work discussed so far; even in *4 Transactions* Antin speaks about differences among women in a feminist space occupied exclusively by white ethnic, Euro-American, middle-class women. Only in her invented autobiographies, each of which creates a character and a history, does she deal directly with other kinds of difference. In

many of Antin's performances she deliberately situates herself in the margins and plays roles that shift between invented and real figures— the seventeenth-century English king Charles I who becomes the King of Solana Beach in San Diego, California; Florence Nightingale, who is the impetus for the Little Nurse, who later transforms into Eleanor Nightingale; or in the case of the piece that I will discuss, the black prima ballerina from the Ballets Russes, Eleanora Antinova. Before dealing with the specifics of Antin's blackface performance, however, it is useful to look at Richard Dyer's description of the ballerina as the epitome of whiteness:

> The white woman as angel was . . . both the symbol of white virtuousness and the last word in the claim that what made whites special as a race was their non-physical, spiritual, indeed ethereal qualities. It held up an image of what white women should be, could be, essentially were, an image that had attractions and drawbacks for actual white people. . . . The ambiguity of the image is caught in the figure of the ballerina in the Romantic ballet (and the related genres of *féerie,* pantomime, and burlesque), where the soft, flaring gaslight caught and was diffused by the fluffed up, multiple layers of the tutu, introduced in the mid-nineteenth century. Together with scenarios about sprites and the use of pointe work (ballerinas seeming to dance on the tips of their toes and thus to be weightless), the Romantic ballet constructed a translucent, incorporeal image.[33]

Dyer connects nineteenth-century representations of the ballerina with notions of femininity, virtuousness, whiteness, and disembodiment. Antin seems to be working out of similar assumptions, describing the ballet as a "white machine," but then attempts to translate herself across racial boundaries by constructing herself as "black." She thus avoids conforming to the image of what an unmarked white woman performer

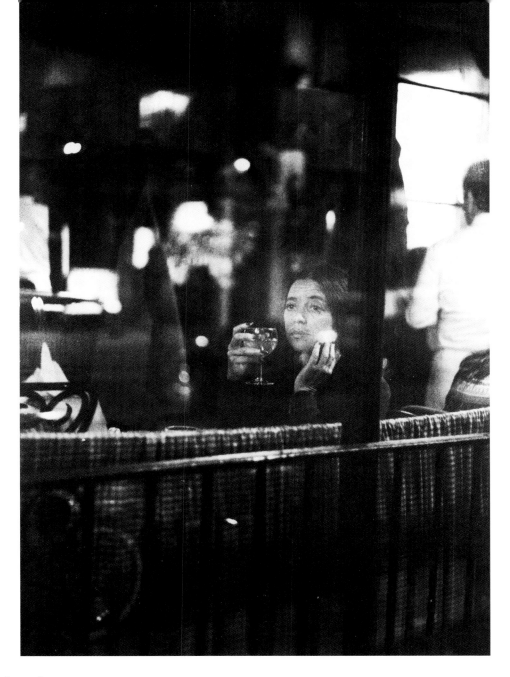

Being Antinova, 1981

should be: "I have a curved spine, my breasts are too large, my legs too short, my feet are weak, they bleed after pointe work, my skin is too dark to be a ballerina. Ballet is, after all, a white machine. There's very little room for life in it. I was a black face in a snowbank."[34] By representing herself as black, rather than what she is—white and Jewish—Antin seems to suggest that Jews like herself, who have assimilated to the point that they are now indistinguishable in appearance from dominant white Americans, can no longer be imagined as having parents or grandparents who were seen in terms of arbitrary racial distinctions. Thus Antin dresses up in blackface to point out that Jewish stereotypes and discrimination against Eastern European Jews earlier in the century are ideologically akin to such treatment of blacks.

Though Antin's black ballerina, Antinova, is from Diaghilev's Ballets Russes, she not only descends from the world of modern dance, but from a whole tradition of U.S. vaudeville theater, in which Jewish women as well as black women were seen as exotic and erotic spectacles. Antin both references and disrupts these images in her work, and her affinity with Antinova goes beyond an interest in presenting her as a mere spectacle. Antinova's memoirs, penned by Antin, present a complex commentary on the marginalization of both Jewish women and black women in exoticized modern dance and performance productions, such as those Diaghilev's Russian ballet company helped to shape and create. In this respect the piece shares affinities with Antin's earlier *4 Transactions* in its perverse performance of the stereotypes she claims to identify and remedy. The roles Antin creates for Antinova are parodies of the kinds of roles an African-American or European Jewish ballerina might have been compelled to perform by a European dance company: for example, Antinova as a slave girl in a ballet where she doesn't move her feet. Antin's Antinova is a comment on the exoticization of Jews and blacks within European modernist ballet. The performance challenges whiteness itself and its class

system as a defining set of normative high cultural practices against which all others are measured and into which all are expected to fit. Her parodic performance of Marie Antoinette as the shepherdess (the queen masquerading as the working-class other), for example, ironically reviews an older form of appropriating otherness, thus disrupting any notion of a transcendent position of whiteness that can be easily occupied.

If the power of the works by Antin that I have shown seems somewhat contingent on reading in the ethnic, racial, and gendered themes, it is important to note that Antin is currently constructing herself more self-consciously as white and Jewish in her recent work: the installation *Vilna Nights*, 1993 (no. 43, pp. 143, 145–47), and *The Man without a World*, 1991 (no. 42, pp. 139–41), a wonderful simulation of a silent-era Yiddish film.[35] *The Man without a World* is consistent with some of her earlier works: Antin looks at the rich shtetl life of Poland in a satirical way, a strategy that is linked to the presentation of the heterogeneity of identities among women in her earlier projects. In the film, however, Antin emphasizes the diversity of identities among Jews as well as the tensions they face living in a world of interlocking oppression, both from within and outside the Jewish community. The film provides new insights into the lives of Jews in Eastern Europe and especially into the conflicts between Jewish tradition and assimilation. By preserving the problems—the limited choices for Jews overall and the especially confining roles for Jewish women as either virgins, mothers, or whores—Antin resists romanticizing an older Jewish culture, a so-called vanishing world. It is worth noting that Antin, the daughter of a former actress in the Yiddish theater in Poland (who was also a passionate communist) and a socialist, fiercely atheist father, is also referencing her own generational struggles as a non-religious American Jew, a woman, and a filmmaker. She rethinks an older Jewish Eastern European world where women were not able to participate fully outside prescribed stereotypical feminine roles. Although Antin names the film

The Man without a World and presents it as a "recently rediscovered" film by a forgotten male Jewish film director, Yevgeny Antinov, the untraditional and sometimes irreverent way that the female characters are presented suggests a feminist point of view.

Antin's interest in questions of immigration suggests that second-generation Jews like herself—of Eastern European and Russian descent, but born in the U.S.—did retain their cultural ties to the nations they came from as well as an allegiance to Jewish culture and history. Indeed, Antin's work provides a rare example of a white woman dealing with questions of feminism, assimilation, and Jewishness from the 1970s to the present. One of the recurring pleasures of her work is the way that, through the use of performance as a critical strategy, she transforms conventional social roles into complicated relationships laced with humor and irony. At the same time, her notion of the performative also highlights the open-endedness of questions connected to identities, since it acknowledges her ambivalence at positioning herself or others as fixed, stable identities that can be fully knowable or controlled.

In placing Antin's work in historical perspective in terms of gender and ethnicity, I have attempted to provide a richer account of her work as well as her struggles as a Jewish artist who played a decisive role in the first wave of conceptual feminist art in the U.S. Besides her contribution to this wider social movement in the arts, Antin deserves attention as a committed artist and as an irreverent and original thinker, who is determined to follow her own independent path.

This article is dedicated to the memory of Kathy Acker, a former colleague from the San Francisco Art Institute, whose work was in part influenced by Eleanor Antin's. It was Kathy Acker who initially suggested that I contact Eleanor Antin about my own work on Jewish identities and feminist art.

Lisa E. Bloom is an associate professor in women's studies and comparative cultures at Josai International University in the Chiba prefecture, Japan.

Portions of this paper are published in the following places: "Ethnic Notions and Feminist Strategies of the 1970s: Some Work by Judy Chicago and Eleanor Antin," *in* Jewish Identity and Art History, *ed. Catherine Soussloff (Berkeley and Los Angeles: University of California Press, 1999)* and *"Contests for Meaning in Body Politics and Feminist Conceptual Art: Revisioning the 1970s through the Work of Eleanor Antin," in* Performing the Body/Performing the Text, *ed. Amelia Jones and Andrew Stephenson (London: Routledge, 1999). A Japanese-language version of the latter essay appears under the same title in* Rim: Pacific Rim Women's Studies Association Journal *(Josai International University, Chiba-ken, Japan) 7, no. 1 (March 1998): 46–70.*

1. Miriam Schapiro, *Anonymous Was a Woman: A Documentation of the Women's Art Festival, A Collection of Letters to Young Women Artists* (Valencia, California: Feminist Art Program/California Institute of the Arts, 1974), 53.

2. Ibid.

3. Ibid., 66.

4. Antin quotations from *Anonymous Was a Woman* appear on p. 58.

5. For further background on the feminist art programs active in Los Angeles in the early 1970s, see the California Institute of the Arts exhibition, *The F-Word: Contemporary Feminisms and the Legacy of the Los Angeles Feminist Art Movement* (October 1998; curator, Nancy Buchanan).

6. *Anonymous Was a Woman*, 54.

7. See Linda Nochlin's groundbreaking article, "Why Are There No Great Women Artists?" in *Women in Sexist Society,* ed. Vivian Gornick and Barbara Moran (New York: Basic Books, 1971); reprinted as "Why Have There Been No Great Women Artists?" *Artnews* (January 1971), and in *Art and Sexual Politics,* ed. Thomas B. Hess and Elizabeth C. Baker (New York: Collier, 1973), 1–43.

8. For background on the impact feminism had on the arts in the U.S. during this period, see *Sexual Politics: Judy Chicago's "Dinner Party" in Feminist Art History,* ed. Amelia Jones (Berkeley and Los Angeles: University of California Press, 1996). For Britain, see *Framing Feminism: Art and the Women's Movement 1970–1985,* ed. Rozsika Parker and Griselda Pollock (London: Pandora, 1987). For a thoughtful assessment of the current status of feminist art, art criticism, and arts education in the U.S. and the U.K., see *New Feminist Art Criticism,* ed. Katy Deepwell (Manchester and New York: Manchester University Press, 1995).

9. For two excellent examples of how a feminist political project effected the rethinking of art history, see Whitney Chadwick, *Women, Art, and Society* (New York: Thames and Hudson, 1997); and Griselda Pollock, *Vision and Difference: Femininity, Feminism, and the Histories of Art* (New York: Routledge, 1988).

10. See *Confessions of the Guerrilla Girls* (New York: HarperCollins, 1995) for the poster campaigns and activities of the Guerrilla Girls, an anonymous group of U.S. feminist political artists formed in 1985 to specifically critique racist and sexist art-world institutional practices.

11. For examples of available writings on the arts by Third World women and U.S. women of color, as well as ethnic white women, see *With Other Eyes: Looking at Race and Gender Politics in Visual Culture,* ed. Lisa Bloom (Minneapolis: University of Minnesota Press, fall 1999); and Michele Wallace, "Why Are There No Great Black Artists? The Problem of Visuality in African-American Culture," in *Black Popular Culture* (Seattle: Bay Press, 1992), 333–46. For more on lesbian feminism, see *Stolen Glances: Lesbians Take Photographs,* ed. Tessa Boffin and Jean Fraser (London: Pandora, 1991).

12. It might be worthwhile to rethink the term "Jewish" with a capital *J,* especially since it is often used to reinforce the notion in mainstream American culture that "Jewishness" is strictly a religious identity. Also, though I focus in this essay on Eleanor Antin, a Jewish-American woman of Eastern European and Russian descent based in the U.S., it is important to emphasize the diversity of the Jewish diasporic community. Consider, for example, the marked differences between German and Eastern European Jews (many of whom did not speak English in the mid-1940s), or the complicated status of a Jewish Iraqi in the U.S. today.

13. Providing a critical account of the cultural aspect of Jewishness in the work of many U.S. Jewish artists and critics from the 1930s to the present is part of my current book project, *Ghosts of Ethnicity: Rethinking Ethnicity, Nationalism, and Feminist Art Practices in the U.S.*

14. See Sander Gilman, *The Jew's Body* (New York: Routledge, 1991); Ann Pellegrini, *Performance Anxieties: Staging Psychoanalysis, Staging Race* (New York and London: Routledge, 1997); and Richard Dyer, *White* (London: Routledge, 1997).

15. Introduction to *The Power of Feminist Art: The American Movement of the 1970s, History and Impact,* ed. Norma Broude and Mary D. Garrard (New York: Harry N. Abrams, 1994), 10.

16. Yolanda M. López and Moira Roth, "Social Protest: Racism and Sexism," in *The Power of Feminist Art,* 140.

This article is dedicated to the memory of Kathy Acker, a former colleague from the San Francisco Art Institute, whose work was in part influenced by Eleanor Antin's. It was Kathy Acker who initially suggested that I contact Eleanor Antin about my own work on Jewish identities and feminist art.

Lisa E. Bloom is an associate professor in women's studies and comparative cultures at Josai International University in the Chiba prefecture, Japan.

Portions of this paper are published in the following places: "Ethnic Notions and Feminist Strategies of the 1970s: Some Work by Judy Chicago and Eleanor Antin," in Jewish Identity and Art History, *ed. Catherine Soussloff (Berkeley and Los Angeles: University of California Press, 1999)* and *"Contests for Meaning in Body Politics and Feminist Conceptual Art: Revisioning the 1970s through the Work of Eleanor Antin," in* Performing the Body/Performing the Text, *ed. Amelia Jones and Andrew Stephenson (London: Routledge, 1999). A Japanese-language version of the latter essay appears under the same title in* Rim: Pacific Rim Women's Studies Association Journal *(Josai International University, Chiba-ken, Japan) 7, no. 1 (March 1998): 46–70.*

1. Miriam Schapiro, *Anonymous Was a Woman: A Documentation of the Women's Art Festival, A Collection of Letters to Young Women Artists* (Valencia, California: Feminist Art Program/ California Institute of the Arts, 1974), 53.

2. Ibid.

3. Ibid., 66.

4. Antin quotations from *Anonymous Was a Woman* appear on p. 58.

5. For further background on the feminist art programs active in Los Angeles in the early 1970s, see the California Institute of the Arts exhibition, *The F-Word: Contemporary Feminisms and the Legacy of the Los Angeles Feminist Art Movement* (October 1998; curator, Nancy Buchanan).

6. *Anonymous Was a Woman,* 54.

7. See Linda Nochlin's groundbreaking article, "Why Are There No Great Women Artists?" in *Women in Sexist Society,* ed. Vivian Gornick and Barbara Moran (New York: Basic Books, 1971); reprinted as "Why Have There Been No Great Women Artists?" *Artnews* (January 1971), and in *Art and Sexual Politics,* ed. Thomas B. Hess and Elizabeth C. Baker (New York: Collier, 1973), 1–43.

8. For background on the impact feminism had on the arts in the U.S. during this period, see *Sexual Politics: Judy Chicago's "Dinner Party" in Feminist Art History*, ed. Amelia Jones (Berkeley and Los Angeles: University of California Press, 1996). For Britain, see *Framing Feminism: Art and the Women's Movement 1970–1985*, ed. Rozsika Parker and Griselda Pollock (London: Pandora, 1987). For a thoughtful assessment of the current status of feminist art, art criticism, and arts education in the U.S. and the U.K., see *New Feminist Art Criticism*, ed. Katy Deepwell (Manchester and New York: Manchester University Press, 1995).

9. For two excellent examples of how a feminist political project effected the rethinking of art history, see Whitney Chadwick, *Women, Art, and Society* (New York: Thames and Hudson, 1997); and Griselda Pollock, *Vision and Difference: Femininity, Feminism, and the Histories of Art* (New York: Routledge, 1988).

10. See *Confessions of the Guerrilla Girls* (New York: HarperCollins, 1995) for the poster campaigns and activities of the Guerrilla Girls, an anonymous group of U.S. feminist political artists formed in 1985 to specifically critique racist and sexist art-world institutional practices.

11. For examples of available writings on the arts by Third World women and U.S. women of color, as well as ethnic white women, see *With Other Eyes: Looking at Race and Gender Politics in Visual Culture*, ed. Lisa Bloom (Minneapolis: University of Minnesota Press, fall 1999); and Michele Wallace, "Why Are There No Great Black Artists? The Problem of Visuality in African-American Culture," in *Black Popular Culture* (Seattle: Bay Press, 1992), 333–46. For more on lesbian feminism, see *Stolen Glances: Lesbians Take Photographs*, ed. Tessa Boffin and Jean Fraser (London: Pandora, 1991).

12. It might be worthwhile to rethink the term "Jewish" with a capital *J*, especially since it is often used to reinforce the notion in mainstream American culture that "Jewishness" is strictly a religious identity. Also, though I focus in this essay on Eleanor Antin, a Jewish-American woman of Eastern European and Russian descent based in the U.S., it is important to emphasize the diversity of the Jewish diasporic community. Consider, for example, the marked differences between German and Eastern European Jews (many of whom did not speak English in the mid-1940s), or the complicated status of a Jewish Iraqi in the U.S. today.

13. Providing a critical account of the cultural aspect of Jewishness in the work of many U.S. Jewish artists and critics from the 1930s to the present is part of my current book project, *Ghosts of Ethnicity: Rethinking Ethnicity, Nationalism, and Feminist Art Practices in the U.S.*

14. See Sander Gilman, *The Jew's Body* (New York: Routledge, 1991); Ann Pellegrini, *Performance Anxieties: Staging Psychoanalysis, Staging Race* (New York and London: Routledge, 1997); and Richard Dyer, *White* (London: Routledge, 1997).

15. Introduction to *The Power of Feminist Art: The American Movement of the 1970s, History and Impact*, ed. Norma Broude and Mary D. Garrard (New York: Harry N. Abrams, 1994), 10.

16. Yolanda M. López and Moira Roth, "Social Protest: Racism and Sexism," in *The Power of Feminist Art*, 140.

17. For a fuller discussion of the issue of women's Jewish identities, see Lisa Bloom, "Ethnic Notions and Feminist Strategies of the 1970s: Some Work by Judy Chicago and Eleanor Antin," in *Jewish Identity and Art History,* ed. Catherine Soussloff (Berkeley and Los Angeles: University of California Press, 1999).

18. Arlene Raven and Deborah Marrow, "Eleanor Antin: What's Your Story?" *Chrysalis: A Magazine of Women's Culture* 8 (summer 1979): 44.

19. Ann-Sargent Wooster, *The First Generation: Women and Video, 1970–75* (New York: Independent Curators Incorporated, 1993), 21.

20. Ibid., 41. (Originally cited in Eleanor Antin, "Dialogue with a Medium," *Art-Rite* 7 [autumn 1974]: 23–24.)

21. Cindy Nemser, "Eleanor Antin," in *Art Talk* (New York: Scribners, 1975), 281.

22. Joanna Frueh, "The Body through Women's Eyes," in *The Power of Feminist Art,* 195.

23. New York: Pantheon, 1956.

24. Unpublished correspondence with the artist, October 1998.

25. Ibid.

26. Sander Gilman, "The Jew's Body: Thoughts on Jewish Physical Difference," in *Too Jewish: Challenging Traditional Identities,* ed. Norman Kleeblatt (New Brunswick, New Jersey: Rutgers University Press, 1996), 70.

27. *Art Talk,* 282.

28. Eleanor Antin, "Women without Pathos," *Artnews* (January 1971): 3–4; reprinted in *Art and Sexual Politics,* 86–87.

29. Ibid.

30. Ibid.

31. Ibid.

32. In some ways this project resembles Elaine Reichek's *Post-Colonial Kinderhood,* 1993, displayed at the Jewish Museum, New York City. Both works are ironical portraits that deal simultaneously with questions of assimilation, domestic interiors, and white ethnic female lives.

33. *White,* 129–31.

34. Quoted in Henry Sayre's introduction to *Eleanora Antinova Plays* (Los Angeles: Sun & Moon Press, 1994), 13.

35. For an excellent review of the film, see Jeffrey Skoller, "The Shadows of Catastrophe: Eleanor Antin's *The Man without a World," Film Quarterly* 49, no. 1 (fall 1995): 28–32. See also Ellen Zweig, "Constructing Loss: Film and Presence in the Work of Eleanor Antin," *Millennium Film Journal* 29 (fall 1996): 34–41.

A DIALOGUE WITH ELEANOR ANTIN

Howard N. Fox

The setting:
The artist's studio on the campus
of the University of California, San Diego, in La Jolla,
March 19, 1998.

FOX:

Eleanor, before you were a visual artist
you had professional aspirations to be an actress. What
made you decide to become a visual artist?

ANTIN:

Actually, I think they were always related.
From the beginning, even before I wanted to be an
actress, I knew I was an artist. Maybe I was eight years old,
but I knew it. Like in school—I made pictures, I wrote lit-
tle poems. We were studying astronomy, and I had to
make a report on the constellation Cassiopeia. Instead I
wrote a poem about her, so I could write about Greek
mythology and make up stories and not have to spend
too much time on science and light-years and all that
stuff! I never obeyed the rules too much, but it was a pro-
gressive school, so they pretty much left me on my own,

191

making pictures, writing stories, acting. They even used to let me read the Bible aloud in assembly once a week—until I laughed once, and they never invited me again. I read it very sternly: "Yea, though I walk through the valley of the shadow of death, I will fear no evil: for thou art with me ..." One day that struck me as very funny, and I just fell into hysterics. So they fired me. I guess even in those baby days I had my calling. Causing trouble.

Then I went to Music and Art High School, where I was an art major, and then on to City College of New York, where I majored in writing and minored in art. But I quit CCNY in my last year when I got a job with a traveling road company as an actor in William Inge's *Bus Stop*. I didn't play the Marilyn Monroe part. In the play there was a very nice role for a waitress, a real role. In the movie it was wiped out, but in the play it was a nice role.

FOX:
And you had a stage name.

ANTIN:
Eleanor Barrett, like Elizabeth Barrett.
My kid sister, Marcia, who also wanted to be an actor, changed her name first. She was about fourteen and had her first part-time job in a hospital, and she got her Social Security card under the name Lee Barrett. So we figured we had to be the same, the Barrett Sisters, and I became Eleanor Barrett.

FOX:
And why the name Barrett?

ANTIN:
Because of Elizabeth Barrett,
though I hated her poems. I liked Emily Dickinson much better—or T. S. Eliot, who was my favorite poet—but that didn't seem to matter. It was a done deal, and we became

the Barrett Sisters. I was registered as Eleanor Barrett in Actors' Equity, but in fact it would have been easy to drop the stage name when the Living Theater asked me to join them. They were building their first theater downtown, around 14th Street, and they were going to have the usual Off-Broadway limited-Equity contract: a couple of Equity people, like Judith [Malina] and Julian [Beck], and the others would be non-paid, or low-paid, slaves. When they asked me to come on board, I said, "Well, I'm Equity." So they said, "No problem, just change your name." "Change my name?" I got very indignant and ultimately refused. When I think back now, I wonder why I got so uptight, because it was a fake name to begin with. It would have been very easy to go back to being Eleanor Fineman, though in those days an ethnic name wasn't respectable for an actress—unless you were a character actor. It's not like now, when it's the thing. But, you know, when you're starting out, you want to be professional, you want to do things the "right" way. That was probably the first and last time I ever did anything the "right" way, and it made me miss my chance to go around the world with Malina and Beck. I think I would have enjoyed myself, too. So I went back to my miserable little "correct" career, a little work here, there, little things.

My favorite acting job was at an NAACP convention at the new convention center in New York during the civil rights movement. I was represented in the Actors' Equity book with a photo that I thought looked rather glamorous, kind of dark and exotic. One day I got this call from Ossie Davis, asking would I audition for a role in a play he was producing for the convention about Rosa Parks, the woman who refused to sit in the back of the segregated Montgomery buses, which started off the civil rights demonstrations. So—I'm an old radical—I said, "Yeah," and I went for the audition. When I walked in, everyone there was black, and they began to stare at me, and I started to laugh, and the next thing we were all laughing,

including Ossie—he's a darling guy—and he says, "Well, have a seat." So there I was together with these black actors, and I ended up playing the role of a bitchy white woman who wanted her maid to ride the buses so she could come and clean my house and take care of my kids. I was really good as the person you loved to hate. I came in looking like a Southern belle with this big white hat and a tight pink dress and cute little wedgies. I was really good in the part, and Ossie kissed me after the play. We all had a ball; the audience was great. I remember Governor Rockefeller was there, and he laughed a lot. It was a fun experience.

Unfortunately, if I was working at all, it was mostly stupid stuff. I remember doing a TV pilot for children, in which I was Joan of Arc. But because they thought they shouldn't make children unhappy, she didn't get burned at the end! She just went off with the Dauphin and everybody was happy. It was so stupid! Since Joan was just a kid, I figured it would work if I played her athletically—whatever that meant in the fifteenth century. But the director kept saying [*with mock high seriousness*], "Piety, my dear, piety." He literally wanted me to keep my nose in the air, I guess to seem more saintly. And I thought to myself—remembering that I had one more term at college to get my degree and registration for classes was coming up and maybe I should go back to school—I thought, if he says that one more time, I'm out of here. And he said it: "Piety, my dear." And I said, "That's it!" I quit and walked out. I was modeling for artists to support myself at the time, and I was embarrassed to tell them I was an actor because people thought actors were stupid. So I decided I wanted to be a writer again, and I went back to school. This must have been about late '59 or something. I can't remember. We're talking about so much life packed into only a couple of years, all very intense and crowded.

Too much water under the bridge. I can't remember unimportant things like dates. But I went back to school

and became a writer. I remember spending a summer on Fire Island writing poems that I planned to sell to the *New Yorker* and make a lot of money. [*laughter*]

FOX:
How did you meet David Antin?

ANTIN:
I met him when he was a student at CCNY. He was a couple of years ahead of me, and he had already been there for seven years, always taking new majors, and he didn't want to leave. He was there forever, until they kicked him out—they graduated him. He said, "I didn't take Math 101, how could I graduate?" And they said, "Yeah, but you took Math 750. Out!" So they got rid of him. I had met him there in writing classes, and David introduced me to the poets Jerry Rothenberg and Robert Kelly, who were also at City—it was so great there—and we all hung around the cafeteria together. I can't remember all the poets and writers and actors, we knew so many. Actually, David opened a poetry bookshop—the Blue Yak—with Jerry, and I think Robert, and I seem to remember Rochelle Owens and George Economou also. Brata Gallery, the artists' co-op, was right around the corner on 10th Street, and a custom tailor specializing in clothes for fat guys was next door. David and I were good friends all this time, always going around with other people. It was a couple of years later that we got together and I moved in with him. Sometime in 1961, I think.

FOX:
So this is all when David was a poet and before he became involved in the art world as a critic. But what was your own early involvement in the art world? You were an actor and a writer, but you also minored in art at CCNY. Did you continue to paint after you graduated?

ANTIN:

Yes. One of our friends was Amy Goldin,
the art critic, who was also a painter, sort of a fourth-gen-
eration abstract expressionist who became hard edge. She
was a member of the Brata Gallery, which used to show
abstract expressionists. It was like an inside scene, but
they were moving into pop by then, and they had a show
in which each member of Brata could invite somebody
else to show with them, and Amy invited me. I was doing
these big abstract assemblage paintings, which is what I
put in the show. They were collaged with nets and knives
and burlap and sand and God knows what else. I enjoyed
doing them. I used to work that way when I was back in
Music and Art High School. I remember I was into pur-
ples and browns. I liked painting that way, when you paint
with your hands as well as your brush and your knife.

FOX:

Did you continue painting very much longer?

ANTIN:

I actually took it seriously for a few years.
I especially liked the activity of painting. It's so private, so
peaceful-like; there's an innocence about it, a kind of fool-
ishness. Anyway, pop was coming in, and I was *very* attract-
ed to hard edge. I started doing valentines, huge valentines,
big canvases. I'd limit myself to two colors—the color of
the valentine and the color of the ground. If I didn't force
limitations on myself, some sort of insistent system, I'd go
nuts with the possibilities of everything. It's easier to move
around in a small space. So I would do these big hearts for
friends, and I let them choose the colors.

FOX:

That was a significant choice
for one working out of abstract expressionism, and its
valorization of the *artiste.*

But I suckered them,

because I chose the color tonalities, I decided which was the figure and which was the ground, I chose the scale. Later I started fooling around with series, doing these sort of quasi-narrative "sets," each painting showing part of a valentine, like a group of fragments on different sized and shaped canvases, swimming on a white wall. You couldn't see it all at once. You'd have to mentally connect the fragments to see that they formed a valentine. I haven't thought of this in a hundred years! This was very weird in its day, I want you to know. We're talking early 1960s. I guess they were conceptual paintings.

FOX:

There wasn't too much conceptual art
until about 1966. Were you seeing incipient forms of it or thinking about conceptual strategies in the early 1960s?

ANTIN:

As far as art was concerned, I was all into pop,
even though I loved abstract expressionism—still do— and I was also very attracted to poetry. I was just eating everything up, going out of my mind with pleasure. There was an incredible renaissance going on in New York. In literature I still liked the Beats, but there was so much new going on. I mean Diane Wakoski, Paul Blackburn, Jackson Mac Low, Jerry and David, Rochelle Owens, Armand Schwerner, Ted Berrigan, Ted Enslin, who used to drop in from Maine, John Ashbery had returned from France. And then there was the Judson Dance Theater. We used to go to everything at Judson—everyone was there, from Yvonne Rainer to Carolee Schneemann. All these artists! And critics, too. We were close with Nico and Lalia Calas; and Allan and Sylvia D'Arcangelo, they were very close friends. And Les and Kathy Levine. Bob Morris and Yvonne Rainer. I think we originally met Bob through

Diane Wakoski when they were living together. And we got friendly with other minimalists as well. I think David made those initial connections because he was starting to write art criticism for Tom Hess, the editor of *Artnews,* a very charming guy. I loved doing my paintings. I loved writing. I was being published in some of those mimeograph magazines we were all reading. I was doing public readings also. Not that much though: I hadn't found my voice yet. But I was hanging around downtown. I can't tell you what an exciting time it was!

FOX:

Your involvement in the literary scene
was the inspiration for your three-year project, *Blood of a Poet Box,* with its blood specimens of a hundred poets. Dating from 1965, it's definitely one of the very earliest examples of what has come to be called "conceptual" or "information" art. And yet you've said you were really coming out of incipient pop art and your immersion in the heady artistic climate of New York. Does that apply to the personality "portraits" of *California Lives* that are assembled from consumer goods? How did they come about?

ANTIN:

They were pure California.
I came here in 1968 and happened to discover the Sears catalogue. In New York nobody read catalogues, though I suppose they had Montgomery Ward upstate, but who took them seriously? I mean, they sold farm implements and housedresses. But I came to California and saw these hundreds of pages of the Sears catalogue. I thought, oh, my God, you can make a life; you can *invent* a life and never leave your house, much like people do today with computers. It impressed me as so very "California" to invent the world differently with every purchase!

FOX:

By the way, Eleanor, why did you leave New York?

ANTIN:

Well, New York was very boring.

FOX:

Really!

ANTIN:

Yeah, and our son Blaise
[named after Blaise Cendrars, the modern French poet, novelist, and art critic] was a year old, and we just got really bored with New York. The art scene was getting boring.

FOX:

[*baffled, incredulous*]:
How can you say that?! You just finished telling me—

ANTIN:

I know, I know; but life's like that, Howard.
Here today, gone tomorrow. New York had all been so intense, so familial, so provincial in a sense. But there was another world out there, and on the streets of New York who would know it? I was a New York brat. I was ignorant. And by then it was the last gasp of minimalism. We had begun making the scene in the early 1960s, around the time minimalism first appeared, and by 1968 when we left New York it was repeating itself. It had lost its edge and was turning into a kind of attractive, dry formalism that looked good in rich people's houses.

I was beginning to have a very mixed reaction to the minimalists. I found them all personally very friendly and very nice, but by then I was meeting the newer generation of artists and critics, Vito [Acconci], John Perrault, Joanie Jonas, the early conceptualists, different Fluxus people, like George Maciunas, Jeff and Bici Hendricks. I always

loved Jeff's beautiful sweetness. And Alison Knowles and Dick Higgins. And we were close to Lawrence Alloway and Sylvia Sleigh; I liked them. She painted my portrait looking fierce. I had a lot of friends there. We both did. I don't know why New York was feeling boring, but suddenly we wanted to get out of there. Yet I don't know why, now that I think about it . . .

FOX:

Well minimalism as an intellectual construct, it seems to me, has a kind of terminus, a dead end. Once you've taken away everything that you can take away, you reach an endgame. I mean, you could keep producing minimalist objects, but after a while the idea exhausts itself and the culture wants to move on. I think that's where conceptual art comes in.

ANTIN:

Right, it moved in then.

FOX:

I mean, you take away the materiality of an object, of course, and then you can—

ANTIN:

You know something, Howard? In early interviews I used to tear them down, the minimalists, and later I came to realize that in a sense they were my teachers. I didn't know it then, but I was having my art education right there, going to those minimalists' shows, because they taught me one thing—it was one of the greatest lessons, and I didn't even know they were doing it—they taught me how to make a show, because they were so *theatrical*. They were incredibly theatrical in their presentations.

FOX:

Well, that's what [art critic] Michael Fried said about them, too.

But he didn't like them for that reason,
and to me their theatricality was a good thing. Like you'd
go to a Bob Morris show. You get off an elevator and
enter a gallery and he's got one gray object in the middle
of the room. There's nothing else but that object. It steals
the whole room. It's not doing it by crowding you, you
can still move; it's just filling the space with its nothing-
ness. It's pure theater. There's an energy oscillating from
this object that's literally taking over the room. It's very
aggressive. I mean, that's the kind of thing that really
trained me. That every show has to have a core energy,
that it has to grab you; sure, it could seduce you, there's
lots of ways to skin a cat, but it's always an organic whole.
Now, me, I have so many different parts to my installa-
tions, but each show always has its own poetic image.
Everything radiates out from that. I learned this from
them. This is not what you get from seeing a show of
abstract expressionists. You understand what I mean? It
was so fabulous, what I got from the minimalists. When
I think about it now, I miss them. We had good times
then. So I understand what you're saying about why we
left New York.

FOX:
But I *don't* know why you left.

ANTIN:
Howard, it was so boring already.
We had to get out of there. When you fall out of love, it's
final. There's no logic. It's over.

FOX:
Wasn't there also a job offer?

ANTIN:
Oh sure, that's true.
But you don't have to take every job that comes along. If

you're enjoying New York, why would you want to go to San Diego? It was just a dumb sailor town then. But when David was offered a job at the University of California in San Diego, we thought it sounded exciting. It was *California!* I'd never lived anywhere outside of New York City. This was a great chance, and we just got rid of everything and went. That's how it happened. Paul Brach was chair of the art department at UCSD, and he was starting to build it up. David was this hot young critic, and Paul liked him and invited us to come out.

FOX:

So you moved here,
you found the Sears catalogue, and that's how you began to think about inventing lives. I thought *New York Women* and *California Lives* were based on real people.

ANTIN:

The eight New York women
are real people, but *California Lives,* which came first, is a mixture. They're kind of sociological types, iconic. Some of them were made up and some of them were real, like Georgia DeMeir, this little old lady who lived across the street. But I didn't really know her. And it wasn't really necessary for the audience to know who these people were. Did you catch that word? "Audience"? We're talking gallery visitors here. Wow!

FOX:

Yes, not *objets d'art,* but people.

ANTIN:

When I showed these pieces in 1970
at Gain Ground Gallery back in New York, most people seemed to like them because of the objects. It was pop, but it wasn't magazine pop, advertising pop. It was colloquial, everyday pop. But then a couple of people said, "It's very nice, dear, but we don't know these people." That shocked

me, because one of the pleasures of the show—for me—
was that I was presenting an image of Southern
California. Remember, in those days there was a kind of
trailer-park look to California—sleepy little towns and
stoned-out surfers. These were the days of the Vietnam
War, and I was very antiwar, but this was, like, *America*. I
fell in love with it. I couldn't stop listening to country
music. I mean, I loved it—white trash, white soul voices,
breaking at every phrase. I still do, even though I've been
living here for years—longer than I ever lived in New
York, I'm so old already—it's still exotic to a New York
Jewish commie like me.

One of these iconic characters—Tim, I named
him—is the quintessential Marine recruit. They would
line these kids up at Lindbergh Field [now San Diego
International Airport] on their way to boot camp at
Pendleton [U.S. Marine base]. Were these the murderous
soldiers we hated? The monsters who napalmed people
and defoliated forests? These poor, sad, pasty-faced chil-
dren? It was like the triumph of white bread. And I
thought, oh, my God, this is pathetic. They were the sor-
riest physical specimens you ever saw in your life. I felt so
sorry for them, I mean, I was still profoundly against the
war, but now because it was going to kill these kids as
well. I knew these people. I recognized them. These were
my neighbors, the kids at the checkout counter, guys who
pumped gas. It was a profound awakening, and it all
became part of my art.

With these iconic people it was like I was casting a
movie, a Southern California movie. If you saw them in a
movie, you'd recognize them. You know what I'm saying?
Even though I was seeing them personally for the first time
when I moved here, I had read Tennessee Williams, Carson
McCullers, William Faulkner. We all had. So what did those
gallerygoers mean when they said they didn't know these
people? What happened to New Yorkers when they entered
an art gallery? What sort of compartmentalization was

taking place? And I thought, "These guys are crazy. I'm glad I don't live there anymore." That's when I decided for the next show I would do portraits of New Yorkers, and because I was a young feminist I wanted to try my hand at women. I wanted to enter what had become the embattled terrain, crowded with land mines, that was the contemporary discourse on representations of women; and my recent experience taught me it had better be images of women they knew.

FOX:

So far, all of the pieces that you were doing imply a narrative. They require the viewer to make some kind of connection that isn't an aesthetic response to formalistically conceived objects but an *imaginative* response to a selection of found or store-bought objects that have cultural meanings. Viewers have to fill in details about these objects and conjecture about the people they represent. That's not storytelling, but it is a narrative activity that does require a kind of willingness to make-believe from the viewer. This is very opposite to the formal qualities—also the immediacy and literalism—of minimalist art, where you walk into the room and experience that gray object asserting its presence. You don't have to imagine anything; it's sheer confrontation. But responding to your art calls upon a different habit of mind.

ANTIN:

People are used to thinking about these things now. This is probably the influence of feminism opening art up to autobiography, story, everyday life. But in those days, who was going to invent a story? They didn't know how to do that yet—not in an art context. Remember, "narrative" was still a dirty word—to academic feminists, it was anathema—and these works were minimal, spare in appearance. They presented the viewer with an implacable surface that didn't give an inch. This was very much a

function of the newness of the objects. They were tacky, fragile. Curiously, when these works are shown today, they've acquired the patina of nostalgia. They aren't new anymore. Life has traveled through them. They're still cool and minimal, but with a difference.

FOX:

Well, your minimalism would be very different from the sleek, machined minimalism of Donald Judd's Plexiglas and stainless-steel boxes or of Morris's industrial fabrications. Your consumer goods may be manufactured, but the very gesture of using them seems rooted in something a lot more homespun and domestic, and—dare I say the F-word?—feminine. What's more, they suggest stories. Why did you gravitate toward narrative anyway?

ANTIN:

You know, Howard, I'm not a shopper. I panic when I shop. I'm indecisive and cheap. People think my jeans are a trademark. "A statement," somebody once said approvingly. Hell, I'm afraid to shop. I lose my normal confidence. I don't look like myself in store mirrors, I always pick out the wrong thing. It never fits my life or my body or my pocketbook. Then I get depressed, angry. I blame everybody. If I hadn't found the Sears catalogue, I'd never have done these pieces. They're not domestic. They're literary: they come from a book.

I have a very good therapist who says she likes to listen to me talk about my life because I make up stories all the time. She doesn't think I'm neurotic just because I fantasize unlikely disasters and implausible intricacies at the drop of a hat. I make up stories out of everything. I do it without even realizing I'm doing it, and because it can frequently be some paranoid horror—no, not so much paranoid or horror, but more some dark set of possibilities; you could say that it's a neurotic habit of mind. Why shouldn't the stories

be dark? Dark stories are more compelling. What's interesting about a sitcom? Besides, our existential situation in the world is doomed—you might say darkly finite—so maybe I'm just being realistic. It's great having a literary therapist. She accepts the way my mind works.

FOX:

It's a habit.

ANTIN:

Yeah, I don't know if I was born with it, but I got it. Stories erupt in me all the time. I don't even remember them. Sometimes I catch myself scaring myself, "Cool out, Ely, it's just me." I was always doing it, but I think what got me started foregrounding narrative in my work was feminism and its fascination with personal experience.

FOX:

Let's talk about that.

What was your relationship to the women's movement and to women's art at the time?

ANTIN:

Whoa, that's a big subject!

I don't know where to begin. As soon as it appeared, I was immediately attracted to the discourse. Believe it or not, I read—it's embarrassing to say because it's such a cliché [*laughing*]—I read Simone de Beauvoir and Betty Friedan [*more laughter*]. It's an embarrassment!

FOX:

Why? That's who everybody was reading.

ANTIN:

They were great!

Memoirs of a Dutiful Daughter was a beautiful book; it's her best book. And then *The Feminine Mystique* was an eye-opener about popular culture. Suddenly pop didn't

look as friendly anymore. I began to devour the material. Now I don't remember exactly when I got friendly with the women from L.A., but I became close friends with Suzanne Lacy. And Miriam Schapiro, who was teaching down here and later up at Cal Arts [California Institute of the Arts]. I also was friendly with Pauline Oliveros and Linda Montano, and they were becoming feminized politically. And Ida Horowitz (who became Ida Applebroog when she moved to New York) was perhaps my closest friend. Then we started this women artists' group. It was not a consciousness-raising group. I'm too perverse a person to deal with anything like that. I'm not nice or polite enough. I can't resist shocking people. I can hold together for an hour or so, but then the shit hits the fan and I start to explode. I'm a menace in faculty meetings. I get stir-crazy.

But this group was different. We were doing some similar things to what Grand Union did five years later in New York—improvising out of each other's actions, movements, contact, trying to work harmoniously together—or not. It was a concept that Pauline Oliveros was realizing in her work out here: a sort of "tuning" to other people. We started doing this sometime in '72, and by the middle or end of '73 we had split up. We had too little in common as women and as artists to stay together longer, but it was very interesting for a while.

We used to improvise these sculptural performances. We had lots of materials all over the floor, giant piles of ropes, rods, planks, whatever people brought in, and then somebody would make a move onto the floor, somebody else would react, join her, or do her own thing in a different part of the room—it was a very large loft space. We were all moving, making, doing, interacting, or not, but tuning to each other, feeling the energy from each other, moving toward and with each other—God, this is beginning to sound like a return to abstract expressionism in performance, I never realized that before—and finally,

after anywhere from twenty to maybe forty-five minutes, we'd find our way to an organic ending. And we always knew when it was over. Sometimes with a bang or a whimper, but we all knew. I loved that part best. Achieving an ending.

FOX:

Endings? I'm surprised,
because I think of your art as being about new beginnings. Not that these early activities were *your* art; but I suppose even these actions, coming out of feminist dialogue, are themselves a sort of new beginning. They presage some of your early interest in personae. There's also something very American about all of this.

ANTIN:

Yes, because I invent myself so freely.
And I'm inventing histories all the time.

FOX:

I think a lot of Europeans feel
that they are products of their cultural history, and if there's anything that America was founded on, it was that we can reject that. We can always start over.

ANTIN:

That's also why I love Southern California.
It's easier to believe those things—and act on them—here than back East. Here, David and I don't even have a street address; our house is off a dirt road, lost in the sage.

FOX:

For you, history would seem to be less of a yoke
or a prescription than a medium that you can deal with. You're looking at history, not as a prescriptive litany—or, to continue the metaphor, as a fixed address properly situated among all the others—but as something that you can take from and borrow from and remake.

ANTIN:

Right. But I don't make it all up.

I enjoy doing the research. I'm always looking to find the few moments that have a poetic resonance for me, when my character's personal experience erupts through the years to meet me. For example, when I was doing *Before the Revolution,* in which I play Marie Antoinette, I read tons of pretty dry stuff analyzing the economic and political situation of the eighteenth century, along with autobiographies, biographies, letters, even novels. Through a fortunate accident I found this delicious little memoir, an old book that must have been published in the 1820s. What it was doing in the open stacks of the UCSD library I don't know, but it was sitting there minding its own business, never having been checked out by anyone, with a thick brown cover with gold embossments, not very many pages. It was the personal memoir, translated into English, of the wife of Marie Antoinette's jailer.

From her I learned that Marie Antoinette had had her period on the day of her execution. She didn't precisely say that, this was after all published in the early 1800s, but she said the queen was bleeding. Before she got into the executioner's cart—this sort of ignoble cart that they sent for her, not at all like the magnificent coach in which her husband had gone to his death the year before, but this little cart drawn by a shabby horse that you might use to bring in firewood from the country to sell in the city—before she got into the cart, she grabbed the wet rags she had been wearing, bloody rags, and hid them behind a loose brick in the wall. I guess she stuck something else inside her, I don't know, but I remember reading that and thinking, oh, my God. I mean suddenly through the centuries, you've got a two hundred years' separation, and suddenly there's a connection with this woman who is going to her death, worried about bleeding onto her skirts, because that is one of *the* embarrassing moments for all women. Is she worrying about when

she'll have to get down from the cart and walk up the steps of the platform to the guillotine? Does she feel blood running down her legs? Does she smile ironically, anticipating the black humor of gushing from both ends at the same time? It's very hard to be a great, wronged, and dignified queen when you're forced to wear your vulnerability as a woman like a badge. I would've bet my life that this predicament was some component of her final experience of dying. Suddenly, I felt the years wash away, and I was connected.

Unfortunately, it didn't fit into the piece I was doing so I never used my sad little aperçu. Though I would have if I were making a movie—can you imagine both the absurdity and power of that scene in a movie? But it helped give me this connection. In fact, in the whole center of the play *Before the Revolution,* I talk about connecting. How do I reach Marie, and how do I reach Antinova, my ballerina persona? Since they are me, how do I reach me? Who is reaching for whom? I had come to a moment in Marie Antoinette's life by spying, voyeurism. All my life I've been a spy, but not by gossiping; voyeurism is a private, secret, somewhat embarrassing activity. I want to *see.* And I use these personal histories to explore issues that I think are very real, even if some of the people are dead. In a sense history is a kind of—I won't say battleground—but a kind of playing field, a theater, say, for me to move things around in, or maybe a chessboard, except that there are no rules. I sort of play things out until the game's over. Until, you might say, I've found my ending.

FOX:
When you're delving into history
and finding these connections, does it truly enable you to go beyond the limits of yourself and allow you to reinvent yourself? How is that different from just make-believe?

Listen, Howard,

I'm a very intense and passionate person who's always standing over some sort of void or abyss. So what if it's mostly in my head? What's realer than that? Now at the same time I'm tough, so I'm not going to fall in. But because the one thing that matters most to me in my life, and what I've spent most of my life doing, is making art, I've had to make the rest of my life fairly simple. I teach, I have a husband whom I really love, I have a son, now a daughter-in-law, and I have friends, so I'm lucky. But often I don't have too much time for them. I work very hard. I get five hours of sleep a night—if I'm lucky—but I'm always working, there's just not much time left for anything else. So I live in my head, making up stories. I really prefer spending my life in what you might say—with not a little touch of irony—is a "traditional" woman's way of living, like those eighteenth- and nineteenth-century women who were stuck in their roles and their class because they couldn't escape, so they wrote romantic novels. But in my case I've *chosen* that way. My personae, my historical fictions, are actually all the lives that I'm not going to live because I *chose* not to. I certainly don't want to be regretful when I'm an old woman, but do I really want to go live in Marrakesh and walk around the markets and pick up market women to sleep with, like Jane Bowles? I mean, it's very interesting to have your jealous lover poison you slowly, but do I really want this? No! *Mir ken geharget vehren!* (You could die!), as my mother would say. But at the same time I like to imagine it. To me, the uninvented life, to paraphrase the cliché, is hardly a life. I always see the full psychological, philosophical, and political implications of my personae and the world they and I live in. I'm not like some have said: "Oh, Eleanor believes that she's a ballerina." What am I, a schizophrenic? I'm not a moron: I know I'm not a ballerina. Who the hell wants to be a ballerina, anyway? Besides

Antinova is so fucking ironical, she may not believe it
either. But in my art I can enjoy a delicious feeling of
removal and being at the same time.

FOX:

You've focused pretty distinctly on four personae:
the King, the Black Movie Star, the Nurse, and the
Ballerina.

ANTIN:

In practice it became three, not four.
The King came first, when I wanted to see what my male
self would be like, who he would be. And I realized my
bearded self was a king—a dead ringer for Charlie One—
and kings must have a country, a kingdom—even if a lost
one. He became my political self. Then I wondered who
would be my most wonderful, grand, beautiful, female
self? As I said, a lot of this came out of my involvement in
feminist discourse. So, that was the Ballerina. Her charac-
ter started out as a generic, nameless ballerina—my artist
self—and a few years later she became Eleanora Antinova,
the black ballerina of Diaghilev's Ballets Russes.

FOX:

Right. Both the Nurse and the Ballerina
have had more than one incarnation. Some of your per-
sonae have been longer-lived than others; in fact, the
Black Movie Star seems to have had only a very short
career. Whatever happened to her?

ANTIN:

I began to see that simply being black
was hardly a character. It might affect your character and
your history, but being black is not who a person is. And
all a movie star does is play roles. That isn't a whole per-
son either. I didn't see a great potential for the Black
Movie Star, so I didn't develop her; but I did revive

the aspect of blackness in the performance titled *El Desdichado* (The unlucky one). The King became a Gypsy king, swarthy, kind of Moorish. The Ballerina, of course, became Antinova, and Antinova, too, was black.

FOX:

We'll talk more about Antinova later. Who came next?

ANTIN:

The Nurse.

That was when my friend the writer Melvin Freilicher said, "Your selves are all such great people—kings, ballerinas, movie stars. Is that really true of you?" Hardly. But who could embody the many dark, tacky, colloquial, and embarrassing parts of me? The two most pathetic women's roles I could think of in those days were an airline stewardess and a nurse. Back then they were seen as almost pornographic figures in the cultural imagination. I mean, they were service figures, and instead of being grateful the culture was contemptuous of them. Service is the main role our culture has allotted to women, and we've been put down for it ever since. So I decided my next self should be a nurse. And then she turned around and surprised me by being the most inventive of all my selves, because she was always making up stories.

The first Nurse, the Little Nurse, was the paper-doll figure in two video movies, *The Adventures of a Nurse* and *The Nurse and the Hijackers,* all about her little fantasies and escapades all over the place, little love stories and soap operas. She was always inventing herself as this heroine—sort of victim and heroine at the same time. Being victimized by men and transcending them. Later I realized that while I had been exploring women's traditional romantic aspirations in the two nurse movies, I hadn't yet explored the nature of "service" and its historical role in women's lives. So I looked back in history at the founder of nursing and found Eleanor Nightingale.

The Angel of Mercy was the title of both a series of some sixty photographs made to look like vintage nineteenth-century prints and a related performance, freely based on the figure of Florence Nightingale and her trek through the Crimean War with the British army.

That work brought up many moral and ethical issues, not just about war, but about the meaning of service to others in the pursuit of war. If you're a nurse, and you save one soldier, and then he goes back and kills some more people, you have in reality become a multiple murderer. But if a man is bleeding, you have to bandage him. That's what a nurse does. And bandaging the man, whoever he is, is the moral thing to do. It's the human thing, even though, alas, humans don't do it all that much. But nurses do. It's the nature of their profession—or was, before managed care came into the picture.

But Antinova remains my favorite.

FOX:
Antinova is a very complex character.

ANTIN:
Antinova was my family, my childhood, my Eastern European roots, my childish passion for ballet and high culture—all the delicious, foolish, lovely baggage I got from my mother along with her leftist politics. My mother was a communist, in love with Russia. I guess the revolution coming to Russia was a stroke of great romantic luck for her. The confluence of Imperial Russian high culture and the beautiful Bolshevik dream ravished her completely. And it was such a beautiful vision they had: From each according to his ability, to each according to his needs. Comrade Stalin remained her hero for a long time, too long. Then there was her beloved Yiddish.

But the Yiddish world she gave me was high-culture Yiddish, secular and literary. My mother had been an actress on the Yiddish stage in Poland, playing two-bit

shtetls and dreaming of great roles in Warsaw and Vilna. I lived through a *Walpurgisnacht* of pleasure dealing with this material—Diaghilev, early modernism, music, art, Paris in the twenties. But I don't believe I'm Antinova, okay? At the same time think of Flaubert at his trial, saying about Emma Bovary, *"Madame Bovary, c'est moi."* Though he never wore tight corsets and long skirts or needed to be rescued from a boring husband.

FOX:

So, in a rather deep sense Antinova is you, as Emma Bovary was Flaubert.

ANTIN:

Yeah, yeah, I guess so. She's me. But I'm not her. You know what I'm saying? She takes on all the problems of being an artist who lived too long and refused to go away, of insisting on her own vision and history in a world taken up with other things. That's my play *Who Cares about a Ballerina?*, in which the old, retired Antinova tries to dictate her memoirs to a series of different typists (all played by the same actress), who don't get it—even when they're trying to. Like the young, punky one, who translates Antinova's life into a Harlequin romance. Finally, there's one typist who understands, who can see and hear Antinova's ghosts, but she's half-blind and half-deaf. So it goes! Yeah! *C'est moi!*

FOX:

Eleanor, I've been reflecting a lot lately on your art, and it occurs to me that all of your personae are "others," aliens, exiles. They're people who, if they existed in real life, would be outsiders. You invent a king, but your King is dispossessed of his country, powerless against the real estate developers of Solana Beach. Later you make him a Gypsy king, leading his followers to a promised land that turns out to be a wasteland. You create a Black Movie

215

Star at a time when there were virtually no blacks in the movies, so she's already an oddity; and you put her in Hollywood, the insiders' capital of the planet, where she can't help but be the eternal outsider. There's Nurse Nightingale, who had to virtually disown her family and live amid carnage to fulfill her noble calling, and who transmutes in the next century into the Little Nurse, who is constantly having to overcome—or overlook—being treated like a bimbo by every cad who lays eyes on her. And then there's Antinova—a ballerina, but a fallen one whose history is already behind her, leaving her to wistfully reminisce while struggling to eke out some way to survive until the next day. What draws you to these kind of personae?

ANTIN:

[*somewhat nonplussed*]:
Well, but when you think about it, Miss Nightingale was not a social outsider. She was an aristocrat.

FOX:
Yes, but you described the Nurse as pathetic—

ANTIN:
The Little Nurse, yes.
Yes, both of them, of course . . . because they're both in service. In a sense they're in service to the whole world. It's a kind of subjugation.

FOX:
Yes, but there's something far more poignant
and resonant to all of your personae than subjugation, don't you think?

ANTIN:
[*falteringly*]: Yeah, well, maybe
they are outsiders . . . but then I always . . . I always think of . . . [*wavering*] I think that I've always felt, like . . . [*restlessly*] in a sense I've always felt myself . . . Look, I may have

fallen in love with Southern California, with white-trash culture, but I'm an outsider in it. I'm not trying to be inside it, and I don't want to be. I mean, they vote Republican or Libertarian, and they have guns and want their God-given right as Americans to attend an execution a day . . . [*reflectively*] I didn't choose the positioning, but I've always felt like an outsider. In a sense I'm an exile, as a Jew. It may not look that way because the American immigration has been so successful, but as Jews we never really know when they might not turn around and open the doors and throw us in and gas us to death. I mean, it's unlikely, sure, but you never know. So as a Jew, I'm an outsider. As a woman, I'm an outsider. When I go to the movies, I empathize with the male hero. The woman is usually a wife, a mother, a whore, or a loser. We take part in American culture by coming in from the outside, by making the most delicate adjustments. And then [*decisively*] I'm an artist—the perfect outsider! So I don't see anything wrong with being an exile. I don't think it's a bad condition. I'm used to it. I've lived that way all my life, and I guess I'm attracted to other exiles. I mean, who are the insiders? Probably less people in this world fit in than we think. What would "fitting in" mean? That I'd live in a suburb and be a bourgeois idiot with 2.5 children? I don't want that. What a boring life. I wouldn't even know how to live it.

FOX:

People tend to think of you as a comedic artist, which you often are. But in your plays and movies, the personae and central figures may not always be—or even rarely are—victorious in their follies and plights; some of them, like the lovers in *The Man without a World*, come to an unhappy end. Yet your characters always seem to be redeemed in their dreams, in their aspirations. They have their plights—Antinova has to perform in blue movies, the King is exiled—but there's a morality, a moral rightness to their conditions.

Yes, yes. But in *Help! I'm in Seattle*
—the end of Antinova—she sees herself as a festering
mushroom, sitting in an armchair in some seedy board-
inghouse lobby, with cockroaches jumping off her lap.
We're talking about total decay, seeing herself as a repul-
sive corpse who can still talk. Like being thrown onto
some rocky shore from a shipwreck: her time, her friends,
her work, everything's gone. There's nothing redeeming
about it. It stinks, like her, like the whole fucking world.
Except that I put in her mouth this grand vision of inex-
orable defeat at the hands of time . . . being abandoned by
life, which never warned her of its betrayal. And I think
what you see as redeeming is the poetry of her vision,
awful as it is. And maybe that's triumphant. I guess even
tacky Little Nurse Eleanor, who gets up from every one of
her nasty little fucks—each one of the scenes in *The
Adventures of a Nurse* ends in a fuck—but she keeps get-
ting up from each of them, and she goes on vacation. So
there's something sweet and brave and gutsy about her.
And then there's Eleanor Nightingale. Queen Victoria
gives her a big medal at the end. So I guess she's tri-
umphant in the worldly sense, only she's standing up
there with her medal surrounded by corpses. And the
King makes his last appearance in a performance, *El
Desdichado,* in a sort of children's crusade of the old, the
crippled, the poor, the losers, leading them to the White
City, which turns out to be a city of stone and sand and
bone and ashes. God, now that I think about it, everything
I do is that way. It's like dancing on the brink of disaster,
kind of the image I have of my life, I guess. Is it apocalyp-
tic or just plain paranoia? [*a pause; then quietly*] Yeah,
they tend to end very sad, but at the same time I guess
you're right. Not triumphant so much as—

FOX:
—with a moral purpose?

ANTIN:

Yeah, maybe . . .

FOX:

Are you a moralist?

ANTIN:

[*pensively*]: I guess I must be.
I used to think, "If only they'd listen to me, I would set it all right." That's why I was a king. I told you, I may be ironical, I may be funny, but I'm not kidding. In the early part of my career I was talking about the simpler politics of injustice, like when the King [in the performance *The Battle of the Bluffs*] led a revolution of the very old people with their shuffleboard sticks—his infantry—and the very young people with their skateboards—his cavalry— against the developers, bankers, sheriff's men, landlords, electric company, and they almost won.

But can you really win? Have you ever seen a revolution that didn't swallow itself? Isn't defeat built into the world, as basic as carbon? Aren't we all doomed? We go out in the morning, and we're going to be defeated at night. If we have really bad luck, we'll be defeated by noon. You said I was a comedic artist, but the comedy in my art is more like the story they tell about the poet Max Jacob—or maybe it was Robert Desnos, I don't remember, I've heard it about both—who was in the concentration camp, waiting his turn to go into the ovens. He went up and down the long line of people waiting with him, and he leaned over their hands and read their futures from their palms. . . . That's one of my favorite stories. [*crying*] I'm sorry. [*composing herself*] Okay. . . . Ask me something else.

FOX:

[*moved, disturbed*]:
But nothing in life—unless you're a very religious person

who has full faith in a life after death—is going to elimi-
nate the ultimate defeat. But for you, is there something
that redeems or exalts humankind?

ANTIN:

For me personally it was making art.
And to me that means inventing, making meaning hap-
pen where there wasn't any before. It has made my life
worth living. Hey, it even helped me survive the art world.

FOX:

As we talk, I realize yet again
how fundamental theater is to your philosophical beliefs.
Is that related to your move into film in the mid-1980s?

ANTIN:

All of my filmic work
is based on the opening up, the unpacking, of images that
have haunted me from my childhood. We talked earlier
about Russia, about early communism. And ballet. I don't
think we talked specifically about that. It's so absurd, ballet,
isn't it? I mean, it's ridiculous. It's nonsense. Sure, it's pret-
ty, but big deal. So's ice-skating. But we went to the Ballets
Russes performances all the time—Christmas, birthdays,
whenever they were in town. It was the Colonel de Basil
company then, of course: Markova, Dolin, Danilova; and
the baby ballerinas, Riabouchinska, Slavenska. The names
rolled off my tongue like chocolate syrup. We often didn't
have money for food, and this was before credit cards, so
my mother would cash a bum check on Friday afternoon,
and she'd stock up the refrigerator. Later we'd go to the bal-
let and sit way up in the balcony. On Sunday afternoons
we'd go to Carnegie Hall and sit way, way up in the boonies.
After those concerts I loved the long, crowded, slow crawl
down the endless stairs, looking at the photos of the dead
artists, usually with foreign names. Then we'd take the
noisy, smelly train back to the Bronx, and I'm sure my

mother felt as alone and alienated from the everyday world as I did. We were both in the wrong place. Maybe that was when I became an exile.

You and I were speaking one time about Jewish roots, and I recall that you described your "love affair" with Jewish culture. That was the phrase you used, but then you corrected yourself, saying, "a love affair, yes, but an unrequited love." I don't know whether you remember that.

ANTIN:

How interesting.
I suppose I was referring to the fact that the Jewish culture that I love is all in my head. For one thing it's gone. The Holocaust killed whatever was left of that kind of shtetl life. I mean, Howard, they were miserable little towns. It was Podunk, for God's sake. Even if they were large, they had that small-town suspiciousness, that narrow mentality. Who would want to live in such a boring place? Maybe Vilna, places like that, you know, cities, hangouts for the Jewish intelligentsia, bohemians sitting around cafés and dreaming of Paris, Moscow, Palestine, America. Smoking and arguing and feeling each other up and drinking into the night. It was the old Greenwich Village culture I grew up in when I was a young girl. And that's not there anymore, either. So it's imaginary, my love affair is a fantasy. Like the Russia that also isn't there anymore, that was never there, anyway, except in my mother's head. Ghosts. All ghosts. I have a head full of ghosts.

FOX:

But good ghosts.

ANTIN:

My movie *The Man without a World*

221

was my try at bringing them back. At making them real again. The Russian revolutionaries, anarchists, Zionists, even an early modernist poet—my protagonist—and the outsiders, the Gypsies. My filmic installation *Vilna Nights* took it further into the next decade, into the Holocaust. You can hear the ghosts wailing through the deserted streets. That one is up-front about ghosts. But *The Man without a World* is about people on the edge, a world on the edge about to go under, but still inhabited by living, cranky, unhappy, amusing, aspiring, passionate, sexy people. Then I did the installation *Minetta Lane,* my dream of the artist's life, *La Bohème.* When I was a kid, I'd play hooky from school and go down to the Village and spy through people's windows. Later I lived there, modeled for artists, and fell in love with a new jerk every other week. My mother had taught me that being an artist was the greatest thing in the world. I don't think she really believed it, but I didn't know that. I adored her and believed everything she said.

FOX:

There's that mischievous presence
in *Minetta Lane,* that young girl who spies on people and magically shows up in their apartments, and she's invisible to the inhabitants.

ANTIN:

Little Miriam, I call her,
though nobody knows her name. Yeah, she's a kind of poltergeist, an imp of the perverse, a kind of nasty Puck. She's this troublemaker who fucks everything up. Out of pleasure. For fun. She's a trickster. In *Minetta Lane* she fucks up an artist's painting, she causes two lovers to split up, and an old man dies as she slowly and gleefully puts out the lights. Whatever you want to call her—time, spirit, it doesn't matter—she's out there, not so much in the world

as in your head. And she'll get you. Sooner or later, she'll get you, giggling at her games. She's more like the inner demon, I think.

But she's not like the bigger presence in *The Man without a World*, which ends with intimations of the Holocaust as the poet runs off with the Gypsies. They go dancing down the road to Warsaw, followed by Mr. Death. In that last scene the poet's the only one who sees Death, unlike the little Gypsy ballerina, dancing bravely down the road with her magician and fortune-teller, while the poet shrugs and follows. He's probably whistling, but who can tell? It's a silent film. And Mr. Death adjusts his cuffs, tips his hat, and follows them down the road.

FINIS

Checklist of the Exhibition

Note: Some components of the installations on this checklist have been previously exhibited as separate works of art.

Page numbers refer to illustrations.

Unless otherwise noted, all works are lent by the artist, courtesy of Ronald Feldman Fine Arts, New York.

1 *Blood of a Poet Box,* 1965–68
 Wood box containing one hundred glass slides of poets' blood specimens and specimen list
 11½ x 7¾ x 1½ in. (29.2 x 19.7 x 3.8 cm)
 (p. 21)

2 *Here,* from *Movie Boxes,* 1969–70
 Photomontage and text in aluminum-and-glass case
 37½ x 25½ x 3 in. (90.2 x 64.8 x 7.6 cm)
 Lent by Marcia Goodman, Encinitas, California
 (p. 25)

3 *And,* from *Movie Boxes,* 1969–70
 Photomontage and text in aluminum-and-glass case
 37½ x 25½ x 3 in. (90.2 x 64.8 x 7.6 cm)
 Lent by Marcia Goodman, Encinitas, California
 (p. 25)

4 *Coming,* from *Movie Boxes,* 1969–70
 Photomontage and text in aluminum-and-glass case
 37½ x 25½ x 3 in. (90.2 x 64.8 x 7.6 cm)
 Lent by Marcia Goodman, Encinitas, California

5 *Jeanie,* from *California Lives,* 1969;
 replicated 1998
 Folding TV snack table, melamine cup and saucer, plastic hair curler, king-size filter-tipped cigarette, matchbook, and text panel
 Dimensions variable
 (p. 30)

6 *Molly Barnes,* from *California Lives,* 1969;
 replicated 1999
 Acrylic bath mat, lady's electric razor, pills, talcum powder, and text panel
 Dimensions variable

7 *The Murfins,* from *California Lives,* 1969;
 replicated 1998
 Aluminum stepladder, trowel, can of adhesive, Fresca can, faux brick tiles, and text panel
 Dimensions variable
 (p. 31)

8 *Merrit,* from *California Lives,* 1969;
 replicated 1998
 Gasoline can, bush hat with "peace" decal, metal comb, and text panel
 Dimensions variable
 (p. 31)

9 *Naomi Dash,* from *Portraits of Eight New York Women,* 1970; replicated 1998
 Chrome towel rack, bath towel, nylon stockings, shower cap, litter box with litter, and text panel
 Dimensions variable
 (p. 178)

10 *Carolee Schneemann,* from *Portraits of Eight New York Women,* 1970; replicated 1998
 Wood easel, mirror, jar of honey with honeycomb, crushed crimson velvet, and text panel
 Dimensions variable

11 *Lynn Traiger,* from *Portraits of Eight New York Women,* 1970; replicated 1998
 Wood door and jamb, leather key case with keys, straw doormat, glass milk bottle, plastic cottage-cheese container, paper envelope, and text panel
 Dimensions variable
 (p. 178)

12 *100 BOOTS,* 1971–73
Black-and-white picture postcards
Fifty-one postcards, each 4½ x 7 in. (11.4 x 17.8 cm)
Exhibited with recipients' responses and other
related ephemera
(pp. 52–57)

13 *100 BOOTS in Their Crash Pad,* 1973
One hundred black rubber boots, wood door
and jamb, porcelain sink mounted on wall,
lightbulb on electrical wire, mattress, sheets,
blankets, sleeping bags, radio with vintage 1973
music sound track, flooring, molding, and
wallpaper
Dimensions variable

14 *Representational Painting,* 1971
Videotape (black-and-white, silent,
thirty-eight minutes)
Courtesy of Electronic Arts Intermix, New York
(p. 45)

15 *Library Science,* 1971
Twenty-five black-and-white photographs, each
12⅛ x 8⅛ in. (30.8 x 21 cm), with accompanying
Library of Congress catalogue cards, each 3 x 5 in.
(7.6 x 12.7 cm), library step stool, seven exhibition
announcement cards, and text panel
Dimensions variable
(pp. 35–37)

16 *Domestic Peace,* 1971–72
Handwritten text on graph paper and typewritten
text and ink on paper
Seventeen pages, each 8½ x 11 in.
(27.9 x 21.6 cm)
(pp. 40–41, 171, 173)

17 *4 Transactions,* 1972
Typewritten text and ink on paper
Four pages, each 11 x 8½ in. (27.9 x 21.6 cm)
(p. 39)

18 *Renunciations,* 1972
Typewritten text on paper
Three pages, each 11 x 8½ in. (27.9 x 21.6 cm)
(pp. 42–43)

19 *Carving: A Traditional Sculpture,* 1972
Black-and-white photographs and text panel
144 photographs, each 7 x 5 in. (17.8 x 12.7 cm)
The Art Institute of Chicago, Twentieth-Century
Discretionary Fund, 1996.44
(pp. 47, 158)

20 *The Eight Temptations,* 1972
Color photographs, mounted on board
Eight photographs, each 7 x 5 in. (17.8 x 12.7 cm)
(pp. 49–51)

21 *The King,* 1972
Videotape (black-and-white, silent,
fifty-two minutes)
Courtesy of Electronic Arts Intermix, New York
(p. 63)

22 *Portraits of the King,* 1972
Black-and-white photographs, mounted on board
Three (of five) photographs, each 13¾ x 9¾ in.
(34.9 x 24.8 cm)
(pp. 64–65)

23 The King's costume
Costume consisting of cape, hat, blue jeans,
leather boots, and false beard

24 Drawing from *The King's Meditations*
(The Castle), 1974
Wash, ink, and chalk on photosensitive paper
17½ x 21 in. (44.5 x 53.3 cm)
(p. 70)

25 Drawing from *The King's Meditations*
(The Horses' Asses), 1974
Wash, ink, and chalk on photosensitive paper
17½ x 20½ in. (44.5 x 52 cm)

26 Drawing from *The King's Meditations*
(Banquet in the Clouds), 1974
Wash, ink, and chalk on photosensitive paper
13½ x 17½ in. (33 x 44.5 cm)
Lent by Marc Nochella, New York
(p. 70)

27 Drawing from *The King's Meditations*
(Country Cottage), 1974
Wash, ink, and chalk on photosensitive paper
17½ x 18½ in. (44.5 x 47 cm)

28 Drawing from *The King's Meditations*
(Royal Coach), 1974
Wash, ink, and chalk on photosensitive paper
17½ x 18 in. (44.5 x 45.7 cm)
(p. 71)

29 *The King of Solana Beach,* 1974–75
Black-and-white photographs, mounted on
board, with text panels
Eleven photographs, two text panels, each 6 x 9
in. (15.2 x 22.9 cm)
(pp. 66–69)

30 *El Desdichado,* 1983
Videotape (color, with sound, eight minutes);
excerpts of video documentation of a live
performance originally staged at Ronald Feldman
Fine Arts, New York

31 *The Adventures of a Nurse*
Video installation consisting of *The
Adventures of a Nurse,* 1976,
videotape (color, with sound, sixty-four
minutes); bed with bedspread and throw
pillows; night table; lamp; diary; and paper dolls
Dimensions variable
Videotape courtesy of Electronic Arts Intermix,
New York
(pp. 90–93)

32 *The Nurse and the Hijackers*
Video installation consisting of *The Nurse
and the Hijackers,* 1977, videotape (color, with
sound, eighty-five minutes); airplane set;
and paper dolls
Dimensions variable
Sportscaster paper doll lent by Samuel David
Winner, M.D., Del Mar, California
Videotape courtesy of Electronic Arts Intermix,
New York
(pp. 96–99)

33 *The Angel of Mercy*
Video installation consisting of *The Angel of
Mercy,* 1977, videotape (color, with sound, sixty-
six minutes), 1981 version of the live perfor-
mance originally staged at M. L. D'Arc Gallery,
New York, in 1977; *The Angel of Mercy: The
Nightingale Family Album,* 1977, twenty-five tinted
gelatin-silver prints, mounted on paperboard,
each 18 x 13 in. (45.7 x 33 cm); *The Angel of Mercy:
My Tour of Duty in the Crimea,* 1977, thirty-eight
tinted gelatin-silver prints, mounted on paper,
each 30⅜ x 22 in. (77.2 x 55.9 cm); twenty
Masonite cutouts, each approximately 54 x 30 in.
(137.2 x 76.2 cm), from the performance *The
Angel of Mercy,* 1977
Dimensions variable
Videotape courtesy of Electronic Arts Intermix,
New York; photographs lent by the Whitney
Museum of American Art, New York, purchased
with funds from Joanne Leonhardt Cassullo and
the Photography Committee
(pp. 101, 103, 104–9)

34 *Caught in the Act*
Video installation consisting of *Caught in the
Act,* 1973, videotape (black-and-white, with
sound, thirty-six minutes); *Choreography I—
Center Stage* (Short Tutu), 1973, eight black-and-
white photographs, mounted on board, each
7 x 4¾ in. (17.8 x 12.1 cm); *Choreography II—
Curtain Call* (Long Tutu), 1973, seven black-
and-white photographs, mounted on board,
each 7 x 4¾ in. (17.8 x 12.1 cm); *Choreography
III—Classical Sighting* (Long Tutu), 1973, six
black-and-white photographs, mounted on
board, each 7 x 4¾ in. (17.8 x 12.1 cm);
Backstage Moments—Torn Ribbon, 1973, two
black-and-white photographs, mounted on board,
each 7 x 4¾ in. (17.8 x 12.1 cm); *Backstage
Moments—Making Up,* 1973, black-and-white
photograph, mounted on board, 7 x 4¾ in.
(17.8 x 12.1 cm); *Backstage Moments—Waiting in
the Wings,* 1973, black-and-white photograph,
mounted on board, 7 x 4¾ in. (17.8 x 12.1 cm)
Dimensions variable
Videotape courtesy of Electronic Arts Intermix,
New York
(pp. 73–75, 77)

35 *The Ballerina and the Bum,* 1974
Videotape (black-and-white, with sound, fifty-
four minutes)
Courtesy of Electronic Arts Intermix, New York
(pp. 78–83)

36 *The Little Match Girl Ballet,* 1975
Videotape (color, with sound, twenty-seven
minutes)
Courtesy of Electronic Arts Intermix, New York
(pp. 84–87)

37 *Recollections of My Life with Diaghilev* (from
the performance and exhibition), 1981
Installation consisting of drawings, ink on paper,
each approximately 14 x 11 in. (35.6 x 27.9 cm);
eighteen sepia photographs, each 14 x 11 in.
(35.6 x 27.9 cm); five printed pages of text, each
14 x 11 in. (35.6 x 27.9 cm); handmade portfolio,
approximately 14 x 11 in. (35.6 x 27.9 cm);
watercolors on paper, each approximately 14 x 11
in. (35.6 x 27.9 cm); bentwood chairs; Oriental
carpet; potted palms; and ballet slippers
Dimensions variable
Ten pen-and-ink drawings lent by Jamie Wolf,
Beverly Hills; ballet slippers lent by Barry Sloane,
Los Angeles
(pp. 11–14, 111, 121–25)

38 *Loves of a Ballerina,* 1986
Filmic installation consisting of dressing table
with mirror, mock railroad car and tracks,
and mock theater marquee, all incorporating
video projection; and mannequin with costume
and suitcase
Dimensions variable
(p. 127)

39 *From the Archives of Modern Art,* 1987
Videotape (black-and-white, with music sound
track, twenty-four minutes)
Courtesy Milestone Film and Video, New York
(p. 129)

40 *The Last Night of Rasputin,* 1989
Videotape transcription of 16-mm film (black-
and-white, silent with music sound track,
thirty-eight minutes)
Courtesy Milestone Film and Video, New York
(pp. 135–37)

41 *The Last Night of Rasputin,* 1989; revived 1999
Live performance, incorporating film of the
same title (no. 40)

42 *The Man without a World,* 1991
Videotape transcription of 16-mm film (black-
and-white, silent with music sound track,
ninety-eight minutes)
Courtesy of Milestone Film and Video, New York
(pp. 139–41)

43 *Vilna Nights,* 1993
Filmic installation consisting of stagelike
environment with three rear-screen video
projections
The Jewish Museum, New York
Gift through the Estate of Francis A. Jennings,
in memory of his wife, Gertrude Seder Jennings,
and an anonymous donor, 1997-130
Dimensions variable
(pp. 143, 145–47)

44 *Music Lessons,* 1997 (in collaboration with
David Antin)
Videotape transcription of 16-mm film (color,
with sound, forty-seven minutes)
Courtesy Paranoid Productions, San Diego
(p. 153)

45 *Waiting in the Wings,* 1999
Audio installation with stage props created
for this exhibition

Exhibition History

1982 La Mamelle, San Francisco. April 20–May 22

Jane Voorhees Zimmerli Art Museum, Rutgers University, New Brunswick, New Jersey. *Women Artists Series: Eleanor Antin* (catalogue). October 18–November 5

Minneapolis College of Art and Design. *Recollections of My Life with Diaghilev.* November 12–30

1983 Tortue Gallery, Santa Monica. *Eleanor Antin: Being Antinova.* July 15–August 27

Ronald Feldman Fine Arts, New York. *El Desdichado.* November 19–December 30

1986 Ronald Feldman Fine Arts, New York. *Loves of a Ballerina.* December 6–January 3, 1987

1988 MAG Galleries, Santa Monica. *Loves of a Ballerina.* February 19–March 12

Installation Gallery, San Diego. *Loves of a Ballerina.* March 19–April 24

Artemisia Gallery, Chicago. *Photographic Works.* December 1–30

1995 Ronald Feldman Fine Arts, New York. *Minetta Lane: A Ghost Story.* January 14–February 18

Santa Monica Museum of Art. *Minetta Lane: A Ghost Story.* April 8–June 11

Craig Krull Gallery, Santa Monica. *100 BOOTS Revisited.* April 22–May 27

1996 Southeastern Center for Contemporary Art, Winston-Salem, North Carolina. *Ghosts* (catalogue). May 4–July 28

1997 Whitney Museum of American Art, New York. *Eleanor Antin: Selections from "The Angel of Mercy"* (brochure). January 8–March 9

1998 Ronald Feldman Fine Arts, New York. *Eleanor Antin: Portraits of Eight New York Women, 1970.* May 9–June 13

1999 Craig Krull Gallery, Santa Monica. May 29–July 3

Selected Group Exhibitions

1969 Dwan Gallery, New York. *Language 3*

1970 Centro de Arte y Comunicación, Buenos Aires. *2.972.453* (catalogue). October 31–November 14

1971 Septième Biennale de Paris

Museum of Modern Art of Buenos Aires. *Art Systems*

Fine Arts Gallery, University of British Columbia, Vancouver. *Image Bank Postcard Show.* October 13–30

1972 Nova Scotia College of Art and Design, Halifax. February

Long Beach [California] Museum of Art. *Invisible, Visible: Twenty-one Artists* (catalogue). March 26–April 23

Montgomery Gallery, Pomona [California] College, in collaboration with the Libra Gallery, Claremont Graduate School, Claremont, California. *Art Form and Ideas: An Exhibition-Symposium.* April 23–May 7

Midland Group Gallery, Nottingham, England. *Experiment 2.* October 7–28

Focus Gallery, San Francisco. *Critic's Choice.* October 10–November 4

1973 Galerie Ursula Wevers, Cologne. *Projection*

Los Angeles County Museum of Art. *Dimensional Prints* (brochure). February 6–June 3

California Institute of the Arts, Valencia. *c. 7500* (catalogue). May. Traveled to Moore College of Art, Philadelphia; Wadsworth Atheneum, Hartford, Connecticut; Walker Art Center, Minneapolis; Royal College of Art, London; Smith College Museum of Art, Northampton, Massachusetts; Institute of Contemporary Art, Boston

Xerox Corporation, Rochester, New York. *Art of the 70s* (catalogue). May

1974 Cologne, *Project '74*

Kölnischer Kunstverein, Cologne. *Flash Art* (catalogue)

Focus Gallery, San Francisco. *Directions 74.* February 5–March 12

Artists Space, New York. *Personae.* April

Museum of the Philadelphia Civic Center. *Women's Work—American Art.* April–May

Samuel S. Fleisher Art Memorial, Philadelphia. *In Her Own Image.* April 5–May 18

Mount San Antonio College, Walnut, California. *Word Works* (catalogue). April 16–May 9

Palomar College, San Marcos, California. *Antin, Baldessari, Plagens.* October 22–November 20

1975 VIII São Paulo Biennale. *Video Art U.S.A.* (catalogue)

Espace Pierre Cardin, Paris. *Rencontre Internationale Ouverte de Video*

Institute of Contemporary Art, University of Pennsylvania, Philadelphia. *Video Art* (catalogue). January 17–February 25. Traveled to Contemporary Arts Center, Cincinnati; Museum of Contemporary Art, Chicago; Wadsworth Atheneum, Hartford, Connecticut

University of Maryland Art Gallery, College Park. *(photo) (photo)² . . . (photo)ⁿ: Sequenced Photographs* (catalogue). February 26–March 25. Traveled to San Francisco Museum of Art

Museum of Contemporary Art, Chicago. *Bodyworks* (catalogue). March 8–April 27

Long Beach [California] Museum of Art. *Southland Video Anthology I* (catalogue). June 8–September 7

La Jolla [California] Museum of Contemporary Art. *University of California, Irvine, 1965–1975* (catalogue). November 7–December 14

La Jolla [California] Museum of Contemporary Art. *The Irvine Milieu, 1965–75* (catalogue). November 18–December 14

Fine Arts Building, New York. *Lives.* November 29–December 20

Whitney Museum of American Art, Downtown Center, New York. *Autogeography: An Exploration of the Self through Film, Objects, Performances, and Video* (brochure). December 11–January 7

1976 80 Langton Street, San Francisco. *Video: Antin and Blanchard*

Venice, Italy. *37th Venice Biennale*

Los Angeles Institute of Contemporary Art. *Autobiographical Fantasies* (catalogue). January 13–February 20

University Art Museum, University of California, Berkeley. *Commissioned Video.* March 2–28

Mandeville Art Gallery, University of California, San Diego. *Faculty Art Exhibition* (catalogue). April 2–May 25

Museum of Fine Arts, Boston. *Changing Channels.* June 1–22

Long Beach [California] Museum of Art. *Southland Video Anthology II* (catalogue). Part 1: September 4–October 17; Part 2: October 23–January 9

1977 Holly Solomon Gallery, New York. *Surrogate Self*

Whitney Museum of American Art, Downtown Center, New York. *Words.* March 9–April 13

Museum of Contemporary Art, Chicago. *A View of a Decade* (catalogue). September 10–November 10

School of the Brooklyn Museum of Art, Brooklyn, New York. *Contemporary Women: Consciousness and Content.* October 1–27

Contemporary Arts Museum, Houston. *American Narrative/Story Art: 1967–77* (catalogue). December 17–February 25. Traveled to Fine Arts Museum, New Orleans; Winnipeg Art Gallery; University Art Museum, University of California, Berkeley; University Art Museum, University of California, Santa Barbara

Philadelphia College of Art. *Time* (catalogue). April 24–May 21

1978 Independent Curators Incorporated. *Sense of Self: From Self-Portrait to Autobiography* (catalogue). Traveled to Neuberger Museum of Art, Purchase College, State University of New York; New Gallery of Contemporary Art, Cleveland; University of North Dakota, Grand Forks; Alberta College of Art, Calgary; Tangeman Fine Art Gallery, University of Cincinnati; Allen Memorial Art Museum, Oberlin [Ohio] College

Museum of the American Federation for the Arts, Miami. *Storytelling in Art*

Institute of Contemporary Art, Boston. *Narration.* April 18–June 18

Philadelphia Museum of Art. *Eight Artists* (catalogue). April 29–June 25

Indianapolis Museum of Art. *Painting and Sculpture Today 1978* (catalogue). June 15–July 30

Franklin Furnace Archive, New York. *Art Words and Book.* June 20–August 26

Long Beach [California] Museum of Art. *Summer Video Archives.* June 25–September 17

Baxter Art Gallery, California Institute of Technology, Pasadena. *Making Senses: Proposal for a Children's Museum.* November 24–January 7

1979 Tiroler Landesmuseum Ferdinandeum, Innsbruck, Austria. *Kunst als Photographie 1949–1979* (catalogue). Traveled to Neue Galerie am Wolfgang Gurlitt Museum, Linz; Neue Galerie am Landesmuseum Joanneum, Graz; Museum des XX Jahrhunderts, Vienna.

Museum Bochum, Bochum, Germany. *Words Words.* Traveled to Palazzo Ducale, Genoa, Italy. January 27–March 14

Hampshire [Massachusetts] College. *Images of the Self* (catalogue). February 19–March 14

Hirshhorn Museum and Sculpture Garden, Smithsonian Institution, Washington, D.C. *Directions* (catalogue). June 14–September 3

Art Association of Newport [Rhode Island]. *Narrative Realism* (catalogue). August 18–September 16

Santa Barbara [California] Museum of Art. *Dialogue/Discourse/Research* (catalogue). September 1–October 28

Salt Lake Art Center, Salt Lake City. *Collaborations and Amplifications.* September 29–October 28

Visual Arts Gallery, School of Visual Arts, New York. *The Intimate Gesture.* October 2–22

1980 Graham Gallery, New York. *Originals.* January 15–February 20

High Museum of Art, Atlanta. *Contemporary Art in Southern California* (catalogue). April 26–June 10

Mandeville Art Gallery, University of California, San Diego. *Faculty Art Exhibition.* June 6–26

1981 Museum of Contemporary Art, Chicago. *California Performance*

Independent Curators Incorporated. *No Title: From the Collection of Sol Lewitt* (catalogue). Traveled to Wesleyan University Art Gallery and the Davison Art Center, Wesleyan University, Middletown, Connecticut; University Art Museum, California State University, Long Beach; Ackland Art Museum, University of North Carolina, Chapel Hill; Everhart Museum, Scranton, Pennsylvania; Grey Art Gallery, New York University; Museum of Art, Fort Lauderdale, Florida; Wadsworth Atheneum, Hartford, Connecticut

The New Museum of Contemporary Art, New York. *Alternatives in Retrospect: A Historical Overview 1969–1975* (catalogue). May 9–July 16

Newport Harbor [California] Art Museum. *Inside Out: Self beyond Likeness* (catalogue). May 22–July 12. Traveled to Portland [Oregon] Art Museum; Joslyn Art Museum, Omaha

Laguna [Laguna Beach, California] Art Museum. *Southern California Artists: 1940–80* (catalogue). July 24–September 13

Contemporary Arts Museum, Houston. *Other Realities: Installation for Performance* (catalogue). August 1–September 27

Judith Christian Gallery, New York. *Famous Californians.* September 18–October 14

The New Museum of Contemporary Art, New York. *Persona* (catalogue). September 19–November 12

1982 Ronald Feldman Fine Arts, New York. *War Games.* February 27–April 17

William Rockhill Nelson Gallery and Atkins Museum of Fine Arts, Kansas City, Missouri. *Repeated Exposure: Photographic Imagery in the Print Media* (catalogue). March 21–May 9

Ronald Feldman Fine Arts, New York. *Revolutions per Minute (The Art Record).* April 24–June 5. Traveled to Tate Gallery, London; School of the Art Institute of Chicago; Berkshire Museum, Pittsfield, Massachusetts

Emily Lowe Gallery, Hofstra University, Hempstead, New York. *Androgyny in Art* (catalogue). November 6–December 19

1983 California State University, Chico. *Performance as Art*. February 21–March 18

Dayton [Ohio] Art Institute. *Inside Self: Someone Else?* March 1–May 30

Carver Community Cultural Center, San Antonio, Texas. *The Writing's on the Wall*. May 26–June 19

Long Beach [California] Museum of Art. *At Home* (catalogue). September 4–November 6

Museum of Modern Art, New York. *Video Art: A History*. October 3–January 3

1984 American Federation of Arts, New York, traveling exhibition. *Revising Romance: New Feminist Video* (catalogue). Traveled to Institute of Contemporary Art, Boston; Walter Phillips Gallery, School of Fine Art, Banff, Alberta; Southwest Alternate Media Project, Houston; Women's Caucus for Art, Houston; Visual Studies Workshop, Rochester, New York; University Art Gallery, Ohio State University, Columbus; Neighborhood Film/Video Project, Philadelphia; Northwest Film Study Center, Portland, Oregon; Art Culture Resource Center, Toronto; International House, Philadelphia; American Museum of the Moving Image, New York; New Langton Arts, San Francisco; Long Beach [California] Museum of Art; Cornell Cinema, Cornell University, Ithaca, New York; Norman MacKenzie Art Gallery, University of Regina, Saskatchewan; Hobart and William Smith Colleges, Geneva, New York; Florida Atlantic University, Boca Raton; Image Co-Op, Montpelier, Vermont; Currier Gallery, Manchester, New Hampshire; Seattle Central Community College; Syracuse University; Dalhousie Art Gallery, Halifax, Nova Scotia; Real Art Ways, Hartford, Connecticut; Binghamton University, State University of New York; Webster University, St. Louis

Otis Art Institute of Parsons School of Design, Los Angeles. *Book Works*. January 3–February 11

Sidney Janis Gallery, New York. *American Women Artists: The Recent Generation* (catalogue). February 11–March 3

Institute of Contemporary Art, Boston. *New Soap Video*. March 22–April 17

Mandeville Art Gallery, University of California, San Diego. *Faculty Exhibition*. May 25–June 24

Koplin Gallery, Los Angeles. *Olympiad: Summer 1984*. July 14–August 29

Tortue Gallery, Santa Monica. *In Celebration*. July 14–September 1

Long Beach [California] Museum of Art. *Video: A Retrospective, Long Beach Museum of Art 1974–1984* (catalogue). September 9–November 4

Contemporary Arts Museum, Houston. *Video: Heroes/Anti-Heroes*. September 29–December 2

Hirshhorn Museum and Sculpture Garden, Smithsonian Institution, Washington, D.C. *Content: A Contemporary Focus, 1974–84* (catalogue). October 4–January 6

Massachusetts Institute of Technology, Cambridge. *On the Wall, On the Air: Artists Make Noise* (catalogue). December 15–January 27

1985 Milton and Sally Avery Center for the Arts, Edith C. Blum Institute, Bard College, Annandale-on-Hudson, New York. *The Maximal Implications of the Minimal Line* (catalogue). March 24–April 28

San Francisco Museum of Modern Art. *Signs of the Times: Some Recurring Motifs in Twentieth-Century Photography* (catalogue). May 10–July 14

San Francisco Museum of Modern Art. *Extending the Perimeters of Twentieth-Century Photography* (catalogue). August 2–October 6

Fine Arts Gallery, California State University, Los Angeles. *Black-and-White Drawings from the David Nellis Collection* (catalogue). September 23–October 18. Traveled to Del Webb Library, Loma Linda [California] University

The Palladium, New York. *Guerrilla Girls Exhibition*. October

1986 University Art Gallery, Sonoma State University, Rohnert Park, California. *With the Land: A Photographic Survey*. March 13–April 20

Turman Gallery, Indiana State University, Terre Haute. *Intimate/INTIMATE* (catalogue). March 22–April 22

1987	Photographers Gallery, London. *Photography as Performance* (catalogue). September 11–October 18

Fresno [California] Arts Center and Museum. *A Survey of California Women Artists, 1945 to the Present*

Schick Art Gallery, Skidmore College, Saratoga Springs, New York. *Self-Portraits: The Message, the Material.* January–March. Traveled to Emily Lowe Gallery, Hofstra University, Hempstead, New York

Installation Gallery, San Diego, Los Angeles Contemporary Exhibitions (LACE), and Foundation for Art Resources, Los Angeles. *Projections in Public: San Diego and Los Angeles.* April 3–May 2

Art Gallery, University of Wisconsin, Milwaukee. *Women's Autobiographical Artist's Books* (catalogue). October 18–November 22

American Film Institute, Los Angeles. *Video Festival.* October 22–25. Traveled to Neighborhood Film/Video Project, Philadelphia; Washington Project for the Arts, Washington, D.C.

University of California, Riverside. *Women Artists of the University of California Faculty* (catalogue). November 1–December 13. Traveled to University of California, Irvine; University of California, San Diego; University of California, Santa Barbara; University of California, Davis; University of California, Santa Cruz

International Center of Photography, New York. *Fabrications* (catalogue). November 11–30. Traveled to Carpenter Center for the Visual Arts, Harvard University, Cambridge

1988	The Katonah [New York] Gallery. *Self as Subject.* January 23–March 6

Institute of Contemporary Art, Boston. *Histories: New Video Art.* January 28–March 27

Mandeville Art Gallery, University of California, San Diego. *UC San Diego Faculty Exhibition.* April 6–May 15

Whitney Museum of American Art Downtown, at the Federal Reserve Plaza, New York. *Identity: Representations of the Self.* December 13–February 10

1989	Bound & Unbound, New York. *The Book Is in the Mail.* February

Cincinnati Art Museum. *Making Their Mark* (catalogue). February 22–April 2. Traveled to New Orleans Museum of Art; Denver Art Museum; Pennsylvania Academy of the Fine Arts, Philadelphia

Whitney Museum of American Art, New York. *Biennial Exhibition* (catalogue). April 18–July 9

Kunstverein Munich, West Germany. *Konstruierte Fotografie.* October 28–December 3. Traveled to Kunsthalle Nürnberg, Museum für Aktuelle Kunst, Bremen; and Kunstverein Karlsruhe

Paul Kasmin Gallery, New York. *URREALISM.* December 5–January 6

1990	Museum of Modern Art, New York. *Video and Myths.* January 4–February 27

University Art Gallery, Sonoma State University, Rohnert Park, California. *Photographs Updated: Similar Images/Dissimilar Motives.* March 15–April 12. Traveled to Santa Barbara [California] Museum of Art

Jan Kesner Gallery, Los Angeles. *Pharmacy.* April 6–May 12

Milton and Sally Avery Center for the Arts, Edith C. Blum Art Institute, Bard College, Annandale-on-Hudson, New York. *Art What Thou Eat* (catalogue). September 2–November 18. Traveled to New-York Historical Society

1991	California Museum of Photography, Riverside. *New Moves: Collaborations by Dancers and Videographers*

Bakersfield [California] Museum of Art. *Challenging Myths: Five Contemporary Artists.* March 28–May 5

Ronald Feldman Fine Arts, New York. *Editions, Prints, Photographs, Multiples.* June 12–August 15

1992	Laguna Art Museum, Laguna Beach, California. *Proof: Los Angeles Art and the Photograph, 1960–1980.* Traveled to DeCordova Museum and Sculpture Park, Lincoln, Massachusetts; Friends of Photography, Ansel Adams Center, San Francisco; Montgomery [Alabama] Museum of Art; Tampa [Florida] Museum of Art; Des Moines [Iowa] Art Center

Mandeville Art Gallery, University of California, San Diego. *Video Works by UCSD Faculty and Graduate Alumni.* January 11–February 9

1993 Armory Center for the Arts, Pasadena. *Intersections: Art and Play.* April 18–May 30

Exit Art, New York. *The Design Show: Exhibition Invitations in the U.S.A., 1940–1992.* May 1–July 24

The Jewish Museum, New York. *From the Inside Out: Eight Contemporary Artists* (catalogue). June 13–November 14

Ronald Feldman Fine Arts, New York. *Summer '93.* June 21–August 20

P.P.O.W., New York. *Disorderly Conduct.* July 7–August 6. Traveled to Hobart and William Smith Colleges, Geneva, New York; Carleton College, Northfield, Minnesota

Wexner Center for the Arts, Ohio State University, Columbus. *The First Generation: Women and Video, 1970–1975.* October

1994 Cleveland Center for Contemporary Art. *Outside the Frame: Performance and the Object.* Traveled to Newhouse Center for Contemporary Art, Snug Harbor Cultural Center, Staten Island, New York

Grey Art Gallery, New York University. *1969: A Year Revisited.* June 9–July 22

David Zwirner Gallery, New York. *Sampler: Southern California Video Collection.* November 5–December 4

1995 Exit Art/The First World, New York. *Endurance.* March 4–April 15. Traveled to University Galleries, Illinois State University, Normal

University Art Gallery, University of California, San Diego. *UCSD Visual Arts Faculty Exhibition.* April 7–May 20

Parrish Art Museum, Southampton, New York. *Face Value: American Portraits.* July 16–September 3. Traveled to Wexner Center for the Arts, Ohio State University, Columbus; Tampa [Florida] Museum of Art

Track 16 Gallery, Santa Monica. *Chain Reaction.* October 6–December 22

Museum of Contemporary Art, Los Angeles. *Reconsidering the Object of Art: 1965–1975* (catalogue). October 15–February 4

The Center for Curatorial Studies, Bard College, Annandale-on-Hudson, New York. *Sniper's Nest: Art That Has Lived with Lucy R. Lippard.* October 28–December 22. Traveled.

Museum of Contemporary Art, San Diego. *Common Ground.* November 5–February 10

1996 Museum of Contemporary Art, San Diego. *Art from the Permanent Collection*

Ronald Feldman Fine Arts, New York. *Withdrawing.* January 13–February 17

Armand Hammer Museum of Art and Cultural Center at UCLA, Los Angeles. *Sexual Politics: Judy Chicago's "Dinner Party" in Feminist Art History.* April 24–August 18

Laguna Art Museum, Laguna Beach, California. *Maiden California.* May 12–July 7

Nicole Klagsbrun Gallery, New York. *Making Pictures: Women and Photography, 1975 to Now (Part II).* December 14–January 21

1997 Sandra Gering Gallery, New York. *Dream of the Fisherman's Wife.* February 15–March 15

Centre National d'Art Contemporain, Grenoble. *Vraiment Feminisme et art.* April 6–May 25

Mandeville Art Gallery, University of California, San Diego. *UCSD Visual Arts Thirtieth Anniversary Faculty Exhibition.* April 10–May 24

The Center for Curatorial Studies, Bard College, Annandale-on-Hudson, New York. *Drawing Performance.* April 27–May 5

Bedford Gallery, Dean Lesher Regional Center for the Arts, Walnut Creek, California. *The Shoe Show.* September 11–November 2

Rhona Hoffman Gallery, Chicago. *No Small Feat: Investigations of the Shoe in Contemporary Art.* September 12–October 18

Performance History

Escape from the Tower
California Palace of the Legion of Honor, The
Fine Arts Museums of San Francisco
1976: The Clocktower, New York

The King's Meditations
Center for Music Experiment, University of
California, San Diego

1976 *It's Still the Same Old Story*
The Clocktower, New York

1974 *The Ballerina Goes to the Big Apple*
Woman's Building, Los Angeles
1975: Stefanotty Gallery, New York

Eleanor 1954
Woman's Building, Los Angeles

1975 *Battle of the Bluffs*
California Palace of the Legion of Honor, The
Fine Arts Museums of San Francisco
1976: Fine Arts Gallery, San Diego; American
Theater Association Convention, Los Angeles;
Venice Biennale, Venice, Italy; Los Angeles
Institute of Contemporary Art; The
Clocktower, New York. 1977: Contemporary
Arts Museum, Houston; Museum of
Contemporary Art, Chicago. 1978: Center for
Music Experiment, University of California,
San Diego; Student Lounge, University of
Houston. 1980: Alberta College of Art, Calgary;
Eleventh Annual International Sculpture
Conference, Ford's Theatre, Washington, D.C.;
National Women's Caucus, College Art
Association, New Orleans. 1981: Newport
Harbor [California] Art Museum; Concordia
University, Montreal; Western Front,
Vancouver, B.C. 1982: Emily Lowe Gallery,
Hofstra University, Hempstead, New York; La
Mamelle, San Francisco

1977 *The Angel of Mercy*
(with exhibition of photographs and props
of the same title)
M. L. D'Arc Gallery, New York; La Jolla
[California] Museum of Contemporary Art
1981: Los Angeles Institute of Contemporary Art

1979 *Before the Revolution*
The Kitchen Center for Video, Music, and
Dance, New York (subsequent related exhibi-
tion of performance props at Ronald Feldman
Fine Arts, New York; see solo exhibition histo-
ry in this volume); Santa Barbara Museum of
Art (with exhibition of drawings and perfor-
mance props)

1980 *Recollections of My Life with Diaghilev*
Ronald Feldman Fine Arts, New York (with
exhibition of drawings and performance
props); 80 Langton Street, San Francisco
1981: School of the Art Institute of Chicago;
Contemporary Arts Museum, Houston;
University of Regina, Saskatchewan. 1982:
Minneapolis College of Art and Design (with
exhibition of drawings and performance
props); Oklahoma Museum of Art, Oklahoma
City; Los Angeles Contemporary Exhibitions;
Sushi, San Diego; Espace DBD, Los Angeles.
1983: Tortue Gallery, Santa Monica; California
State University, Chico. 1984: Institute of
Contemporary Art, Boston; Dougherty Arts
Center, Austin; Randolph Street Gallery,
Chicago. 1985: American Studies Association
Tenth Biennial Convention, San Diego; Forum
Theater, sponsored by the Laguna [California]
Art Museum and the Laguna Beach School
of Art

1983 *El Desdichado*
Ronald Feldman Fine Arts, New York (with exhibition of performance props)

1984 *Student Days in Paris*
Radio Station WGBH, Boston

1986 *Help! I'm in Seattle*
Los Angeles Contemporary Exhibitions; Intersection, San Francisco; Lyceum Space, Horton Plaza, San Diego
1987: Franklin Furnace Archive, New York

1987 *Who Cares about a Ballerina?*
Bowery Theater, San Diego
1988: Anderson Center for the Arts, Binghamton University, State University of New York; Beyond Baroque Foundation, Venice, California

1989 *The Last Night of Rasputin*
(live performance, incorporating film of the same title)
Whitney Museum of American Art, New York; Portland [Oregon] Art Museum; Film Forum/Los Angeles Contemporary Exhibitions; Instituto de Estudios Norteamericanos, Barcelona; 8th Annual National Graduate Women's Studies Conference, University of Michigan, Ann Arbor
1990: Sushi, San Diego; Pacific Film Archives, Berkeley; Arizona State University, Tucson; Hirshhorn Museum and Sculpture Garden, Smithsonian Institution, Washington, D.C.
1991: Summer Arts Festival, Humboldt State University, Arcata, California. 1999: Los Angeles County Museum of Art; Chester Springs Studio Center for Visual Arts, Chester Springs, Pennsylvania

1998 *As Time Goes By*
Whitney Museum of American Art at Philip Morris, New York; Los Angeles Municipal Art Gallery

Film and Video History

<div>

1977 *The Nurse and the Hijackers*
Videotape (color, with sound, eighty-five
minutes)

1981 *The Angel of Mercy*
Videotape (color, with sound, sixty-six minutes)

1986 *It Ain't the Ballets Russes*
Film (16-mm, color, with sound, twenty-three
minutes)

1987 *From the Archives of Modern Art*
Videotape (compilation of six silent, black-
and-white, 16-mm films, with music sound
track, twenty-four minutes)

1989 *The Last Night of Rasputin*
Film (16-mm, black-and-white, silent with
music sound track, thirty-eight minutes)

1991 *The Man without a World*
Film (16-mm, black-and-white, silent with
music sound track, ninety-eight minutes)

1997 *Music Lessons*
(in collaboration with David Antin)
Film (16-mm, color, with sound, forty-seven
minutes)

</div>

1971 *Representational Painting*
Videotape (black-and-white, silent,
thirty-eight minutes)

1972 *The King*
Videotape (black-and-white, silent, fifty-two
minutes)

1973 *Caught in the Act*
Videotape (black-and-white, with sound,
thirty-six minutes)

1974 *The Ballerina and the Bum*
Videotape (black-and-white, with sound, fifty-
four minutes)

 The Bearded Ballerina
Videotape (black-and-white, with sound,
eighteen minutes)

1975 *The Little Match Girl Ballet*
Videotape (color, with sound, twenty-seven
minutes)

1976 *The Adventures of a Nurse*
Videotape (color, with sound, sixty-four
minutes)

 The Little Dancer
Videotape (color, three minutes)

Selected Bibliography

The entries in this bibliography are arranged chronologically.

Writings by the Artist

"Painter Poems." *Art and Literature,* no. 11 (winter 1967): 113–14.

"Women without Pathos." *Artnews* 69 (January 1971): 45. Reprinted in Thomas B. Hess and Elizabeth C. Baker, eds. *Art and Sexual Politics.* New York: Collier Books, 1973.

"Proposal for a Film Festival Exhibition." In "Two Proposals: The Ideas of Adrian Piper and Eleanor Antin." *Art and Artists* 6 (March 1972): 44–47.

"Out of the Box." *Artgallery* 15 (June 1972): 26.

"Episode from an Epistolary Novel." In *Breakthrough Fictioneers,* ed. Richard Kostelanetz. New York: Something Else Press, 1973.

"Painter Poems." In *Open Poetry,* ed. Ron Gross and George Quasha. New York: Simon and Schuster, 1973.

"Eleanor Antin's Recollections (from *Recollections of My Life with Diaghilev, 1909–1929*)." *Artweek* 4 (October 27, 1973): 6.

"Reading Ruscha." *Art in America* 61 (November–December 1973): 64–71.

"Letter to a Young Woman Artist," in *Anonymous Was a Woman: A Documentation of the Women's Art Festival, A Collection of Letters to Young Women Artists,* Miriam Schapiro, ed. Valencia, California: Feminist Art Program/California Institute of the Arts, 1974.

"Notes on Transformation." *Flash Art,* nos. 44–45 (March–April 1974): 68–69.

"An Autobiography of the Artist as an Autobiographer." *L.A.I.C.A Journal,* no. 2 (October 1974): 18–20.

"Video as Medium." *Art-Rite* (October 1974).

"Introduction" [guest editor statement]. in *L.A.I.C.A. Journal,* no. 4 (February 1975): 10.

"What Is Female Imagery? A Conversation between Antin, Chicago, Raven, Iskin, de Bretteville." *MS,* May 1975, 62–64, 80–83.

Statement in *University of California, Irvine, 1965–1975* (exhibition catalogue). La Jolla, California: La Jolla Museum of Contemporary Art, 1975, p. 88.

"Renunciations" and "Carving." In *Tri-Quarterly* (winter 1975).

"The King's Meditations." *Crawl out Your Window* (spring 1976).

"Olga Fyodorova's Story (from *Recollections of My Life with Diaghilev*)." *Sun & Moon: A Journal of Literature and Art,* nos. 6–7 (winter 1978–79): 83–91.

"Some Thoughts on Autobiography." *Sun & Moon: A Journal of Literature and Art,* nos. 6–7 (winter 1978–79): 80–82.

Before the Revolution. Santa Barbara, California: Santa Barbara Museum of Art, 1979.

Untitled letter by Antin to the editor discussing her "black transformation." *Chrysalis: A Magazine of Women's Culture* no. 10 (1980): 6–7.

"A Romantic Interlude (from *Recollections of My Life with Diaghilev*)." *Sun & Moon: A Journal of Literature and Art,* nos. 9–10 (summer 1980): 228–48.

"The Painters' Word: Thirty-nine Lofty Views on Picasso." *SoHo Weekly News,* May 21, 1980.

Profile: Eleanor Antin. Interview with Antin by Nancy Bowen and introduction by Arlene Raven. Chicago: Video Data Bank, School of The Art Institute of Chicago, 1981.

"Pocahontas." *Skew,* no. 1 (1981).

"My Friend, the Hijacker." *Paper Air* 2 (1981).

"Eleanora Antinova's Journal." *High Performance,* no. 13 (spring 1981): 48–57.

"Art Criticism Today—Multiple Views" [includes brief statement by Antin]. *Images & Issues* 2 (spring 1982): 40–41.

Being Antinova. Los Angeles: Astro Artz, 1983.

"Populism: Report from the Field." *Art Com,* no. 20 (1983).

"Antinova: Artist and Model." *Michigan Quarterly Review* (winter 1984).

"The Suicide (a new chapter from *Recollections of My Life with Diaghilev*)." *Zone* 10 (1985).

Eleanora Antinova Plays. Introduction by Henry Sayre; essay by Frantisek Deak. Los Angeles: Sun & Moon Press, 1994.

"Inventing the Past." *Performing Arts Journal,* no. 49 (1995): 54–58. Reprinted in *Ghosts.* Winston-Salem, North Carolina: Southeastern Center for Contemporary Art, 1996.

100 BOOTS. Introduction by Henry Sayre. Philadelphia: Running Press, 1999.

"The Last Night of Rasputin" [performance text]. *White Walls* no. 4 (forthcoming).

Selected Exhibition Catalogues

Dimensional Prints. Text by Joseph E. Young. Los Angeles: Los Angeles County Museum of Art, 1973.

Bodyworks. Text by Ira Licht. Chicago: Museum of Contemporary Art, 1975.

(photo) (photo)² . . . (photo)ⁿ: Sequenced Photographs. Text by David Bourdon. College Park, Maryland: University of Maryland Art Gallery, 1975.

Southland Video Anthology 1976–1977. Text by David Ross. Long Beach, California: Long Beach Museum of Art, 1976.

The Angel of Mercy. Texts by Jonathan Crary, Kim Levin, and Eleanor Antin. La Jolla, California: La Jolla Museum of Contemporary Art, 1977.

Matrix 34. Text by Andrea Keller. Hartford, Connecticut: Wadsworth Atheneum, 1977.

American Narrative/Story Art: 1967–1977. Texts by Alan Sondheim, Marc Freidus. Edited by Paul Schimmel. Houston: Contemporary Arts Museum, 1978.

Los Angeles in the Seventies. Text by Hal Glicksman. Fort Worth, Texas: Fort Worth Art Museum, 1978.

Dialogue/Discourse/Research. Text by William Spurlock. Santa Barbara, California: Santa Barbara Museum of Art, 1979.

Directions. Text by Howard N. Fox. Washington, D.C.: Smithsonian Institution Press, 1979.

Contemporary Art in Southern California. Text by Clark V. Poling. Atlanta: The High Museum of Art, 1980.

Alternatives in Retrospect: A Historical Overview 1969–1975. Texts by Jacki Apple, Mary Delahoyd. New York: The New Museum of Contemporary Art, 1981.

Persona. Texts by Lynn Gumpert and Ned Rifkin. New York: The New Museum of Contemporary Art, 1981

Androgyny in Art. Text by Gail Gelburd. Hempstead, New York: Joe and Emily Lowe Art Gallery, 1982.

At Home. Texts by Arlene Raven, Lyn Blumenthal, Barbara Pascal and Susan King, and Cheri Gaulke. Long Beach, California: Long Beach Museum of Art, 1983.

Content: A Contemporary Focus, 1974–1984. Texts by Howard N. Fox, Miranda McClintic, and Phyllis Rosenzweig. Washington, D.C.: Smithsonian Institution Press, 1984.

Diversity and Presence: Women Artists of the University of California Faculty. Text by Melinda Wortz. Riverside, California: University of California, Riverside, University Art Gallery, 1987.

8 Artists. Text by Anne D'Harnoncourt. Philadelphia: Philadelphia Museum of Art, 1988.

1989 Biennial Exhibition. Text by John Hanhardt. New York: Whitney Museum of American Art, 1989.

Making Their Mark: Women Artists Move into the Mainstream, 1970–1985. Texts by Ellen G. Landau, Calvin Tomkins, and Randy Rosen. New York: Abbeville Press in association with the Cincinnati Art Museum, 1989.

Art What Thou Eat: Images of Food in American Art. Texts by Donna Gustafson, Nan A. Rothschild, Kendall Taylor, Gilbert T. Vincent. Edited by Linda Weintraub. Annandale-on-Hudson, New York: The Edith C. Blum Institute, Bard College, 1991.

The First Generation: Women and Video, 1970–1975. Texts by JoAnn Hanley and Ann-Sargent Wooster. New York: Independent Curators Incorporated, 1993.

From the Inside Out: Eight Contemporary Artists. Texts by Arthur C. Danto and Susan Tamarkin Goodman. New York: The Jewish Museum, 1993.

Independent Video, Alternative Media. Chicago: The School of the Art Institute of Chicago, 1994.

Outside the Frame—Performance and the Object: A Survey History of Performance Art in the USA since 1950. Text by Gary Sangster. Cleveland: Cleveland Center for the Arts, 1994.

Face Value: American Portraits. Texts by Maurice Berger, Max Kozloff, Kenneth E. Silver, Michele Wallace, and Donna De Salvo. Southampton, New York: Parrish Art Museum, 1995.

Reconsidering the Object of Art: 1965–1975. Texts by Ann Goldstein, Anne Rorimer, Lucy R. Lippard, Stephen Melville, and Jeff Wall. Los Angeles: Museum of Contemporary Art, 1995.

Ghosts. Texts by Eleanor Antin and Henry Sayre. Winston-Salem, North Carolina: Southeastern Center for Contemporary Art, 1996.

Sexual Politics: Judy Chicago's "Dinner Party" in Feminist Art History. Texts by Laura Cottingham, Amelia Jones, Susan Kandel, Anette Kubitza, Laura Meyer, and Nancy Ring. Berkeley and Los Angeles: University of California Press in association with UCLA at the Armand Hammer Museum of Art and Cultural Center, 1996.

Sniper's Nest: Art That Has Lived with Lucy R. Lippard. Edited by David Frankel. Annandale-on-Hudson, New York: Center for Curatorial Studies, Bard College, 1996.

Out of Actions: Between Performance and the Object, 1947–1979. Texts by Kristine Stiles, Guy Brett, Hubert Klocker, Shinichiro Osaki, and Paul Schimmel. Los Angeles: Museum of Contemporary Art, 1998.

Books

Hess, Thomas B., and Elizabeth C. Baker, eds. *Art and Sexual Politics.* New York: Collier Books, 1973.

Lippard, Lucy R. *Six Years: The Dematerialization of the Art Object.* New York: Praeger Press, 1973.

Nemser, Cindy. *Art Talk: Conversations with Twelve Women Artists.* New York: Charles Scribner's Sons, 1975.

Bonito Oliva, Achille. *Europe/America: The Different Avant-Gardes.* Milan: Deco Press, 1976.

Lippard, Lucy R. *From the Center: Feminist Essays on Women's Art.* New York: Dutton, 1976.

Schneider, Ira, and Beryl Korot. *Video Art: An Anthology.* New York: Harcourt Brace Jovanovich, 1976.

Wilding, Faith. *By Our Own Hands: The Women Artists' Movement, Southern California 1970–1976.* Santa Monica: Double X, 1977.

Munro, Eleanor. *Originals: American Women Artists.* New York: Simon and Schuster, 1979.

Himmelstein, Hal. *On the Small Screen.* New York: Praeger Press, 1981.

Rubinstein, Charlotte Streifer. *American Women Artists: From Early Indian Times to the Present.* Boston: G. K. Hall, 1982.

Contemporary Artists. 2nd ed. New York: St. Martin's Press, 1983.

Gruber, Bettina, and Maria Vedder. *Kunst und Video, Internationale Entwicklung und Künstler.* Cologne, Germany: DuMont Buchverlag, 1983.

Pincus-Witten, Robert. *Entries (Maximalism): Art at the Turn of the Decade.* New York: Out of London Press, 1983.

Roth, Moira, ed. *The Amazing Decade: Women and Performance Art in America, 1970–1980.* Los Angeles: Astro Artz, 1983.

Crane, Michael, and Mary Stofflet, eds. *Correspondence Art.* San Francisco: Contemporary Arts Press, 1984.

Hertz, Richard. *Theories of Contemporary Art.* Englewood Cliffs, New Jersey: Prentice Hall, 1985.

Heller, Nancy G. *Women Artists: An Illustrated History.* New York: Abbeville Press, 1987.

Hoy, Anne. *Staged, Altered, and Appropriated Photographs.* New York: Abbeville Press, 1987.

Goldberg, RoseLee. *Performance Art: From Futurism to the Present.* New York: Harry N. Abrams, 1988.

Levin, Kim. *Beyond Modernism: Essays on Art from the '70s and '80s.* New York: Harper and Row, 1988.

Raven, Arlene. *Crossing Over: Feminism and Art of Social Concern.* Ann Arbor, Michigan: UMI Research Press, 1988.

Sayre, Henry M. *The Object of Performance: The American Avant-Garde since 1970.* Chicago: University of Chicago Press, 1992.

Kostelanetz, Richard, et al. *Dictionary of the Avant-Gardes.* Chicago: Chicago Review Press, 1993.

Slotkin, Wendy. *The Voices of Women Artists.* Englewood Cliffs, New Jersey: Prentice Hall, 1993.

Broude, Norma, and Mary D. Garrard, eds. *The Power of Feminist Art: The American Movement of the 1970s, History and Impact.* New York: Harry N. Abrams, 1994.

Lippard, Lucy R. *The Pink Glass Swan: Selected Feminist Essays on Art.* New York: The New Press, 1995.

Welch, Chuck, ed. *Eternal Network: A Mail Art Anthology.* Calgary: University of Calgary Press, 1995.

Stiles, Kristine. *Theories and Documents of Contemporary Art: A Sourcebook of Artists' Writings.* Berkeley and Los Angeles: University of California Press, 1996.

Gaze, Delis, ed. *Dictionary of Women Artists.* Vol. 1. London and Chicago: Fitzroy Dearborn Publishers, 1997.

Jones, Amelia, and Andrew Stephenson, eds. *Performing the Body/Performing the Text.* London: Routledge, 1999.

Soussloff, Catherine, ed. *Jewish Identity in Art History: Ethnicity and Discourse.* Berkeley and Los Angeles: University of California Press, 1999.

Boezello, Frances. *Seeing Ourselves: A History of Women's Self-Portraiture.* London: Thames and Hudson, 1999.

Warr, Tracey, ed. *The Artist's Body.* London: Phaidon (forthcoming).

Periodicals and Newspapers

1970

Alloway, Lawrence. "Art." *The Nation* 210 (February 23): 222.

Henry, Gerrit. "Eleanor Antin." *Artnews* 69 (March): 10.

Atirnomis. "Antin at Gain Ground." *Arts Magazine* 44 (April): 66.

Goldin, Amy, and Robert Kushner. "Conceptual Art as Opera." *Artnews* 69 (April): 40–43.

Perreault, John. "Art: Pushing It." *Village Voice,* December 10, p. 24.

1971

Henry, Gerrit. "New York Letter." *Art International* 15 (January): 37–42.

Baker, Elizabeth C. "Los Angeles, 1971." *Artnews* 70 (September): 27–39.

Richard, Paul. "The Saga of 100 Empty Boots." *Washington Post,* September 14, p. B-9.

Morris, Michael. "Greetings from Image Bank: The Image Bank Postcard Show." *Artscanada,* nos. 162/163 (December 1971/January 1972): 133–36.

1972

"Aware: Art as Library Science." *American Libraries* 3, no. 2 (February): 184–85.

Lippard, Lucy R. "Two Proposals: The Ideas of Adrian Piper and Eleanor Antin." *Art and Artists* 6 (March): 44–47.

Wilson, William. "Art Walk: A Critical Guide to the Galleries." *Los Angeles Times,* September 15, sec. 4, p. 4.

Nix, Marilyn. "Eleanor Antin's 'Traditional Art.'" *Artweek* 3 (September 16): 3.

Plagens, Peter. "Eleanor Antin at Orlando Gallery." *Artforum* 11 (November): 87–89.

Forgey, Ben. "Conceptual Shows Blossom Here." *Washington Star,* December 10, sec. H, p. 8.

Gold, Barbara. "Portrait of the Artist as an Exhibitionist." *Baltimore Sun,* December 17.

1973

Winer, Helene. "Show Launches Womanspace." *Los Angeles Times,* February 5, sec. 4, p. 7.

Wilson, William. "Exhibit of Prints at Museum." *Los Angeles Times,* February 12, sec. 4, p. 2.

Bourdon, David. "Washington Letter." *Art International* 17 (April): 65–68.

Johnston, Laurie. "100 Boots to End Cross-Country 'March' at Museum." *New York Times,* May 16.

Loercher, Diana. "Tramp, Tramp, Tramp, the Boots Are Marching." *Christian Science Monitor,* June 22, p. 11.

Marvel, Bill. "These Boots Were Made for Mailing." *National Observer,* June 30, p. 22.

Kozloff, Max. "Junk Mail: An Affluent Art Movement." *Art Journal* 33 (fall): 27–31.

Frank, Peter. "Eleanor Antin (Museum of Modern Art)." *Artnews* 72 (September): 86.

Goldwasser, Noë. "From Boot Hill to the Bronx." *Crawdaddy* (September).

Terbell, Melinda. "Cups, Ballet, Funny Video." *Artnews* 72 (December): 72–73.

1974

Albright, Thomas. "Art Photography Is Out." *San Francisco Chronicle,* February 19.

Nemser, Cindy. "*In Her Own Image* Exhibition Catalog (published in conjunction with the exhibition *In Her Own Image* at Samuel S. Fleisher Art Memorial, Philadelphia)." *Feminist Art Journal* 3 (spring): 11–18.

Curran, Darryl. "Photography in L.A." *L.A.I.C.A. Journal,* no. 1 (June): 40.

Schapiro, Miriam. "Dialogue of Women Artists." *L.A.I.C.A. Journal,* no. 1 (June): 33–35.

Kessler, Charles. "Eleanor Antin at Womanspace." *Art in America* 62 (July–August): 95–96.

1975

Barracks, Barbara. "Pieces of Antin." *Unmuzzled Ox,* no. 2.

Frank, Peter. "Performance and/or Publications." *SoHo Weekly News,* January 30.

Goldin, Amy. "The Post-Perceptual Portrait." *Art in America* 63 (January–February): 79–82.

Moore, Alan. "Eleanor Antin at Stefanotty Gallery." *Artforum* 13 (March): 79–81.

Nemser, Cindy. "Four Artists of Sensuality." *Arts Magazine* 49 (March): 73–75.

Duncan, Carol. "When Greatness Is a Box of Wheaties." *Artforum* 14 (October): 60–64.

Lippard, Lucy R. "Transformation Art." *Ms,* October, 33–39.

Frankenstein, Alfred. "Artist Should Stick to Her Trade." *San Francisco Chronicle,* November 8.

Antin, David. "Television: Video's Frightful Parent." *Artforum* 14 (December): 36–45.

1976
Ballatore, Sandy. "Eleanor Antin: *Battle of the Bluffs.*" *Artweek* 7 (February 7): 7.

Frank, Peter. "Eleanor Antin: Wishes, Lies, and Dreams." *SoHo Weekly News,* February 19.

Crary, Jonathan. "Eleanor Antin." *Arts Magazine* 50 (March): 8.

Marmer, Nancy. "'Autobiographical Fantasies' at Los Angeles Institute of Contemporary Art." *Artforum* 14 (April): 75–77.

Perlmutter, Elizabeth. "Salton Sea to Muscle Beach." *Artnews* 75 (April): 66–68.

Preisman, Fran. "UC San Diego Faculty." *Artweek* (April 17): 1, 16.

Alloway, Lawrence. "Women's Art in the 70s." *Art in America* 64 (May–June): 64–72.

Lippard, Lucy R. "The Pains and Pleasures of Rebirth: Women's Body Art." *Art in America* 64 (May–June): 73–81.

Foote, Nancy. "The Anti-Photographer." *Artforum* 15 (September): 46–54.

Frank, Peter. "Auto-art: Self-indulgent? And how!" *Artnews* 75 (September): 43–48.

Levin, Kim. "Narrative Landscape on the Continental Shelf: Notes on Southern California." *Arts Magazine* 51 (October): 94–97.

Davis, Douglas. "The Size of Non-Size." *Artforum* 15 (December): 46–51.

1977
Russell, John. "Eleanor Antin's Historical Daydream." *New York Times,* January 30, sec. 2, p. 37.

Levin, Kim. "Video Art in the Television Landscape." *L.A.I.C.A. Journal,* no. 13 (January–February): 12–17.

Jennings, Jan. "Performance Art: What You See Is What It Is." *San Diego Evening Tribune,* February 1.

Cavaliere, Barbara. "Eleanor Antin." *Arts Magazine* 51 (March): 27.

Levin, Kim. "Eleanor Antin." *Arts Magazine* 51 (March): 19.

Moore, Sylvia. "Eleanor Antin." *Feminist Art Journal* 6 (spring): 35.

Perlberg, Deborah. "Eleanor Antin at M. L. D'Arc." *Artforum* 15 (April): 68.

Rosler, Martha. "The Private and the Public: Feminist Art in California." *Artforum* 16 (September): 66–74.

Frackman, Noel. "Eleanor Antin." *Arts Magazine* 52 (December): 18.

1978
Agalidi, Sanda. "Paragraphs." *L.A.I.C.A. Journal,* no. 17 (January–February): 48–49.

Moore, Alan. "Eleanor Antin." *Artforum* 13 (April): 18.

Hoberman, J. "The Maya Mystique." *Village Voice,* May 15, p. 54.

Rickey, Carrie. "From Balletomane to Balletomanic." *SoHo Weekly News,* May 25.

Roth, Moira. "Toward a History of California Performance: Part Two." *Arts Magazine* 52 (June): 114–23.

Robinson, Walter. "Storytelling, Infantilism, and Zoöphily." *L.A.I.C.A. Journal,* no. 19 (June–July): 29–30.

Rubinfein, Leo. "Through Western Eyes: Interviews." *Art in America* 66 (September–October): 75–77.

Knight, Christopher. "History/Art." *L.A.I.C.A. Journal,* no. 20 (October–November): 27–29.

1979
Marranca, Bonnie. "Eleanor Antin, Before the Revolution." *Performance Art,* no. 1: 41–42.

Muchnic, Suzanne. "Antin's 'Nurse' in Long Beach." *Los Angeles Times,* January 22, sec. 4, p. 9.

Clarke, John R. "Life/Art/Life, Quentin Crisp and Eleanor Antin: Notes on Performance in the Seventies." *Arts Magazine* 53 (February): 131–35.

Rickey, Carrie. "Eleanor Antin, Long Beach Museum of Art." *Artforum* 17 (March): 72.

Burnside, Madeleine. "Eleanor Antin (Ronald Feldman Fine Arts)." *Artnews* 78 (May): 167.

Cavaliere, Barbara. "Eleanor Antin (Ronald Feldman, The Kitchen)." *Arts Magazine* 53 (May): 29–30.

Pincus-Witten, Robert. "Entries: Cutting Edges." *Arts Magazine* 53 (June): 105–9.

Raven, Arlene, and Deborah Marrow. "Eleanor Antin: What's Your Story?" *Chrysalis: A Magazine of Woman's Culture,* no. 8 (summer): 43–51.

1980
Spurlock, William. "Out of the Studio and into the World: Social and Ecological Issues in Contemporary Art." *National Arts Guide* 2 (March– April): 6–11.

Agalidi, Sanda. "A Barbizon of Performance: What's Cooking? III." *Images & Issues,* no. 1 (summer).

Messerli, Douglas. "Experiment and Traditional Forms in Contemporary Literature." *Sun & Moon: A Journal of Literature and Art,* nos. 9–10 (summer): 3–25.

Larson, Kay. "For the First Time Women Are Leading Not Following." *Artnews* 79 (October): 64–72.

Roth, Moira. "Visions and Re-Visions." *Artforum* 19 (November): 36–39.

1981
Casademont, Joan. "Eleanor Antin, Ronald Feldman Gallery." *Artforum* 19 (January): 73–74.

Gerrit, Henry. "Eleanora Antinova at Ronald Feldman." *Art in America* 69 (January): 128–29.

Levin, Kim. "Eleanora Antinova." *Flash Art,* no. 101 (January–February): 52.

Cavaliere, Barbara. "Eleanor Antin/Eleanora Antinova." *Arts Magazine* 55 (February): 33.

Pincus-Witten, Robert. "Entries: Maximalism." *Arts Magazine* 55 (February): 172–76.

McCambridge, Janet Frye. "Ten from Academe: Ten Artists Talk about Teaching Performance." *High Performance,* no. 13 (spring): 62–63.

Hicks, Emily. "Eleanor Antin: Narrative Juxtapositions." *Artweek,* no. 21 (June 6): 5–6.

Kalil, Susie. "Performance Recorded through Installation Site." *Artweek,* no. 30 (September 19): 1, 16.

Davis, Douglas. "Post-Performancism." *Artforum* 20 (October): 31–39.

Zelevansky, Lynn. "Is There Life after Performance?" *Flash Art,* no. 105 (December–January): 38–42.

1982
Crary, Jonathan. "War Games: Of Arms and Men." *Arts Magazine* 56 (April): 77–79.

Roth, Moira. "Art in the 1980s: A Turn of Events." *Studio International* 195 (June): 16–24.

Ballatore, Sandy. "Reverberations/Revelations (The Art Record)." *Images & Issues* 3 (September–October): 26–27.

1983
[Hoffberg, Judith A.] "Being Antinova." *Umbrella* 6 (September): 111.

Danieli, Fidel. "Eleanor Antin at Tortue." *Images & Issues* 4 (November–December): 59–60.

1984
Deak, Frantisek. "Eleanor Antin: Before the Revolution—Acting as an Art Paradigm." *Images & Issues* 4 (January–February): 20–24.

Zelevansky, Lynn. "Eleanor Antin—Ronald Feldman Fine Arts." *Artnews* 83 (March): 218, 220.

McEvilley, Thomas. "Eleanor Antin: 'El Desdichado' (The Unlucky One)." *Artforum* 22 (April): 77.

Messerli, Douglas. "The Role of Voice in Nonmodernist Fiction." *Contemporary Literature* 25 (fall): 281–304.

Crary, Jonathan. "Eleanor Antin." *Arts Magazine* 59 (November): 19.

Agalidi, Sanda. "Antin/Antinova: The Self as an Art Medium." *Michigan Quarterly Review* 23, no. 1 (winter): 49–64.

1985
Sturken, Marita. "Revising Romance: New Feminist Video." *Art Journal* 45 (fall): 273–77.

Hulser, Kathleen. "Love Stories: A Traveling Show of Feminist Video Offers a Jaundiced View of Romance." *American Film* 11 (November): 63.

1986
Durland, Steven. "Eleanor Antin: *Help! I'm in Seattle.*" *High Performance,* no. 34: 72–73.

Withers, Josephine. "Eleanor Antin: Allegory of the Soul." *Feminist Studies* 12 (spring): 117–22 (and seven unnumbered pages of illustrations).

Sayre, Henry. "Antinova Dances Again." *Artweek* 17 (May 31): 7.

Weiner, Bernard. "Seventy-five Aimless Minutes of Monotonous Monologue." *San Francisco Chronicle*, October 11, p. 38.

Welsh, Anne-Marie. "*Help! I'm in Seattle*: A Low-Key Hybrid of Sorts." *San Diego Union*, November 11, sec. C, p. 8.

McCoy, Ann. "Meditations on the Red Mass." *Bomb*, no. 14 (winter): 38–41.

1987
Martin, Carol. "Eleanor Antin: *Loves of a Ballerina*." *High Performance*, no. 37: 89–90.

Agalidi, Sanda. "Eleanor Antin: *Who Cares about a Ballerina?*" *High Performance*, no. 39: 87.

Carr, C. "Skin Games." *Village Voice*, February 3, p. 85.

Kidder, Gayle. "Antin Pulls It All Together." *San Diego Union*, March 6, sec. E, pp. 1, 5.

Jones, Welton. "This 'Ballerina' Isn't the Stuff of Legends." *San Diego Union*, March 7, sec. D, p. 8.

Grundberg, Andy. "The 80s Seen through a Postmodern Lens." *New York Times*, July 12, sec. C, pp. 1, 29.

1988
Raynor, Vivien. "Self as Subject Examined in Several Mediums in Katonah." *New York Times*, February 7, sec. C, p. 36.

Apple, Jacki. "Altered Egos: The Many Lives of Performance Artist Eleanor Antin." *L.A. Weekly*, February 26–March 3, pp. 34–35.

Freudenheim, Susan. "No Laugh Track Needed for *Loves*." *San Diego Tribune*, March 30, sec. C, pp. 1–2.

Ollman, Leah. "Artist Antin's Installations Span Time." *Los Angeles Times*, April 1, sec. B, p. 29.

Apple, Jacki. "Dreaming of a Ballerina." *Artweek* 19 (April 16): 1.

1989
Woodward, Richard. "Documenting an Outbreak of Self-Presentation." *New York Times*, January 22, sec. H, pp. 31, 35.

Goldring, Nancy. "Identity: Representations of the Self." *Arts Magazine* 63 (March): 85.

Glueck, Grace. "In a Roguish Gallery: One Aging Black Ballerina." *New York Times*, May 12, sec. C, p. 3.

Carr, C. "Re-Visions of Excess." *Village Voice*, May 30, p. 91.

Cadet, Nancy. "Eleanor Antin: *The Last Night of Rasputin*." *High Performance* 47 (fall): 62–63.

Frank, Peter. "Eleanor Antin: *The Last Night of Rasputin*." *L.A. Weekly*, November 17–23, p. 126.

Agalidi, Sanda. "Rasputin Returns: Eleanor Antin at L.A.C.E." *Artweek* 20 (December 21): 12–13.

1990
Roberts, Prudence. "Eleanor Antin at Los Angeles Contemporary Exhibitions." *Art Issues*, no. 9 (February): 26.

Lineberry, Heather S. "Eleanor Antin: *The Last Night of Rasputin*." *Artspace* 14 (July–August): 66–67.

Anderson, Michael. "*Pharmacy* at Jan Kesner." *Art Issues*, no. 12 (summer): 31.

Barker, Stephen. "The Body in Art: New Images of Self." *Artweek* 21 (October): 21–23.

1991
Brass, Kevin. "Modern Silent Movie Re-creates Genre of the 20s." *Los Angeles Times*, June 8, sec. F, pp. 1, 9.

Kalish, John. "Art, Exile, and Anarchy in a Polish Village." *The Forward*, July 26, pp. 10–11.

Brown, Brenda. "Avant-Gardism and Landscape Architecture." *Landscape Journal* 10, no. 2 (fall): 134–54.

Samaras, Connie. "Look Who's Talking." *Artforum* 30 (November): 102–6.

1992
Eiley, Derek. "The Man without a World." *Variety*, March 23.

Turan, Kenneth. "Excess Imagination Fills *The Man without a World*." *Los Angeles Times*, May 20, sec. F, p. 4.

Puig, Claudia. "Leading Women." *Los Angeles Times*, June 13, sec. B, p. 3.

Hoberman, J. "It's Déjà Vu All Over Again." *Premiere* (July): 31–33.

Bonetti, David. "Taking Their Battles to the Gallery." *San Francisco Examiner*, August 11.

Buck, Joan Juliet. "Movies: The Man without a World." *Vogue*, September, 294.

Leacock, Victoria. "Eleanor Antin: A Director of Invention." *Interview*, September, 36.

Shandler, Jeffrey. "Postmodern Shtetl." *The Forward*, September 5, pp. 1, 10.

Carroll, Kathleen. "Silent Man Is Eloquent." *New York Daily News,* September 9.

Holden, Stephen. "Ruse Serves Artificiality, Elaborately." *New York Times,* September 9, sec. C, p. 18.

Kalish, John. "A Director's Silent View." *New York Newsday,* September 9, pp. 48, 69.

Tallmer, Jerry. "The Man without a World." *New York Post,* September 10.

Brown, Georgia. "A World Apart." *Village Voice,* September 15, p. 66.

Hoberman, J. "Voice Choices: *The Man without a World.*" *Village Voice,* September 15, p. 76.

Insdorf, Annette. "Jewish Life Explored in Strange Feature." *San Francisco Chronicle,* October 18, "Datebook," p. 39.

Guthmann, Edward. "Modern-Day Silent Honors Yiddish Classic." *San Francisco Chronicle,* October 21, sec. E, p. 4.

Kissin, Eva H. "The Man without a World." *Films in Review* 42 (November–December): 415–16.

1993
Sherman, Betsy. "Mock 'Lost' Yiddish Silent Film Captures a Grim World." *Boston Globe,* February 12, p. 56.

Saltz, Jerry. "Let Us Now Praise Artists' Artists." *Art & Auction* 15 (April): 74–79, 115.

Lenowitz, Harris. "The Pig in the Market, the Braid in the Mikveh: What's Wrong with the Picture?" *Visions: Art Quarterly* 6 (spring).

Lipson, Karin. "A Museum Reborn." *New York Newsday,* June 11, pp. 62–63.

Solomon, Deborah. "Mansion Site Enlarged, Renovated." *Wall Street Journal,* June 11, sec. A, p. 8.

Kimmelman, Michael. "A Museum Finds Its Time." *New York Times,* June 13, sec. H, pp. 1, 33.

Larson, Kay. "The Ties That Bind." *New York,* July 12, p. 62.

1994
Durland, Steven. "Fine Art, Farm Art, and Funding." *High Performance* 17 (spring): 29.

Apple, Jacki. "Performance Art Is Dead: Long Live Performance Art!" *High Performance,* no. 66 (summer): 54–59.

Cotter, Holland. "1969: A Year Revisited." *New York Times,* July 15, sec. C, p. 23.

1995
Garrett, Shawn-Marie. "Pas de Deux." *Theatre* 25 (no. 3): 96–98.

Karmel, Pepe. "Eleanor Antin: *Minetta Lane: A Ghost Story.*" *New York Times,* February 3, sec. C, p. 27.

Johnson, Ken. "Eleanor Antin at Ronald Feldman." *Art in America* 83 (April): 107–8.

Ollman, Leah. "Ever the 'Wicked Little Girl.'" *Los Angeles Times,* April 2, "Calendar," pp. 6, 92.

Hoberman, J. "Artists Invent a New Jewish Tradition: Diasporama!." *Village Voice,* April 18, p. 29.

Kandel, Susan. "BOOTS Postcard Series Gets Across Message." *Los Angeles Times,* April 27, sec. F, p. 7.

Wilson, William. "Three Windows on Antin's 'Ghost Story.'" *Los Angeles Times,* May 12, sec. F, p. 28.

Hirsch, Faye. "Spotlight: Eleanor Antin." *Flash Art,* no. 183 (summer): 123.

Howell, George. "Anatomy of an Artist: An Interview with Cindy Sherman." *Art Papers* 19 (July–August): 2–7.

Skoller, Jeffrey. "The Man without a World." *Film Quarterly* 49 (fall): 28–32.

McKenna, Kristine. "It's Art, Because They Say It's Art." *Los Angeles Times,* October 8, "Calendar," pp. 6–7, 60.

1996
Joselet, David. "Object Lessons." *Art in America* 84 (February): 68–71, 107

Greenstein, M. A. "And You Thought Feminism Was Dead? Judy Chicago's *Dinner Party* in Feminist Art History." *Artweek* 27 (July): 17–18.

Skoller, Jeffrey. "The Shadows of Catastrophe: Towards an Ethics of Representation in Films by Antin, Eisenberg, and Spielberg." *Discourse: Theoretical Studies in Media and Culture* 19 (fall): 131–59.

Zweig, Ellen. "Constructing Loss: Film and Presence in the Work of Eleanor Antin." *Millennium Film Journal* 29 (fall): 34–41.

Author's Acknowledgments

Ofttimes the more complex and difficult to pull together an exhibition is, the greater the felicity in thanking those whose efforts, skills, insights, or support helped to transform an inchoate vision into a full-fledged show. Organizing this exhibition was unusually challenging, for many of the works it brings together were ephemeral in the first place. In other cases, what physically survived, particularly of many of Antin's early installations, was incomplete.

Thus it took a considerable leap of faith on the part of my curatorial colleagues, director Graham W. J. Beal, president and chief executive officer Andrea L. Rich, and the museum's board of trustees to endorse this project. But all agreed that the challenge of organizing the show should be met, and I remain grateful to them all.

I was truly impressed by the eager anticipation the project seemed to generate everywhere. None was more gratifying or rewarding than the enthusiastic interest of the Fellows of Contemporary Art, under the leadership of current chairman David Partridge and his predecessors Joan Rehnborg and Diane Cornwell, and respectively, the current and previous long-range exhibition committee chairs, Tina Petra and Linda Polesky. When members of the Fellows heard about the project, I was invited to submit a proposal for possible funding. The organization responded with swift, generous sponsorship of the exhibition and this catalogue. I have particularly enjoyed working with exhibition liaison Suzanne Deal Booth, who is a gifted ambassador of a sister arts organization as well as a patron of the arts, and with administrative director Merry Scully.

At the museum, acting director of development Tom Jacobson was the consummate and ever gracious steward of our collaboration with the Fellows in producing this exhibition. Exhibitions program coordinator Christine Weider Lazzaretto and Irene Martín, assistant director of exhibition programs, shepherded the project through its many fiscal and institutional acrobatics, with lithe results. I thank each and all.

Special thanks are due to assistant registrar Jennifer Walchli to whom fell the formidable task of retrieving, transporting, inventorying, and keeping track of the myriad components of Antin's multifaceted installations, enabling us, in essence, to use the museum as a staging ground to reconstitute much of her work. Acting head of conservation Victoria Blyth-Hill, associate conservator Don Menveg, assistant paper conservator Margot Healy, and conservation technician Jean Neeman ministered to the physical health of the works in the show. Though most of the works were lent by the artist, there were several private and institutional lenders whom I thank for helping to ensure a full representation of Antin's oeuvre.

Antin and I conceived the installation of the exhibition as an artistic project in its own right, and we brought some revisionist innovations to bear. For example, while in the past she might have exhibited her faux antique photographs of *The Angel of Mercy* in a neutral white gallery, we decided for this installation to turn the gallery space into a period room, in keeping with the spirit of the artworks. We worked closely with exhibition designer Bernard Kester, who brought his technical savvy and adroit aesthetic sense to our mission of effecting a careful balance between sheer theatricality and a thoughtful display of objects. It was most enjoyable working with him.

Assistant vice president of operations Arthur Owens and his staff turned Bernard's designs into actual construction, and technical services coordinator Kathryn Marsailes and her crew expertly installed the exhibition. Special thanks also go to Elvin Whitesides, manager of the museum's audio-visual department, for installing, coordinating, and maintaining the many film and video components of this complex presentation.

This catalogue, the first ever devoted to a comprehensive survey of the work of Eleanor Antin, is the production of numerous talented individuals. Former intern Rachel Guggelberger amassed all the preliminary research toward the bibliography and exhibition history, and our department's longtime volunteer and great friend, Roz Leader, brought Rachel's excellent work to fruition here. It was a pleasure to work with guest contributor Lisa Bloom, whose thoughtful essay has brought an important perception to this document. Nola Butler conferred upon this volume her consistently really good judgment and the graces of finely edited prose. The design team of Judith Lausten and Renée Cossutta, inspired in part by the museum's head graphic designer Jim Drobka, couched our prose in something closer to poetry in the handsome design of this book. Steve Oliver brought his noted skills to all of the in-house photography. Rachel Ware Zooi deftly coordinated production with great congeniality. My former assistant Nina Berson and current curatorial secretary Amie Lam were the magnetic force that held all of us involved in the production of the catalogue, as well as the show at large, in some kind of magical equipoise. At Antin's studio in San Diego, Pamela Whidden was equally a miracle of quantum physics. Bravo to all!

Finally, Eleanor and I have known each other professionally and personally for some twenty years. Working together closely for the past two years has made us fast friends, confidants, and, in many ways, students of life. We have both learned a great deal about the humanistic and philosophical dimension of her art and about ourselves, as we have reflected back on more than three decades of artistic achievement. It is my hope that the audience for the exhibition and the readers of this book will find our project as fulfilling as I have.

Howard N. Fox
Curator of Contemporary Art
Los Angeles County Museum of Art

Artist's Acknowledgments

I was always scared of the idea of a retrospective. I used to say I'd never have one. Why would I want to lay out my work? It was like being dead and no matter how worthy a corpse may be, she's still dead. How could I take the time out from my new projects to resuscitate the past? Having a long past is being old, and to somebody with a Peter Pan complex like me that's not an admission I make easily to myself. But when Howard Fox asked me if I would be interested in doing a retrospective exhibition, I took a deep breath, closed my eyes, crossed my fingers, and yelled "yes." The idea of working with Howard once again, and this time in an intense collaboration lasting several years, was too attractive for me to resist. But poor Howard, it hasn't been easy. Though all my work is actually quite related, unpacking as it does from a set of core images and ironies, the fluidity of media through which I navigate is enough to make the most resourceful curator give up the ghost. It has indeed been an adventure for both of us and that we came out of it very close friends is perhaps something of a miracle. But maybe not. At the worst moments, it was Howard's way to crack a joke, often a long, dumb, dialect joke, that made us roar with laughter and cooled us out.

Over the years, I've been very fortunate in working with a number of talented and creative people, who have become my friends as well as colleagues. First, and foremost, I would like to thank Phel Steinmetz, my beloved cameraman, and David Thayer, theatre designer extraordinaire. Then there's Lynn Burnstan and Rich Wargo, who worked with me on most of my films. And Ed Roe, Chuck Cox, Sherman George, and Jim Smith, who made it all work. And Marcia Goodman, Suzie Silver, Emily Evans, Roger Sherman, Joe Kucera, Jennifer Kotter, Becky Cohen, Pam Whidden, all my actors, musicians, technicians, costumers, scene painters. Throughout the years the University of California at San Diego has given me a second home and ditto for Ronald and Freyda Feldman in New York, along with the gang at the gallery, especially Marc Nochella and Martina Batan. And I can't forget Amy Heller and Denis Doros over at Milestone. And because, like the whipped cream in the Yankee Doodle, I always save the best for last, David, my life partner and husband, who gave me a life, and Blaise, Cindy, and now baby Zack, because they are.

Eleanor Antin

Lenders to the Exhibition

Eleanor Antin
The Art Institute of Chicago
Ronald Feldman Fine Arts, New York
Marcia Goodman, Encinitas, California
The Jewish Museum, New York
Marc Nochella, New York
Barry Sloane, Los Angeles
Whitney Museum of American Art, New York
Samuel David Winner, M.D., Del Mar, California
Jamie Wolf, Beverly Hills

Exhibitions Initiated and Sponsored by the Fellows of Contemporary Art

The Fellows of Contemporary Art, founded in 1975, is a nonprofit, independent corporation that supports contemporary art in California by initiating and sponsoring exhibitions of emerging and midcareer artists at selected institutions. The Fellows does not make grants to individuals or maintain a permanent facility or collection. In addition to sponsoring exhibitions, the Fellows' membership participates in a very active program of domestic and international tours and exhibition programs.

1976
Ed Moses Drawings 1958–1976
Frederick S. Wight Art Gallery, University of California, Los Angeles, Los Angeles, California
July 13–August 15
Catalogue essay by Joseph Masheck.

1977
Unstretched Surfaces/Surfaces Libres
Los Angeles Institute of Contemporary Art, California
November 5–December 16
Catalogue with essays by Jean-Luc Bordeaux, Alfred Pacquement, and Pontus Hulten.
Artists: Bernadette Bour, Jerrold Burchman, Thierry Delaroyere, Daniel Dezeuze, Christian Jaccard, Charles Christopher Hill, Allan McCollum, Jean-Michel Meurice, Jean-Pierre Pincemin, Peter Plagens, Tom Wudl, Richard Yokomi.

1978–80
Wallace Berman Retrospective
Otis Art Institute Gallery, Los Angeles, California
October 24–November 25
Catalogue with essays by Robert Duncan and David Meltzer.
Supported in part by a grant from the National Endowment for the Arts, Washington, D.C., a federal agency.

Traveled to Fort Worth Art Museum, Fort Worth, Texas; University Art Museum, University of California, Berkeley, California; Seattle Art Museum, Seattle, Washington.

1979–80
Vija Celmins: A Survey Exhibition
Newport Harbor Art Museum, Newport Beach, California
December 15–February 3
Catalogue with essay by Susan C. Larsen.
Supported in part by a grant from the National Endowment for the Arts, Washington, D.C., a federal agency.
Traveled to The Arts Club of Chicago, Chicago, Illinois; The Hudson River Museum, Yonkers, New York; The Corcoran Gallery of Art, Washington, D.C.

1980
Variations: Five Los Angeles Painters
University Art Galleries, University of Southern California, Los Angeles, California
October 20–November 23
Catalogue with essay by Susan C. Larsen.
Artists: Robert Ackerman, Ed Gilliam, George Rodart, Don Suggs, Norton Wisdom.

1981–82
Craig Kauffman Comprehensive Survey 1957–1980
La Jolla Museum of Contemporary Art, La Jolla, California
March 14–May 3
Catalogue with essay by Robert McDonald.
Supported in part by a grant from the National Endowment for the Arts, Washington D.C., a federal agency.
Traveled to Elvehjem Museum of Art, University of Wisconsin, Madison, Wisconsin; Anderson Gallery, Virginia Commonwealth University, Richard, Virginia; The Oakland Museum, Oakland, California.

1981–82
Paul Wonner: Abstract Realist
San Francisco Museum of Modern Art, San Francisco, California
October 1–November 22
Catalogue with essay by George W. Neubert.
Traveled to Marion Koogler McNay Art Institute, San Antonio, Texas; Los Angeles Municipal Art Gallery, Los Angeles, California.

1982–83
Changing Trends: Content and Style, Twelve Southern California Painters
Laguna Beach Museum of Art, Laguna Beach, California
November 18–January 3
Catalogue with essays by Francis Colpitt, Christopher Knight, Peter Plagens, and Robert Smith.
Artists: Robert Ackerman, Caron Colvin, Scott Grieger, Marvin Harden, James Hayward, Ron Linden, John Miller, Pierre Picot, George Rodart, Don Suggs, David Trowbridge, Tom Wudl.
Traveled to Los Angeles Institute of Contemporary Art, Los Angeles, California.

1983
Variations II: Seven Los Angeles Painters
Gallery at the Plaza, Security Pacific National Bank, Los Angeles, California
May 8–June 30
Catalogue with essay by Constance Mallinson.
Artists: Roy Dowell, Kim Hubbard, David Lawson, William Mahan, Janet McCloud, Richard Sedivy, Hye Sook.

1984
Martha Alf Retrospective
Los Angeles Municipal Art Gallery, Los Angeles, California
March 6–April 1
Catalogue with essay by Suzanne Muchnic.
Traveled to San Francisco Art Institute, San Francisco, California.

1985
Sunshine and Shadow: Recent Painting in Southern California
Fisher Gallery, University of Southern California, Los Angeles, California
January 15–February 23
Catalogue with essay by Susan C. Larsen.
Artists: Robert Ackerman, Richard Baker, William Brice, Karen Carson, Lois Colette, Ronald Davis, Richard Diebenkorn, John Eden, Llyn Foulkes, Charles Garabedian, Candice Gawne, Joe Goode, James Hayward, Charles Christopher Hill, Craig Kauffman, Gary Lang, Dan McCleary, Arnold Mesches, John M. Miller, Ed Moses, Margit Omar, Marc Pally, Pierre Picot, Peter Plagens, Luis Serrano, Reesey Shaw, Ernest Silva, Tom Wudl.

1985–86
James Turrell
The Museum of Contemporary Art, Los Angeles, California
November 13–February 9
A book entitled *Occluded Front: James Turrell* was published in conjunction with this exhibition.

1986
William Brice
The Museum of Contemporary Art, Los Angeles, California
September 1–October 19
Catalogue with essay by Richard Armstrong.
Traveled to Grey Art Gallery and Study Center, New York University, New York.

1987
Variations III: Emerging Artists in Southern California
Los Angeles Contemporary Exhibitions
April 22–May 31
Catalogue essay by Melinda Wortz.
Artists: Alvaro Asturias, John Castagna, Hildegarde Duane, David Lamelas, Tom Knechtel, Joyce Lightbody, Julie Medwedeff, Ihnsoon Nam, Ed Nunnery, Patti Podesta, Deborah Small, Rena Small, Linda Ann Stark.
Traveled to Fine Arts Gallery, University of California, Irvine, California; Art Gallery, California State University, Northridge, California.

1987–88
Perpetual Motion
Santa Barbara Museum of Art, Santa Barbara, California
November 17–January 24
Catalogue with essay by Betty Turnball.
Artists: Karen Carson, Margaret Nielsen, John Rogers, Tom Wudl.

1988
Jud Fine
La Jolla Museum of Contemporary Art, La Jolla, California
August 19–October 2
Catalogue with essays by Ronald J. Onorato and Madeleine Grynsztejn.
Travel supported by a grant from the National Endowment for the Arts, Washington D.C., a federal agency.
Traveled to de Saisset Museum, Santa Clara University, Santa Clara, California.

1989–90

The Pasadena Armory Show 1989
The Armory Center for the Arts, Pasadena,
California
November 2–January 31
Catalogue with essay by Dave Hickey, and curatorial
statement by Noel Korten.
Artists: Carole Caroompas, Karen Carson, Michael
Davis, James Doolin, Scott Grieger, Raul Guerrero,
William Leavitt, Jerry McMillan, Margit Omar, John
Outterbridge, Ann Page, John Valadez.

1990

Lita Albuquerque: Reflections
Santa Monica Museum of Art, Santa Monica,
California
January 19–April 1
Catalogue with essay by Jan Butterfield, and
interview with Lita Albuquerque by curator
Henry Hopkins.

1991

Facing the Finish: Some Recent California Art
San Francisco Museum of Modern Art, California
September 20–December 1
Catalogue with essay by John Caldwell and
Bob Riley.
Artists: Nayland Blake, Jerome Caja, Jim Campbell,
David Kremers, Rachel Lachowicz, James Luna,
Jorge Pardo, Sarah Seager, Christopher Williams,
Millie Wilson.
Traveled to Santa Barbara Contemporary Arts
Forum, Santa Barbara, California; Art Center
College of Design, Pasadena, California.

1991–92

Roland Reiss: A Seventeen-Year Survey
Los Angeles Municipal Art Gallery, Los Angeles,
California
November 19–January 19
Catalogue with essays by Betty Ann Brown,
Merle Schipper, Buzz Spector, Richard Smith, and
Robert Dawidoff.
Traveled to University of Arizona Museum of Art,
Tucson, Arizona; The Neuberger Museum of Art,
State University of New York at Purchase, Purchase,
New York; Palm Springs Desert Museum, Palm
Springs, California.

1992–93

Proof: Los Angeles Art and the Photograph, 1960–1980
Laguna Art Museum, Laguna Beach, California
October 31–January 17
Catalogue essay by Charles Desmarais.
Supported by a grant from the National
Endowment for the Arts, Washington, D.C., a
federal agency.
Artists: Terry Allen, Eleanor Antin, John Baldessari,
Wallace Berman, George Blakely, Ellen Brooks,
Gillian Brown, Gary Burns, Jack Butler, Carl Cheng,
Eileen Cowin, Robert Cummings, Darryl Curran,
Lou Brown DiGiulio, John Divola, Robert Fichter,
Robbert Flick, Llyn Foulkes, Vida Freeman, Judith
Golden, Susan Haller, Robert Heinecken, George
Herms, Dennis Hopper, Suda House, Douglas
Huebler, Steve Kahn, Barbara Kasten, Edward
Kienholz, Ellen Land-Weber, Victor Landweber,
Paul McCarthy, Jerry McMillan, Virgil Mirano,
Stanley Mock, Susan Rankaitas, Allen Ruppersberg,
Edward Ruscha, Ilene Segalove, Allan Sekula,
Kenneth Shorr, Alexis Smith, Michael Stone, Todd
Walker, William Wegman.
Traveled to DeCordova Museum and Sculpture
Park, Lincoln Park, Lincoln, Massachusetts; The
Friends of Photography, Ansel Adams Center, San
Francisco, California; Montgomery Museum of Fine
Arts, Montgomery, Alabama; Tampa Museum of
Art, Tampa, Florida; Des Moines Art Center, Des
Moines, Iowa.

1993–94

*Kim Abeles: Encyclopedia Persona, A Fifteen-
Year Survey*
Santa Monica Museum of Art, Santa Monica,
California
September 23–December 6
Catalogue with essays by Kim Abeles, Lucinda
Barnes, and Karen Moss.
Additional support by grants from the Andy
Warhol Foundation for the Visual Arts, Inc., the
Peter Norton Family Foundation, and the J. Paul
Getty Trust Fund for the Visual Arts, a fund of the
California Community Foundation.
Traveled to Fresno Art Museum, California;
Southeastern Center for Contemporary Art,
Winston-Salem, North Carolina; Forum, St. Louis,
Missouri. USIA Arts America Program organized a
tour through Latin America for 1996: National
Museum of Fine Arts, Santiago; Complejo Cultural
Recoleta, Buenos Aires; Museum of Modern Art,
Rio de Janeiro; Museum of Modern Art, Caracas.

1994–95
Plane/Structures
Otis Art Institute Gallery, Los Angeles, California
September 10–November 5
Catalogue with essays by David Pagel, Dave Hickey, and Joe Scanlan.
Supported in part by grants from the National Endowment for the Arts, Washington, D.C., a federal agency; the Lannan Foundation, Los Angeles, California; and the Peter Norton Family Foundation, Santa Monica, California.
Traveled to The Renaissance Society at the University of Chicago, Chicago, Illinois; Pittsburgh Center for the Arts, Pittsburgh, Pennsylvania; Center for the Arts, Wesleyan University, Middletown, Connecticut; Nevada Institute for Contemporary Art, Las Vegas, Nevada.

1995–96
Llyn Foulkes: Between a Rock and a Hard Place
Laguna Art Museum, Laguna Beach, California
October 27–January 21
Catalogue with essays by Rosetta Brooks and Marilu Knode.
Traveled to The Contemporary Art Center, Cincinnati, Ohio; The Oakland Museum, Oakland, California; Palm Springs Desert Museum, Palm Springs, California.

1997
Scene of the Crime
UCLA at the Armand Hammer Museum of Art and Cultural Center, Los Angeles, California
July 22–October 5
Catalogue with essays by Ralph Rugoff, Peter Wollen, and Tony Vidler.
Artists: Terry Allen, D. L. Alvarez, John Baldessari, Lewis Baltz, Uta Barth, Nayland Blake, Chris Burden, Vija Celmins, Bruce Conner, Eileen Cowin, John Divola, Sam Durant, Vincent Fecteau, Bob Flanagan and Sheree Rose, Janet Fries, David Hammons, Lyle Ashton Harris, Richard Hawkins, Anthony Hernandez, Mike Kelley, Ed Kienholz and Nancy Reddin Kienholz, Barry La Va, Sharon Lockhart, James Luna, Monica Majoli, Mike Mandel, Larry Sultan, Paul McCarthy, Richard Misrach, Bruce Nauman, Robert Overby, Nancy Reese, Michelle Rolman, Edward Ruscha, Alexis Smith, George Stone, Jeffrey Vallance.

1998
Access All Areas
Japanese American Community Cultural and Community Center, Los Angeles, California
June 6–July 26
A discourse in cultural representation, art, and new media exhibited simultaneously on the Internet and billboards across the city of Los Angeles. The catalogue was produced in association with Smart Art Press with contributions from Glenn Kaino, Betty Lee, Edward Leffingwell, Joseph Sanatarromana, and Erika Suderburg.
Artists: Glenn Kaino, Betty Lee, Joseph Sanatarromana, Erika Suderburg.

1999
Bruce and Norman Yonemoto: Memory, Matter, and Modern Romance
Japanese American National Museum, Los Angeles, California
January 23–July 4
Catalogue with essays by Ian Buruma, Karin Higa, Timothy Martin, and Bruce and Norman Yonemoto.
Additional support provided by AT&T, the Andy Warhol Foundation for the Visual Arts, the Peter Norton Family Foundation, the National Endowment for the Arts, and the California Arts Council.

Future Exhibitions

1999–2001
On the Edge
Curated by Connie Butler.
Museum of Contemporary Art, Los Angeles,
California
October 1999–February 2001

Fellows of Contemporary Art Video Series

Videos are produced and directed by Joe Leonardi,
Long Beach Museum of Art Video Annex, for the
Fellows of Contemporary Art.

Red Is Green: Jud Fine, 1988
Horace Bristol: Photojournalist, 1989
*Altering Discourse: The Works of Helen and
 Newton Harrison,* 1989
Frame and Context: Richard Ross, 1989
*Experience: Perception, Interpretation, Illusion
 (The Pasadena Armory Show 1989),* 1989
*Similar Differences: The Art of Betye and
 Alison Saar,* 1990
Lita Albuquerque: Reflections, 1990
Los Angeles Murals, 1990
Stretching the Canvas, compilation tape,
 narrated by Peter Sellars, 1990
Michael Todd: Jazz, 1990
Waterworks, 1990
Roland Reiss: A Seventeen-Year Survey, 1991
Kim Abeles, 1993

Fellows of Contemporary Art

Roster of Members

Dean Ambrose
Dewey E. Anderson
Donna Jean Anderson
Erik Anderson
Marsha and Darrel Anderson
Barbara and Charles Arledge
Shirley Martin Bacher
Beatrix Barker
Dorsey and Bill Barr
Irene and Jerry Barr
Ann and Olin Barrett
Binnie Beaumont
Kay Sprinkle Beaumont and
 Geoffrey C. Beaumont
Lanie and Lazare Bernhard
Ilan Bialer
Marsha and Vernon Bohr
Mary Lou and George Boone
Suzanne and David Booth
Etan Boritzer
Wendy Brooks
Linda Brownridge and
 Edward Mulvaney
Gay and Ernest Bryant
Bente and Gerald Buck
Betye Burton
Susan and John Caldwell
Susan B. Campoy
Maureen and Robert Carlson
Charlotte Chamberlain and
 Paul Wieselmann
Kitty and Arthur Chester
Hyon Chough
Barbara Cohn
Aileen and Bob Colton
Susan and Michael Connell
Diane and Michael Cornwell
Peggy and Timm Crull
Jerry and Roberta Daudermann
Christina R. Davis
Jacqueline Davis and David Entin
Letitia Deckbar
Betty and Brack Duker
Lulu and George Epstein
Carolyn Farris
William D. Feldman and Joan Blum
Kathryn Files
Bunny and Clarence Fleming
Joanne and Beau France
Mardi and Merrill Francis
Dextra Frankel
Judy and Kent Frewing
Fritz Geiser
Linda Genereux and Timur Galen
Nancy Goodson
Linda and Arthur Goolsbee
Ruth and Mickey Gribin

Bill Griffin
Stephanie and Ken Grody
Pat and Eugene Hancock
Mary Elizabeth and
 Alfred Hausrath
Dr. Randal Haworth
Carol and Warner Henry
Joan and John Hotchkis
Roberta and Sandy Huntley
Sally and Bill Hurt
Michelle and Bud Isenberg
Leigh and Pat Jackson
Linda and Jerry Janger
Gloria and Sonny Kamm
Stephen A. Kanter
Tobe Karns
Mickey Katz
Suzanne and Ric Kayne
Nan and Mark Kehke
Teri and John Kennady
Tracy and Christopher Keys
Barbara and Victor Klein
Phyllis and John Kleinberg
Susan and Allan Klumpp
Martha Koplin
Jessica and Tom Korzenecki
Virginia Krueger
Hannah and Russel Kully
Anne Lasell
Larry Layne
Dawn Hoffman Lee and Harlan Lee
Luc Leestemaker
Lydia and Charles Levy
Bobbi Linkletter and Guy Blase
Linda Lund
Penny and John Lusche
Gloria and Richard Mahdesian
Barbara and Terry Maxwell
Dee Dee and Ted McCarthy
Amanda and James McIntyre
Lois and Frederick McLane
Elizabeth Michelson
Carolyn and Charles Miller
Donna and Clinton Mills
Rochelle and Jeff Mills
Harry Montgomery
Hilarie and Mark Moore
Adriane and Allan Morrison
Laura Donnelley Morton and
 John Morton
Garna and Steven Muller
Pam and Jim Muzzy
Ann and Bob Myers
Grace and Richard Narver
Lois and Richard Neiter
Dr. and Mrs. Robert H. Newhouse
Sandra Kline Nichols and
 Peter Christine Nichols

Eileen and Peter Norton
Rosemary and Chang Pak
Cathie and David Partridge
Suzanne and Theodore Paulson
Joan Payden
Putter and Blair Pence
Audree and Standish Penton
Marisa and Jacques Perret
Ellie and Frank Person
Tom Peters
Tina Petra and Ken Wong
Peggy Phelps and Nelson Leonard
Linda and Reese Polesky
Dallas Price
Kathy Reges and Richard Carlson
Joan B. Rehnborg
Joan and Tom Riach
Carol and John Richards
Debby and Bill Richards
Gayle and Edward Roski
June W. Schuster
Anton David Segerstrom
Patricia Shea
Frances and Donald Shellgren
Marjorie and David Sievers
Sandy and Marvin Smalley
Ann and George Smith
Annette and Russell Dymock Smith
Miriam L. Smith and
 Douglas Greene
Gwen Laurie Smits
Penny and Ted Sonnenschein
Laurie Smits Staude
Patricia and Charles Steinmann
Margarita and David Steinmetz
Gretel and George Stephens
Clara and Jason Stevens
Ginny and Richard Stever
Arthur Strick
Ann E. Summers
Joan and Louis Swartz
Janet and Dennis Tani
Laney and Thomas Techentin
Elinor and Rubin Turner
Lois and Jim Ukropina
Jolly Urner
Donna Vaccarino
Carolyn and Bob Volk
Cindy and Jim Wagner
Magda and Frederick Waingrow
Madi Weland and Mark Solomon
Linda and Tod White
Mili Julia Wild
Bonnie and Jack Wilke
Jene M. Witte
Cynthia and Eric Wittenberg
Maybelle Bayly Wolfe
Laura-Lee and Robert Woods